Trac

ALLEN MEMORIAL ART MUSEUM OBERLIN COLLEGE, OHIO

ce Ele

STEPHEN D. BORYS

ASSISTED BY SUSANNA NEWBURY
AND ALEXANDER GROGAN
ESSAY BY JENNIE HIRSH

ments

NEW WORK AT OBERLIN

Published in conjunction with the exhibition

TRACE ELEMENTS: NEW WORK AT OBERLIN

Curated and organized by Stephen D. Borys,
Curator of Western Art, Allen Memorial
Art Museum, Oberlin College, Oberlin, Ohio
18 October 2005–15 January 2006

The exhibition and catalogue were made
possible by generous support from the
Dean's Office, College of Arts and Sciences,
and the Office of Sponsored Programs through
a Research and Development Grant, Oberlin College,
and the Friends of the Allen Memorial Art Museum.

Library of Congress Cataloging-in-Publication Data
Borys, Stephen D. (Stephen Donald)
 Trace elements : new work at Oberlin / Stephen D. Borys ;
assisted by Susanna Newbury, Alexander Grogan ;
essay by Jennie Hirsh.
 p. cm.
 ISBN 0-942946-05-7
1. Art, American—Ohio—Oberlin—21st century—
Exhibitions. 2. Oberlin College—Faculty—Exhibitions.
I. Newbury, Susanna. II. Grogan, Alexander.
III. Allen Memorial Art Museum. IV. Title.
N6512.7.B67 2005
709'.771'2307477123—dc22 2005017281

PRODUCED BY WILSTED & TAYLOR PUBLISHING SERVICES

Project management: Christine Taylor and Jennifer Uhlich
Copy editing: Nancy Evans
Design and composition: Jeff Clark
Printing and binding: Friesens in Canada

For Hazel and Roman

CONTENTS

Facing: Detail of JOHN PEARSON,
Yorkshire Series: Regeneration-Continuum: Fall: AMAM;
Genesis: AMAM; Spring: AMAM, 2005 (see fig. 21).

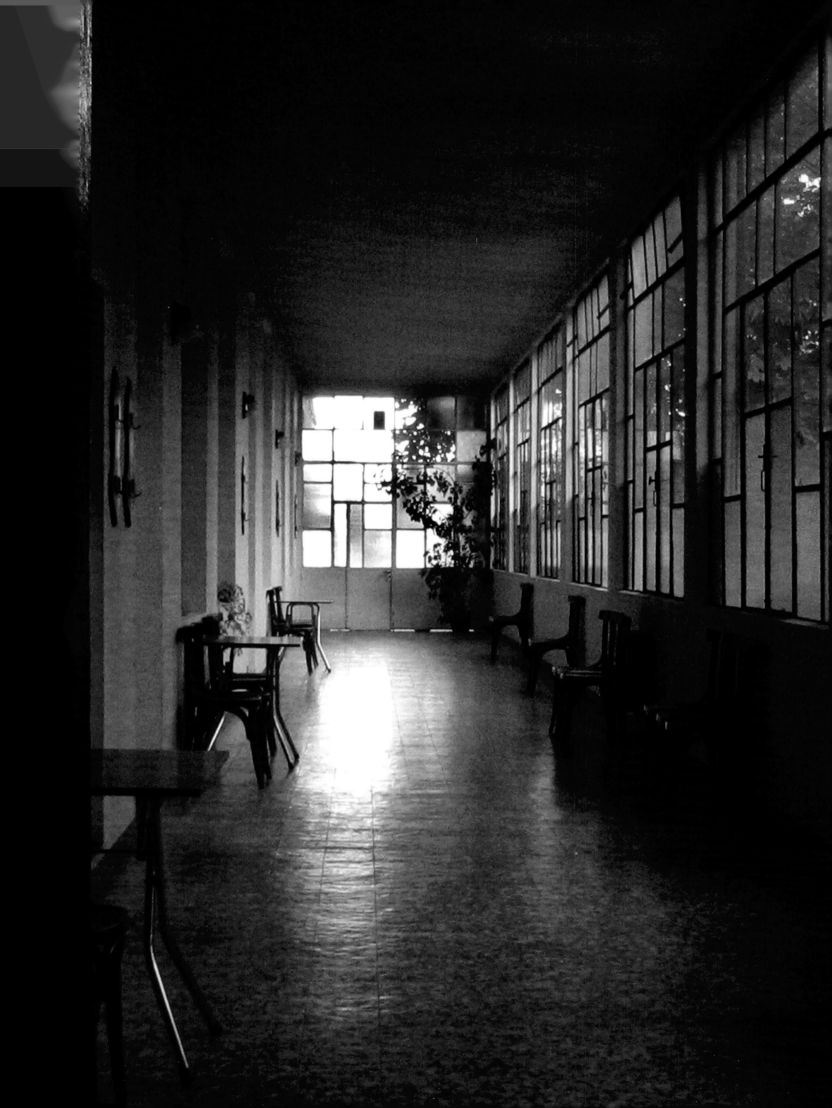

Trace Elements: New Work at Oberlin provides a wonderful opportunity for the Allen Memorial Art Museum to highlight work by Oberlin College's outstanding Studio Art faculty and present it to the Oberlin community and to our wider museum public. This exhibition represents the first faculty show to be held at the museum in over three decades.

Included are works in a variety of media—painting, drawing, printmaking, photography, sculpture, new media, sound, and installation—by artists Rian Brown, Johnny Coleman, Pipo Nguyen-duy, John Pearson, Sarah Schuster, and Nanette Yannuzzi-Macias. Each artist is in a very different stage of his or her career, but all share a desire to continue a personal artistic journey through new work. Their influence and vision is keenly felt by many Oberlin College students whose work they help develop through teaching, research, and ongoing dialogue about art.

The exhibition was organized by the Allen's Curator of Western Art, Stephen D. Borys, who worked closely with each artist to select the works for the show. Spending hours in their studios, Dr. Borys interviewed the artists on several occasions in order to document the varied creative processes they use in making their art. He was ably assisted by two recent Oberlin graduates, Susanna Newbury (OC '05) and Alexander Grogan (OC '05). I would like to thank our colleague Jennie Hirsh, formerly Visiting Assistant Professor of Modern and Contemporary Art and Architecture at Oberlin and currently a postdoctoral fellow in the Program in Hellenic Studies at Princeton University, for charting the evolution of each artist's work in her excellent catalogue essay.

This exhibition strives to identify—within a particular group of artists—currents in art expression today and explore their implications for the future. Because we at the Allen are deeply interested in the practice of contemporary art, we are proud and excited to show our colleagues' work in this exhibition.

STEPHANIE WILES

John G. W. Cowles Director, Allen Memorial Art Museum
Oberlin College, Oberlin, Ohio

Facing: Detail of RIAN BROWN, *Breadcrumbs*, 2005 (see fig. 7).

9

Exhibiting and collecting contemporary art at the Allen Memorial Art Museum has played a vital role in the life of the museum and college for many decades; however, there have been few occasions when the artists who instruct and inspire the students at Oberlin College have been given a critical forum at the museum. *Trace Elements* marks the Allen's first exhibition of new work by the Studio Art faculty in more than thirty years.

This exhibition and catalogue are the results of two parallel developments that have taken place over the past year: first, the documentation of countless hours of both casual and concentrated studio conversations on art and art-making, process and technique, vision and influence; and second, and most notably, the production of new art that is highlighted in the exhibition. It is therefore fitting that the museum's two largest exhibition spaces, the Ellen H. Johnson and John N. Stern galleries, both dedicated to individuals who have supported the collecting and exhibiting of contemporary art at Oberlin, have been given over to the *Trace Elements* exhibition.

My first expression of gratitude is to the six artists whose work is featured here: Rian Brown, Johnny Coleman, Pipo Nguyen-duy, John Pearson, Sarah Schuster, and Nanette Yannuzzi-Macias. Together their teaching and creative output at Oberlin amount to almost ninety years of instruction, with the most senior faculty member, John Pearson, representing thirty-three of those years. This exhibition and publication are about their art and artistic visions, and the diverse yet interconnected worlds they explore in their art-making. The successful realization of this project depended heavily on their participation, and I thank each of them for their dedication and imagination, and for producing exciting new work for the show.

This artistic and curatorial undertaking also celebrates the coming together of studio art and art history traditions and personalities at Oberlin, and it serves as a vital opportunity for students, teachers, and visitors to observe and engage in the shared processes of creating, exhibiting, and studying contemporary art.

The catalogue represents a rewarding collaboration with my colleague Jennie Hirsh and two former students and curatorial assistants at Oberlin College, Susanna Newbury and Alexander Grogan, to all of whom I owe my sincere thanks. Jennie Hirsh produced an enlightening and erudite essay, and offered insightful comments on the catalogue and installation, which helped greatly in my final selection of works. Susanna Newbury wrote the biographies for Johnny Coleman, Pipo Nguyen-duy, and Nanette Yannuzzi-Macias and transcribed many hours of interviews. She also edited the final interview transcriptions and artists' histories. Alexander Grogan wrote the biographies for Rian Brown, John Pearson, and Sarah Schuster, and assisted with interview transcription.

I am grateful to Stephanie Wiles, John G. W. Cowles Director of the AMAM, for her commitment to this exhibition, and to other members of the staff, particularly Leslie Miller, Jian Sakakeeny, Michael Holubar, Michael Jones, Laura Winters, Lucille Stiger, and the security officers. Thanks also go to Mary Kurz and Edward Fuquay in the Art Department.

This exhibition was made possible with the support of grants from the Dean's Office, College of Arts and Sciences, and the Office of Sponsored Programs through a Research and Development Grant, Oberlin College, and the Friends of the Allen Memorial Art Museum.

Special thanks are extended to Christine Taylor and the staff at Wilsted & Taylor Publishing Services for their pivotal role in producing such an attractive catalogue. The thoughtfulness, quick intelligence, and elegance that characterize the book's layout and design are due in large part to the efforts of project manager Jennifer Uhlich, copy editor Nancy Evans, and designer Jeff Clark. I am also grateful to John Seyfried for his superb photography evident throughout this catalogue.

My greatest debt, as always, is to my wife, Hazel Mouzon Borys, who has given me her untiring support in the completion of two major exhibitions and accompanying catalogues in the last year: *The Splendor of Ruins in French Landscape Painting* and now *Trace Elements*. My creative energy would have long since expired had it not been for the intellectual and emotional sustenance she has provided and for the loving care she bestows on our son, Roman.

STEPHEN D. BORYS

Curator of Western Art, Allen Memorial Art Museum
Oberlin College, Oberlin, Ohio

The words in the title of this exhibition encompass multiple meanings, and indeed the works included rely on different aspects of these words' significances. "Trace" is a noun, an adjective, and a verb. As a substantive, it refers not only to a path, a road, a course, a footprint, but also to a sign, a mark, even a pattern on the screen of a cathode-ray tube. As an adjective, "trace" describes minute quantities, while as a verb, it refers to moving along a path, to track, to discover by investigation, and to copy with lines, as in drawing. The word "elements" refers specifically to the four elements once believed to constitute all physical matter: earth, air, fire, and water—a concept that continues to carry symbolic weight in art and culture today. A "trace element" is an element present in soil, water, or air in minute amounts. Typically, such substances, in limited quantities, sustain life; in large doses, they kill. *Trace Elements* weaves a rich textile of the various meanings of these words in its survey of artistic projects that track the evolution of trace elements into embodied wholes.

The six members of the faculty who teach studio art at Oberlin College—Pipo Nguyen-duy, Rian Brown, Sarah Schuster, Nanette Yannuzzi-Macias, Johnny Coleman, and John Pearson—mediate representation through their surroundings, both real and imagined. Their materials, themes, and ideas pose questions about art's dual status as both old *and* new, two dialectically linked sides of re-presentation, through intertwined investigations of autobiography, mythology, scientific inquiry, and site. Oberlin's flat, rural terrain functions as a home base for these artists, a fertile bed from which other landscapes may be conjured. Working across media, they generate figurative and abstract objects and installations that conflate personal and universal responses to nature. Exploring how "trace elements" permeate

Facing: Detail of **NANETTE YANNUZZI-MACIAS**, *Umbilicus: Las Madres*, 1996 (see fig. 68).

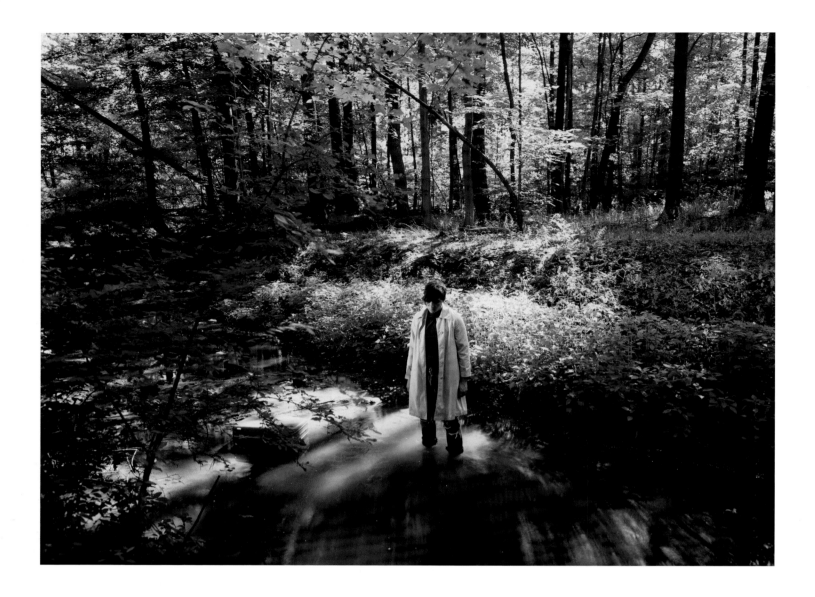

their literal and metaphorical artistic formulations of the intersection of identity, history, and memory provides a framework for the analysis of both their synthetic artistic production and their informative natural worlds. The enduring statements of their work often fall into different camps. Some of these artists suggest that nothing is ever truly new, and that some form of trace element is necessary for the formulation of their work. Ultimately, those works will testify that indeed every work of art, if not a ready-made itself, is *at most* a manipulation of present elements. For others, the renegotiation of found elements will make clear that, in spite of the impossibility of creating *ex nihilo*, their resulting artistic productions are always *at least* slightly different variations, since artistic intervention is ultimately human and, hence, necessarily imperfect. For them, the artist defies the impossibility of originality, always producing forms differing—

even if only slightly—from found elements. At times, the works in this show even argue both positions.

Pipo Nguyen-duy's current work illustrates the psychological fallout experienced in the United States since September 2001, and to that end he relies on the tradition of landscape painting to imagine photographically the fall of man in both *East of Eden* and *The Garden*, the latter a series shown for the first time in *Trace Elements*. Nguyen-duy's reliance on the natural world as a theatrical apparatus uncovers collisions between nature and culture, past and present, in carefully crystallized visions that inscribe themselves onto classical Western visions of the (un)natural world. Mythological references and choreographed staging serve structurally and thematically to infuse his imagined landscape with an eerie sense of art historical déjà vu.

Fig. 1 (Cat. No. 3). PIPO NGUYEN-DUY, *East of Eden: Nomad*, 2003. C-print, 30 × 40 in. Courtesy of the artist.

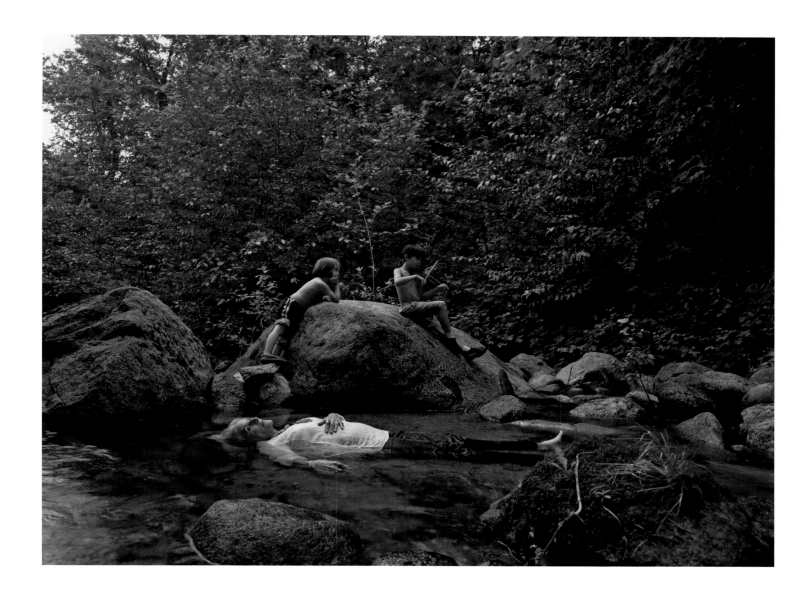

East of Eden stages mysterious interactions between human figures cast into and out of bucolic paradise. In *East of Eden: Nomad* (2003; fig. 1), a modern-day Narcissus clad in a raincoat and blue jeans with a foppish hairdo stands completely enraptured by his own image faintly floating in the pool of water beneath his feet.[1] But whereas standard mythological accounts of Narcissus pose the handsome youth at the edge of a pool, riveted by his own likeness reflected before him, this figure upsets the viewer's expectation of separate likeness, entering into and merging with his syncopated image.[2] The discarded suitcase to the left suggests an abandonment of concerns, all secondary to the pursuit of the self, confronted here by the naturally formed mirror of the water, whose murky surface absorbs not only the figure but the lush greenery all around. Trees leaning to reach the mystical light, perhaps falling, confirm Nguyen-duy's delivery of the spectator *east* of Eden to an idyllic setting weary from and wary of its own fragility.

East of Eden: Rapture (2003; fig. 2) casts together an unusual trio of figures: a water-bound middle-aged woman and two young boys perched on a rock beside her. Forever painterly, Nguyen-duy arranges a triangular composition with a horizontal floating figure at the bottom of a peak made complete by the angled bodies of the two children. Reminiscent of the classicism of Nicolas Poussin, this Orphean combination of pastoral perfection and delicate youth perverts the traditional myth.[3] As the boy to the left leans forward on the rock, we cannot be sure if his chin resting on his right hand implies his interest in the sound of the violin or if, instead, he is considering the gravity of discovering a dead body. If dead, the woman's body naturally evokes a funereal dirge, here delivered by the young musician. This

Fig. 2 (Cat. No. 4). PIPO NGUYEN-DUY, *East of Eden:*
Rapture, 2003. C-print, 30 × 40 in. Courtesy of the artist.

Fig. 3 [above]. JEFF WALL (Canadian, b. 1946), *The Vampires' Picnic*, 1991. Cibachrome transparency in fluorescent light box, 97³/₄ × 139¹/₄ in. The National Gallery of Canada, Ottawa, no. 36801.

Fig. 4 (Cat. No. 11) [facing]. PIPO NGUYEN-DUY, *The Garden: 02-04-A-01*, 2004. C-print, 30 × 40 in. Courtesy of the artist.

aged Eurydice floats on the water, magnetized by its depths, as the child Orpheus prematurely enacts his inevitable separation from his beloved, here already on in her years. By looking away from the body, the two young boys further allude to this myth, where voyeurism is punished in the extreme, Eurydice forever doomed to the underworld as payment for the sin of Orpheus' retrospect. In translating his post-lapsarian state of being into contemporary sites and visual terms, Nguyen-duy's work bears affinities to that of Jeff Wall, whose appropriative strategy also awakens our art historical memories, as in *The Vampires' Picnic* (1991; fig. 3), an inhabited landscape gone awry. In the spirit of paintings like Edouard Manet's *Le Déjeuner sur l'herbe*, which upset social conventions and pictorial precedents in 1863, Wall's macabre photograph, like Nguyen-duy's, introduces a more deadly outcome to a failed social engagement in the contemporary moment.[4]

The six predatory young men who crouch ready to pounce in *East of Eden: Fighting Twins* (2003; see fig. 45) provide us with symmetry as well as its betrayal. The twins' centrality suggests a point of origin (for the image, for representation, for life) that in its original status is already a failed copy, as evidenced by their incongruent clothing

and bodily stance. A carefully chosen complex landscape juxtaposes the natural with the man-made as the foliage hovers around the corpse of an abandoned cement factory. An icon of fabrication of an unnatural substance, cement, the factory testifies to mortality, seen here in sharp contrast to the young trees that sprout to replenish a landscape made barren by the industrial activity of human beings. Strategically set in a bare, wooded landscape, the suited fencers bearing elegant rapiers in *East of Eden: Swordmen* (2003; see fig. 46) seem like aliens in a still less natural version of conflict. Whereas the *Fighting Twins* wear simple costumes of blue jeans and khakis, sweatshirts, and baseball jackets—harkening back to contrived cinematic shots like those of the Jets and Sharks in Jerome Robbins and Robert Wise's 1961 cinematic production of *West Side Story*—the futuristic *Swordmen* engage in a self-consciously formal exercise. Graceful and posed, the fencers are caught in the *act* of choreographed fighting, a courtly sport anything but natural.

East of Eden: In the Garden (2003; see fig. 47) transports the viewer to a more manicured landscape, suburbia, America's ultimate fantasy of controllable nature. Shorn hedges, a meticulously mowed lawn, and carefully planted flowers adorn this private sanctuary. Shot from the back, the ambiguously gendered figure stands just off-center, arms raised. This enigmatic protagonist flaunts a hospital bracelet—perhaps a sign of escape—and remains curiously mesmerized by the (un)natural light caught by streams shooting from a nearby sprinkler. Nguyen-duy's subject eludes the logic of the gaze that once again attempts to resolve his uncanny shots.

In his most recent serial project, *The Garden* (2004; fig. 4), Nguyen-duy further enriches the effects of his photographic imagination on a landscape that preserves the spectral relics of human presence in a site seemingly abandoned to nature. His inclusion of details such as a discarded tractor, a driverless car, and an empty bed in some samples from this series alerts the viewer to what no longer occurs in these greenhouses; these objects simultaneously stand as "modern" ruins that echo and update a long-standing Western painting tradition.[5] These corpses of human purpose, their activity lapsed, now function in the guise of ready-made still lifes.

As opposed to *East of Eden* and its reliance on the discomforting interaction of nature and humanity, *The Garden* references the artificiality of human order applied to nature through architecturally framed cycles of growth and decay. In this instance, the reference is

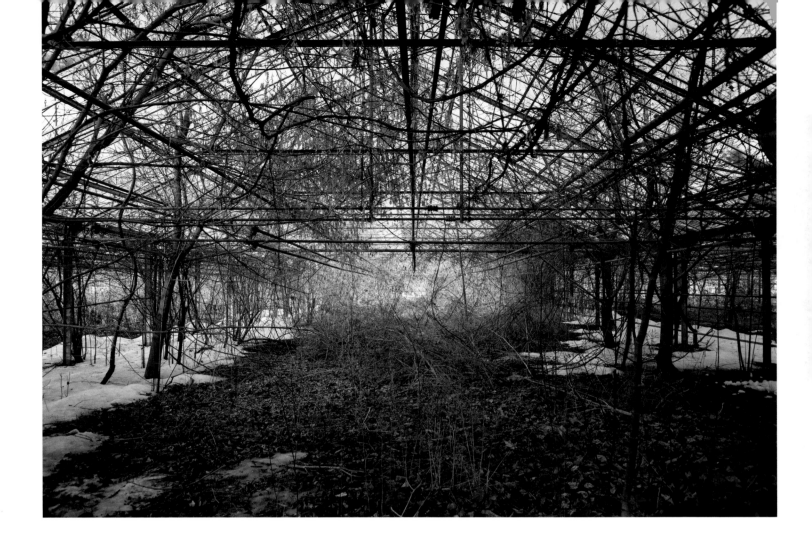

not mythology or old paintings, but their structure: the one-point perspective of Renaissance painting.[6] In symmetrically composed shots of the greenhouses' exposed metal skeletons, Nguyen-duy commands structure *from nature*, a compositional reminder of both photography's and painting's deceptive superimpositions of perspective—the translation of binocular into monocular vision. As such, Nguyen-duy trumps the achievements of Renaissance painting, asserting the supremacy of the eye and the mechanical lens dyad over the alliance of the eye and the paintbrush. He recovers and reframes the grid sent underground by Modern painting in a mechanically executed gesture that resurrects one of the medium's greatest historical moments. The greenhouses' invisible glass skins and metallic supports make perspective transparent, an observation further underscored by the gridlike installation of these works (fig. 4; see figs. 48a, 48b, 49a, 49b).[7]

Nguyen-duy's repetitious act of photographing the structures—the shots now number more than two hundred—is a manic return to site that belies a melancholic orientation toward the failed dream. Like German photographers Bernd and Hilla Becher and American photographer William Christenberry, Nguyen-duy has created his own archive of vernacular architecture. But whereas the Bechers and Christenberry seek out particular building types across different landscapes, Nguyen-duy remains dedicated to the ongoing scientific documentation of this site in northeast Ohio. *The Garden* returns to a lush world no longer contaminated by human domination, marking the post-2001 United States as a postlapsarian state as well. In the space of humanity's overruled precision, nature will dictate which new seeds will grow and where. The emphasis on seriality through the repetitive visits to these sites aligns the works with painterly precedents found in Claude Monet's infamous *Haystacks* and in Paul Cézanne's innumerable visions of Mont Sainte-Victoire, and stimulates a different, abstract perspective gained through the digestion of a body of work.[8]

Attention to painterly detail also permeates the work of filmmaker Rian Brown, who navigates the mythic territory between autobiography, cultural commentary, and their poetic reassembly in the continually changing imagery of film and video. Very much in the spirit of

Fig. 5 [above]. **RIAN BROWN**, *Presence of Water*, 1999. Still. 16mm film, 27 min. Courtesy of the artist.

Fig. 6 (Cat. No. 1) [facing]. **RIAN BROWN**, *Breadcrumbs*, 2005. Three stills. Triple video projection with sound, 16 min. Courtesy of the artist.

Gaston Bachelard, Brown aligns her life-in-flux with a search to uncover its "trace elements" and establish some kind of directional orientation. As Bachelard writes, "in the presence of deep water, you choose your vision; you can see the unmoving bottom or the current, the bank or infinity, just as you wish; you have the ambiguous right to see or not to see."[9] *Presence of Water*, a 16mm film made in 1999 (fig. 5), narrates the tale of the mutual gestation of baby and mother and the emergence of disorientation in land and life. Relying on water as a metaphor for the camera lens and as a portal of self-knowledge, Brown infuses this film about taking steps forward in life with her own autobiography (see fig. 30).[10] The laborious process of optical printing that renders the supersaturated frames of this film serves as a self-reflexive artistic gesture that insists on the film as a site of human production. The film possesses breadth and depth as it traces the steps taken from the conception through to the birth and infancy of a child, simultaneously layering memories, reflections, and the interspersed voice-overs of mother and father. But the same "presence of water" is felt throughout the film as the spectator confronts not only the expulsion of a child afloat in the amniotic fluid of the womb but also the physical suspension of the image trapped in the emulsion of the film itself.[11]

The dry, arid landscapes of Southern California and Mars permeate *The Settler*, Brown's digital video from 2001 (see fig. 31), underscoring the life-giving powers of water necessary for the cultivation of the earth and its inhabitants. *The Settler* testifies to the interdependency of the basic elements, pitting the spectator against the barren, almost cruel nature of earth in the absence of water, always threatened by fire's consumption, as epitomized in her next film, *Death of the Moth* (2003; see figs. 32, 33), a collaboration with Oberlin colleagues Tom Lopez and Tim Weiss. An allegory of humanity's greed, Brown's digital video retraces a caterpillar's metamorphosis into a moth superimposed onto the traced outline of a figure as a symbol of human ignorance, with the poignant, burning body serving as a metaphor for modern-day political hubris.[12] *Death of the Moth* insists on the magnetic beauty of fire, but, like her earlier works, calls for a *balanced* vision of nature in which human beings respect the inner workings of the elements.

Brown's latest work, *Breadcrumbs* (2005), which debuts in *Trace Elements*, expands stylistic and thematic elements from her ear-

lier films in a modern-day "Hänsel and Gretel" projected in a three-channel video installation whose tripartite structure mirrors the three stages of life through a female lens.[13] It powerfully threads together youth, adulthood, and old age, here embodied in three archetypal female figures. Cast as Gretel, Brown repeatedly walks through diverse landscapes—the woods, a path, the beach—rhythmically dropping breadcrumbs from a fabric sack, the ephemeral traces of a life journey (see fig. 28). Compilations of experience and reflection, Brown's films are memory boxes, heirlooms that preserve personal visions through universal cinematic statements. Her works translate into filmic collections of memories that are analogous to the microcosms preserved in Joseph Cornell's delicate boxes. In his *Celestial Navigation* series, Cornell similarly preserves metaphors of fragile human subjects at the mercy of the cosmos. But the boxes that protect these delicate objects—glasses, miniature orbs, and pieces of paper—stand, like Brown's films, as hermetic time capsules siphoned off and stored away, time capsules for present *and* future contemplation.

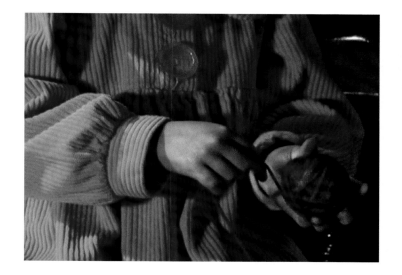

A voice-over poignantly announces that "[a] little girl asked, 'Did you know that caterpillars turn into butterflies?'" Close-up shots of Brown's sandaled feet plodding laboriously across the terrain recall the entranced female character central to *Meshes of an Afternoon*, the 1943 film by Maya Deren, whose trance-like visions were central to Brown's training as a filmmaker.[14] The investigation of female existence in *Breadcrumbs* reshapes the divided subjectivity of the thrice-cast Deren to consider the role of past and future in one articulate, present self. The Janus-faced nature of life in the present, with its mutual access to the past through memory and to the future through fantasy, is thematized by intermittent shots of Brown-as-Gretel winding and unwinding seemingly endless lengths of diaphanous white gauze around her head, entering into and breaking out of a cocoon as the film technically mirrors its narrative structure (fig. 6).

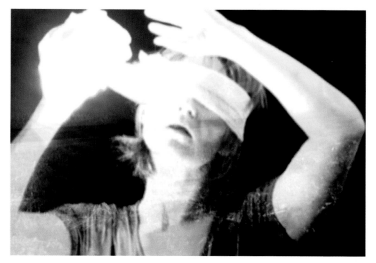

In some of the most lyrical shots of the film, Brown moves through an ambiguous institutional hallway that echoes the corridors of hospitals, hotels, and schools (fig. 7). *Breadcrumbs* pauses to meditate on the impersonal, socially constructed spaces that inevitably infiltrate human activities at various stages of life, sites of the joyous and tragic occasions that mark our existence: birth, healing, sickness, death. The repeated image of the hallway and, more particularly, movement *through the hallway*, suture the film's thematized life

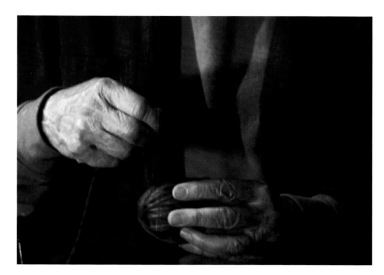

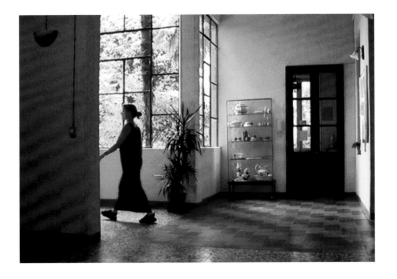

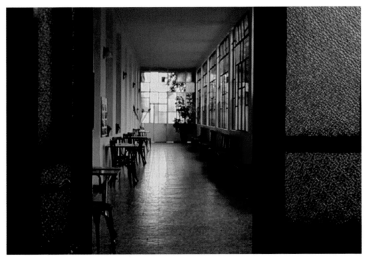

stages. Colored light permeates this passageway, where rays of warm lemon-yellow, shadows of green, and hints of red suggest a school or vacation spot while the cool blue tones express the more somber moods associated with hospitals. *Breadcrumbs* becomes metaphysical as its colors register psychic oscillations in the inanimate architecture of the human condition.

In its survey of painterly styles, *Breadcrumbs* offers shots that masquerade as Old Master and Renaissance paintings, much like the works of video artist Bill Viola. In a particularly striking shot, Brown isolates a moment of intimate exchange as a young girl and grandmother together examine the gingerbread house that they have made (see fig. 29). The illuminated figures and house glow against a dark background while tiny grains of gumdrop sugar capture minuscule points of light. Brown articulates an image that stages the curiosity of youth with the wisdom of old age through video's transposition of painterly precedent. Like Nguyen-duy, Brown pauses to express a debt to painting in a gesture that stabilizes the film's exposure of the fiction of "home." She chooses the easily consumed gingerbread house, whose structure and component parts insist on the fragility of homes whose endurance hangs on emotional commitments. The façade-like structure of the installation in this exhibition further underscores this very point.

Shots of old and young female hands unwinding and rewinding skeins of burgundy yarn recur throughout *Breadcrumbs* (fig. 6). The thread functions as a lifeline between the elderly and young Gretels, a signifier of bloodlines that connect generations. In a playful translation of the thread from wool to candy, the "little girl" eats red licorice laces, a trace of lineage more appealing for a child.[15] The ritualistic winding of the yarn stands as a metaphor for film itself, a medium that allows us to literally "rewind" and "fast-forward," despite the fact that life itself remains one-directional. At the same time, Brown's casting of the yarn inscribes her in a larger history of women's art-making in its allusion to knitting, crocheting, and weaving, all *productive* crafts attributed to women. Artists such as Jackie Winsor addressed such stereotypes directly through sculptures that embody and signify the labor-intensive processes required not only for their genesis, but for handicraft in general.[16] Purposefully mirroring the simple shapes specific to the visual rhetoric of Minimalist sculp-

ture, imposing objects such as Winsor's *Four Corners* (1972; fig. 8) critique such essentializing gestures along with Minimalism's presumptively masculine rhetoric.[17]

For the past twenty years Sarah Schuster's artistic projects have also interrogated systems of sexual reproduction, creation, and human desire. Schuster began her career as a traditional, figurative painter who then embraced themes of replication, women's work, and gestation as her painting grew increasingly invested in feminist politics. Steeped in imagery from the natural world, the painterly themes of figure and landscape still reign supreme in her oeuvre. The doubled enraptured bodies central to Schuster's iconography explore a cultural fixation with melded figures, ranging from scientific studies of conjoined twins to the sexually unified bodies of *conjugatio* popular in Renaissance manuscripts. Schuster's *Origin of the Species* (2001–2002; fig. 9) echoes as well the doubled souls described by Aristophanes in Plato's *Symposium*, in which we read that originally all beings were formed as doubles, attached pairs of two men, two women, or one of each, that eventually cleave, damned to roam the earth in search of their missing halves, hence, an explanation of sexual attraction and orientation.[18] But Schuster's influences extend beyond the Western tradition in her appropriation of the fantastic, multilimbed erotic sculptures adorning the Indian temples of Khajuraho.

Schuster's *Replicants* (2005; fig. 10; see fig. 59) for the Oberlin show are variously sized, intimate rectangular tracings on gessoed wood finished in a graphite-colored oil paint and designed to be exhibited in grid-like combinations. Seemingly "polished" to expose a rich but subtle patina, these ambiguous objects appear to be made of slate or cast metal. Schuster carefully traces in white a rich array of undersea creatures across and around the surfaces of each block, replicating the aesthetic of the classroom chalkboard and children's toy blocks. Delicate and controlled, the ephemeral outlines of wild, gnashing fish, pulsating octopuses, and serpentine eels vibrate against subtly iridescent dark backgrounds that in turn imitate the darkness of the sea. Schuster takes her images from celebrated marine illustrator Richard Ellis, whose delicate drawings document endless deep-sea creatures who live miles below the surface.[19] As she culls specimens for our contemplation, Schuster evokes both the sea

Fig. 8 [above]. JACKIE WINSOR (American, b. 1941), *Four Corners*, 1972. Wood and hemp, 28⁷/₁₆ × 50¹/₂ × 51³/₄ in. Allen Memorial Art Museum, Oberlin College, Ohio. Gift of Donald Droll in memory of Eva Hesse, 1973.87.

Fig. 9 (Cat. No. 23) [below]. SARAH SCHUSTER, *Origin of the Species*, 2001–2002. Acrylic and charcoal on canvas, 60 × 72 in. Courtesy of the artist.

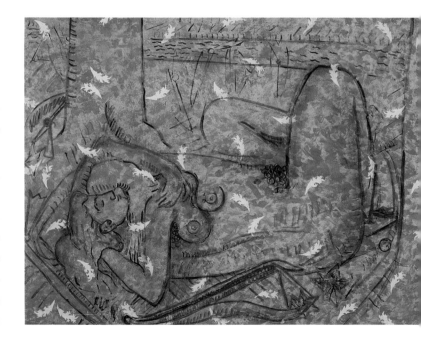

Fig. 10 (Cat. Nos. 24, 24a) [above]. SARAH SCHUSTER, *Replicants* (detail), 2005. Oil and carbon transfer on birch panel, 2 × 2 × 1¹/₂ in. to 4 × 5¹/₂ × 1¹/₂ in. (varied); white transfer paper, 6 × 7¹/₂ in. to 4 × 8 in. (varied). Courtesy of the artist.

Fig. 11 (Cat. No. 25) [facing top]. SARAH SCHUSTER, *Cultivations* (detail), 2005. Oil and carbon transfer on birch panel, 4 panels, each 7 × 5 × 1¹/₂ in. Courtesy of the artist.

Fig. 12 [facing bottom]. MIRIAM SCHAPIRO (American, b. 1923), *The Secret Garden*, 1974. Acrylic, fabric collage, 72 × 80 in. Allen Memorial Art Museum, Oberlin College, Ohio. Gift of the artist, 1975.51.

and the laboratory of its study. Her tracings creep over the edges of the blocks, entrapping the abyss that normally envelops them, while pointing to the fallacy of the window-on-the-world picture plane. As unstable physical objects, *Replicants* hover in between worlds and thus thematize the notion of liminality. Despite their title, these individually painted objects precisely deny the possibility of uniformity.

Yet another instance of Schuster's specular engagement with nature, the individual *Replicants* evoke far more than their underwater habitat. Their container-like shapes and pulsing bodies associate them with female genitalia. Their vicious teeth waiting to bite envision and indeed echo visions of the *vagina dentata* (see fig. 61). Simultaneously attractive and repugnant, *Replicants* confront the viewer with the danger and intrigue of female sexuality with their *external* throbbing forms that are visually synonymous with *internal*, and specifically female, organs. As such, Schuster's *Replicants* are abject in their disruption of a proper distinction between inside and outside.[20] In a way, their dangerous bodies quietly pronounce Jenny Holzer's incisive truism, "Protect me from what I want."[21]

Reproductions of watercolors of roses painted by Pierre-Joseph Redouté, one of the most efficacious artists in the history of botanical illustration, serve as the origin of *Cultivations* (2005; fig. 11; see fig. 60). The bloom of these flowers, incidentally one of the most fetishistically developed species, is not measured according to the size of their leaves or the spread of their blossom; rather, Schuster replaces the markers of organic growth with synthetic, yet personal, gestures that map their gestation as painted objects. Further underscoring their status as objects per se, these roses also wrap around the surfaces of their inscription, reminding the viewer of their fiction as both objects and an overcultivated species. Whereas photographs could isolate various stages of development of a single rose, *Cultivations* refuse to do just that: they champion the pictorial process of growth over the organic, Schuster's artistic process over the hermetic perfection of botanical drawings in work that embraces the uncontrolled and uncontrollable aspects of representation.

For each chosen species of the rose, Schuster produces four separate images, which she then arranges in a row to be read from left to right. The first panel, a gessoed wooden block, is decorated only with Schuster's pink tracing of the Redouté image (fig. 11). Next, in the second panel, Schuster develops the image further, deepening with her brush the skeletal outline of the flower specimen. What appears

in the third panel, though actually painted, is an etching-like version of the flower, as the monochromatic image begins to grow in terms of the added brushstrokes and variations in the pink hues. In the fourth and final panel, Schuster brings her creation into full artistic bloom with her highly palpable facture. Schuster's progressive construction of increasingly atmospheric roses must be viewed from left to right to uphold the logic of the evolution of her tender painterly process (see fig. 60).

Schuster's work is grounded in a project begun in the 1970s by artists such as Miriam Schapiro and Judy Chicago, a critique of the culturally constructed links between female experience and beauty as found, wild and uncontrolled, in nature. Schapiro's *The Secret Garden* (1974; fig. 12), an acrylic and fabric collage, pieces together floral, quilt-like paintings that index the domestic spheres of decorative handicraft and linens so often gendered female. An example of Schapiro's "femmages," *The Secret Garden* pits fictive images of flowers with the actual physical labor by a woman of weaving them together in a work that memorializes artistic process derived from traditionally prescribed female activities.[22] Fixated on natural subjects ascribed to women's interests, Schuster's work stands as a sophisticated critique of the false distinction between art and craft, product and process.

Trained by proto-performance artist Allan Kaprow and feminist artist Mary Kelly, Nanette Yannuzzi-Macias's performances and installations in the past fifteen years have consistently addressed a female

experience.[23] She enlists in the aesthetic consciousness of female body politics initiated by artists such as Louise Bourgeois and continued by more contemporary figures such as Kiki Smith and Mona Hatoum.[24] But over time her focus has shifted from society's obsession with reproductive technology to a reframing of the productive spheres of her life in response to society's inability to think outside very narrowly prescribed professional frameworks. Building on the work of Kaprow, most famous for his 1960s "happenings," Yannuzzi-Macias upsets the traditional division between home and office, confronting the viewer with the inevitable interplay of these two theatrical spheres of life while harking back to Louise Bourgeois's revolutionary *Femmes-Maisons*, a series begun in the 1940s, which famously pictured the burden of domesticity by replacing the heads of female figures with houses.[25]

In her newly created works for *Trace Elements—The Hours*, *Unos Milagritos de la Vida*, and *Piano with Scenes from Life* (all 2005)— the artist summons the heartbeat of domestic life and creative desire within the home as she envelops her viewer in a space pulsating with

the passage of time and littered with remnants of the human body that serve as sacrosanct relics. She corrals traces from the archives of the everyday, normally discarded both physically and psychologically, and preserves them in a meditative shrine that combines sculptural, video, and sound components. The *Collections* (of hair, teeth, fingernails [fig. 13], and red shoes [see fig. 71]), milagros, and ticking machines decorating the space are tiny in scale in comparison with the imposing upright piano with installed video monitors along with an empty bed.[26] As relics of live and dead bodies that grow and decay with age, these examples of bodily refuse along with household furnishings commemorate life as mother to children *and* art.

The schematic bed is rich with symbolism and allusion. Beds witness the key aspects of domestic life, the performance and absence of certain human activities: sleep, sex, dreams. Frail fabric strips woven between skeletal bedposts re-create the structure of a now defunct object. But atop this zigzag of cloth lies neither mattress nor box spring. The haunting ticking of a sea of clocks below reminds the sleepless viewer of what she must do, what she should do, what she will forget to do, while lying in bed. The viewer meets a dysfunctional bed (mis)placed in the gallery space.[27] Yannuzzi-Macias presents a sleepless night, or the underlying sleeplessness of every night. The familiar phrase "biological clock" also comes to mind as the ultimate sign of female productivity, female "usefulness." Underscoring the paramount importance of time through not only the regularized ticks of clocks but also the variable sounds of metronomes, the artist synthetically echoes organic heartbeats by using inorganic machines bound by the shelf life of batteries, wind-up devices, and mechanical gears.

Still more potentially cacophonous is the defunct, upright piano, in which Yannuzzi-Macias has embedded two video monitors that loop selections from her *Video Days*, several hours of footage taken in the artist's home over two months in the summer of 2000 (fig. 14). The piano refers back to a 1996 work, *Umbilicus: Remnants and Huaraches*, in which the artist drew on player-piano scrolls to create hieroglyphic paintings (fig. 15). As such, this piano completes a certain cycle as it plays the *real* music of lives formerly illustrated in paint. For *Video Days*, the artist installed stationary video cameras in two key locations in her home: the kitchen and the front hall, both representa-

tive sites of regular human activity, interaction, and transition. Positioned at similar heights, both cameras depict the movements and activities of human figures somewhere between adult and child size. Cropping adult human heads assigns a child's perspective to the footage while also allowing the artist's home to stand in for any home under similar working-parent conditions. Documenting seemingly banal moments of emptying and loading the dishwasher, opening and closing the refrigerator door, and folding and sorting laundry, *Video Days* memorializes the repetitive rituals that constitute a typical routine. What happens in this kitchen and front hall indeed happens in all of our kitchens and front halls. *Video Days* elevates the normally invisible and yet ever frenetic pace of life in the home, making sacred space of moments often forgotten or dismissed as inconsequential.

Locked onto the stove, dishwasher, and refrigerator in her kitchen, the camera testifies to a range of activities, including cooking, cleaning, and the feeding of children, subtly recalling the more forceful messages of works such as Martha Rosler's *Semiotics of the Kitchen* (1975). Yannuzzi-Macias opens and closes the refrigerator door, fills and empties the dishwasher, and prepares and disposes of various meals, all the while balancing these chores with attending to the constant needs and whims of young children. But this camera presents the kitchen as empty hearth as well, full of its silent moments, as it awaits the next outburst of frenzied activity.

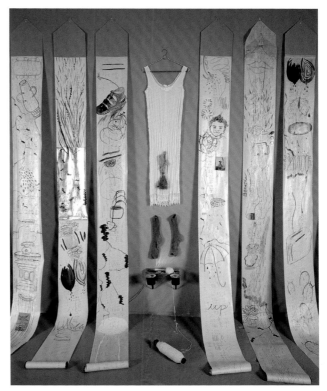

The front-hall footage of *Video Days* tracks similar patterns of human activity as it captures the artist at work folding the never-ending piles of laundry generated by her family. Set to capture life as it would unfold in the living room as well, this camera shares moments of children dancing and playing in the absence of self-consciousness that accompanies human beings as they grow older. Doris Salcedo's *Untitled* (1989–93; fig. 16), a stack of perfectly laundered and pressed white shirts with collars pierced by a vertical metal rod, similarly points to the energy invested in domestic tasks while alluding to the violent demise of innocent victims of political killings in Salcedo's native Colombia. In her footage of laundry and her earlier collection project dedicated to clothes-dryer lint, Yannuzzi-Macias touches on one aspect of domesticity as a metaphor for life and hardship that is easily applicable to non-domestic experience, rendering it all the more evocative.

■

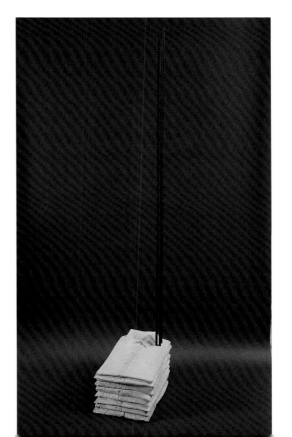

Johnny Coleman's constructed environments stage powerful personal and political dialogues between past and present, artwork and viewer. His artistic practice pieces together a rich cultural history diluted by the assault on individuality and identity experienced by African Americans under both slavery and the present day's continued articulation of racial and class prejudice.[28] Casting himself in a role that echoes the West African griot, he constructs narratives addressed to his family members that, although intimate, invite his spectators to bear witness to political and personal landscapes through messages expressed with love. *A Prayer for My Son and Myself* (1997; see fig. 37) and *A Landscape Convinced: For Nyima* (2001; see fig. 39), two works dedicated to his children, allow Coleman to secure Ayo's and Nyima's existences, to diminish their chance of being de-faced, stripped of name, and assimilated into mass anonymity. Seen as a collective, Coleman's ritualistic sculptural prayers stage lyrical dialogues between different generations born into the African diaspora. Playing local archaeologist, he unearths traces of his current landscape to bring to his work a sense of place and history that becomes, in his magical constructions, infused with a bittersweet song for humanity.

For *Trace Elements*, Coleman has constructed *A Promise of Blue in Green: For My Mother* (see fig. 41), a space that extends his prayer for his mother, Florence Wilma McCoy, a project under way since her death in 2003. As part of this project, Coleman constructed *Station to Station* in 2004 (fig. 17), a work whose messages functioned on both personal and political levels.[29] A monument and indeed a memorial to his mother's spirit, *Station to Station* indexed Coleman's current landscape through physical materials (bales of hay, fragments of tin roofing, and wooden boards) and also the specificity of Oberlin, a key stop on the Underground Railroad as slaves escaped the South. Rich in its allusions, a birdhouse serves as a second example of a way station, echoing the transient nature of safety and the liberty invoked by birds.

In response to *Station to Station*, Coleman made a series of two-dimensional works for which he again combed the local landscape. In his series *Sketches for Stations* (2004; fig. 18), Coleman continued to celebrate his mother's life in intimate wall sculptures of slate with local oak as their backing. In these works, the artist calls attention to his ongoing preoccupation with the birdhouse by schematically tracing its shape against the slate. The dual handprints of the artist serve as an indexical marker of Coleman's presence, an ephemeral trace of

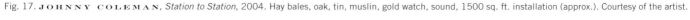

Fig. 17. **JOHNNY COLEMAN**, *Station to Station*, 2004. Hay bales, oak, tin, muslin, gold watch, sound, 1500 sq. ft. installation (approx.). Courtesy of the artist.

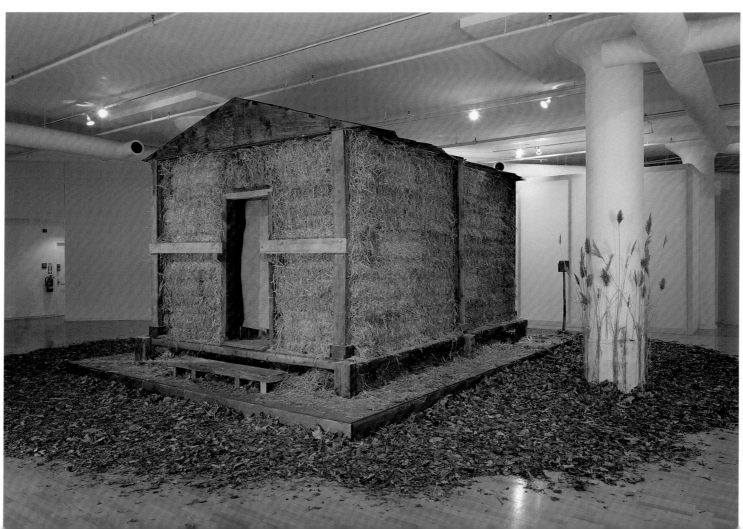

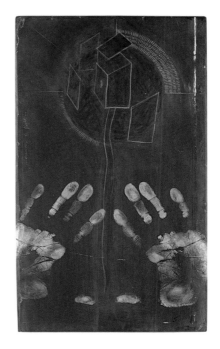

his body layered on top of his chalk drawing of the birdhouse, branding the structure as his own. But his hand- and fingerprints also recall impressions left by other hands pressed against a window—a child waiting for a parent to return home, a man braced against a police car for a pat-down—faint signs of both intimacy and violation. *Remembrance of Blue* (2004; fig. 19), an installation in an interior space of a Greek revival house at the Pomerene Center for the Arts in Coshocton, Ohio, includes a pair of birdhouses as a metaphor for freedom and flight in a meditative space whose dimmed and diffused lighting imparts a ritualistic aura to the installation. As its title suggests, this work delivers the beloved blue sky of his mother's life in California to Ohio, where the clouds less frequently permit such a view.

In *A Promise of Blue in Green*, the sounds of birds from the region around Oberlin coupled with the voices of Coleman's and his brother's children fill the space of a synthesized replica of the tree house and playhouse that the artist built for his son and daughter in his own backyard. This large, soundproof structure with a raised roof requires the viewer to climb a short set of stairs in order to enter into a memorial shrine built of pulled local wooden beams, tin roofing, and dried wildflowers. Scent and sound intermingle upon entry, as the viewer discovers the sounds of youth, several birdhouses, and the color blue. But whereas most birdhouses have only a single opening, Coleman's have two; his constructions themselves embody not just any bird, but Sankofa, a Janus-faced bird-like creature popular in West African mythology that looks back as it flies forward, an allegorical figure of historical (self)consciousness. Through combinations of sounds, smells, and sensual textures, Coleman's constructions literally transport the viewer into his world (California, Ohio, a far-off Africa) and across time as they situate together physical traces and metaphorical indices of the past in material configurations in the present. A portal to another locale in time and space, *A Promise of Blue in Green* topically delivers the laughter of Coleman's children at play in the artist's backyard in harmony with traces of his mother's lingering spirit.

Coleman's striking ability to sculpt space participates in a larger framework of artistic projects dedicated to spatial transfiguration. Part of her *Slave Coast Series*, Carrie Mae Weems's arresting triptych *Grabbing Snatching Blink and You Be Gone* (1993; fig. 20) combines photography and text to memorialize a site that served as a detention

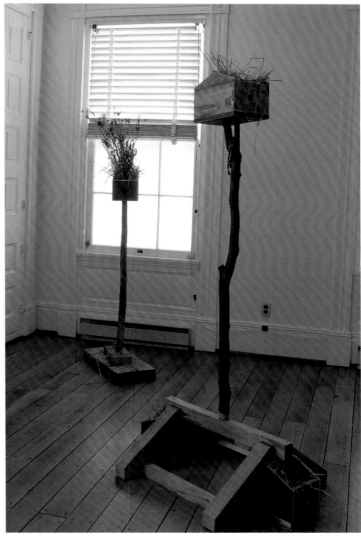

Fig. 18 [top]. **JOHNNY COLEMAN**, *Sketch for Stations*, 2004. Slate, oak, and chalk, 22 × 12 × 2 in. Collection of A. G. and Brenda Miller.

Fig. 19 [bottom]. **JOHNNY COLEMAN**, *Remembrance of Blue*, 2004. Recovered oak and maple, beeswax, straw, dried flowers, sound, 170 sq. ft. Collection of the Pomerene Center for the Arts, Coshocton, Ohio.

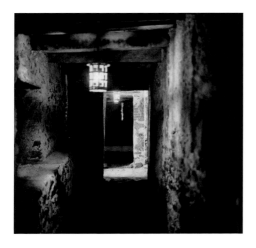

Fig. 20. Carrie Mae Weems (American, b. 1953), *Grabbing Snatching Blink and You Be Gone*, 1993. Gelatin silver print and text panel, 3 panels, each 20 × 20 in. Allen Memorial Art Museum, Oberlin College, Ohio. Ruth Roush Fund for Contemporary Art, 1998.12A–C.

center for slaves prior to their being shipped off to the Western hemisphere.[30] In Weems's images, radiating light illuminates what were once completely darkened dungeons designed for holding and torturing slaves, only the beginning of the barbaric journey continued in the shadows of the slave ships. Though in a different medium, Weems's works make for productive comparison with Coleman's insofar as she uses photography and verbal language to carve out a contemplative niche in re-sculpturing one thing into another. Both artists highlight transformation: in Weems's case, the capacity of the horrible to give birth to the beautiful; in Coleman's, memory's delivery of the past for the potential of the future.

The logic of mathematically driven harmonies found in geometry lies at the heart of the work of John Pearson, the senior member of the studio division in the Department of Art at Oberlin. Though trained as a painter, Pearson works across media, combining his skills and interests to forge elegant shapes that straddle abstraction and figuration, inside and outside, painting and sculpture. Though at first glance a survey of his oeuvre suggests a disconnection from the landscape, his recent work, though ever abstract, forcefully echoes rhythms and forms found in nature. It is in fact the natural landscape itself, whether that of northern England, northeast Ohio, or Japan, that has inspired and informed the transcendental experiences that produce Pearson's painted objects, silkscreened prints, and works in between, all of

which remain infused with the influences of Constructivism, Systems art, and Conceptual art in general. Thus, seemingly devoid of a referent, like the work of the artists of the Minimalist generation to which he belongs, his works call attention to their own materiality and conception. Pearson's current work has grown more organic in its own nature, departing from his earlier focus on the infinite possibilities of combinations of patterns inspired by Piet Mondrian and Sol LeWitt. Inspired by a book of botanical engravings that he once stumbled upon, Pearson generates shapes that distill the graceful curves and sharp angles inherent in nature's creations.[31]

In his latest work, *Yorkshire Series: Regeneration-Continuum: Fall, AMAM; Genesis, AMAM; Spring: AMAM* (2005; fig. 21), Pearson presents a fanciful triptych, whose three parts stand parallel in installation. Though void of figuration, their six-foot size imbues them with an anthropomorphic stance as they both cling to and spring from the walls on which they are installed. Reductions of classical architectural columns also inspired by the figure of man, these elegant objects flatten the surface of the body into a streamlined plane. Further underscoring the artificiality of these objects are the crisp, bright colors applied to their wooden bodies. And though the three pieces are nearly uniform in shape, the tensions created by and between the colors applied to them tease the eye, causing the spectator to question whether the objects are more similar or more different. While the deep red center overtakes the six orange slivers that decorate its body in

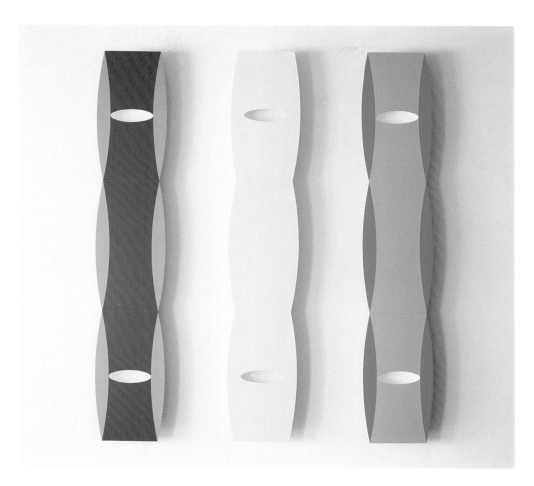

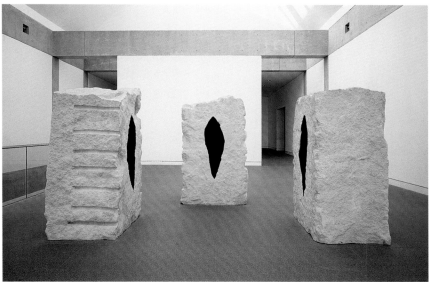

Fig. 21 (Cat. No. 21) [top]. JOHN PEARSON,
Yorkshire Series: Regeneration-Continuum: Fall: AMAM; Genesis:
AMAM; Spring: AMAM, 2005. Acrylic and pencil on wood,
3 panels, each 96 × 16³/₄ × 1¹/₈ in. Courtesy of the artist.

Fig. 22 [bottom]. ANISH KAPOOR (Indian, b. 1954),
Three Witches, 1990. Limestone with pigment, 3 tablets,
80³/₄ × 43 × 53¹/₂ in., 79¹/₈ × 46 × 33 in., 76³/₄ × 45¹/₂ ×
35 in. National Gallery of Canada, Ottawa, no. 35990.1–3.

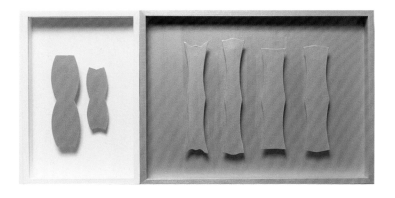

Fig. 23 [top]. **JOHN PEARSON**, *Yorkshire Series: Regeneration-Continuum: #128 & #70*, 2001. Acrylic, basswood frames, archival cotton matt board, and glass, 13^1/$_2$ × 26^1/$_2$ × 1^3/$_4$ in. Courtesy of the artist.

Fig. 24 (Cat. No. 22) [bottom]. **JOHN PEARSON**, *Yorkshire Series: Regeneration-Continuum: AMAM Series: 150, Panels A–K* (detail), 2005. Silkscreen inks and pencil on paper, each 7^3/$_4$ × 5^1/$_4$ in. Courtesy of the artist.

Yorkshire Series: Regeneration-Continuum: Fall: AMAM, the muted blue center of *Spring: AMAM* is held captive by the sharp bright green slivers that rivet it. Pearson plays with chromatic temperature as well, as he heats up one object with red and orange and cools down the other with blue and green.

Between the two, the viewer finds repose on a pristine, white surface in a seemingly less-touched work. But upon reaching what seems to be the completion of these graceful, three-dimensional files, Pearson inscribes fine lines in graphite pencil across their surface, for, though they are sculptures, like any plane they invite the indexical markings of writing, here expressed in a nonverbal form, a purely spiritual distillation of the artist's meditative language. Puncturing all three objects are delicate, elliptical openings that impart further dynamism to these pieces.

Pearson's intractable objects remain in dialogue with works by other contemporary sculptors, such as Anish Kapoor, who similarly unlocks infinite spaces within finite objects. Kapoor's *Three Witches* (1990; fig. 22) are three cumbersome limestone blocks whose rough, ugly surfaces open up in order to reveal the witches' entrails: suspended configurations of mystical shapes traced in electric cobalt blue pigment that delimits space without enclosing it. In describing his sculptures, Kapoor has said that "there can't be an exterior without an interior. My work, if it is about anything, is about the skin—the skin in between exterior and interior, the skin in between object and picture."[32] Pearson, like Kapoor, creates metaphysical spaces in the dramatic interplay between surface and depth, skin and the body beneath it. Both create apertures that *seem* to recede infinitely into space, though they remain circumscribed by the dimensions of the objects themselves.

Of great concern in Pearson's work is modularity, a concept that has figured centrally in his work since the 1990s. The small, framed objects, such as *Yorkshire Series: Regeneration-Continuum: #128 & #70* (2001; fig. 23) stand side by side in harmony, as their delicate, cut-out (un)natural shapes float together, forever trapped in antiseptic containers reminiscent of framed insect-filled terrariums. This series memorializes Pearson's fixation with the endless configurations of shapes and combinations thereof that he, as artist, can choose to create. Again calling attention to their artificial nature, Pearson's poignant choices of colors for these objects, ranging from purity of

white and muted iridescent metallics to the sharpness of primary colors, create unsolvable puzzles as the viewer realizes that the shapes inside vary infinitely in their form and their potential combinations with one another. Still further eluding the discovery of a finite logic, Pearson creates self-contained units that can stand as single objects or as parts of wholes in any infinite number of combinations, whose perpetuity is accelerated by the broad range of horizontal, vertical, or random installation in the gallery space.

Though a self-proclaimed Modernist, Pearson in his recent work expresses traces of the Postmodern aesthetic culture that has grown up around him. And yet the visible craftsmanship invested in each detail of his works undercuts uniformity's threat to not only art, but culture as well. Fascinated by the regularities and surprises encountered by exploring infinite mathematical possibilities, Pearson presents a feast for the eye in *Yorkshire Series: Regeneration-Continuum: AMAM Series: 150, Panels A–K* (2005; fig. 24), a series of 150 prints created for *Trace Elements*. With six variations on a columnar shape, whose variation in background color ranges from warm oranges and pinks to more somber burgundies and blacks, the prints evoke energies associated with youth, adulthood, old age, and eventual death (see figs. 50 and 55). The concave and convex columns that pervade the prints created for *Trace Elements* echo the shapes found not only in nature but also in the mechanical world as they stand like military figurines saluting the public. But Pearson is not content with his miniature army of dancing columns pinned to the gallery wall. In an effort to reinscribe the individuality of his artistic hand, he once again traces pencil lines onto the columns (fig. 24). His drawings not only index his absent presence but also assault the viewer with yet another layer of infinite possibilities, controllable only by his artistic judgment. Pearson stands as a modern humanist insofar as his works insist on and indeed depend on his vision to make choices and set limits.

But the wonderful rhythms and tensions embodied in these prints resonate with diverse contemporary sculptural meditations on the relationship between the real and the synthetic, the natural and the cultural. Of interest here is Damien Hirst's 1992 installation entitled *Pharmacy* (fig. 25), a room-sized work now housed in the Tate Modern in London. Glass apothecary jars filled with brightly colored liquids in green, yellow, red, and blue, representing earth, air,

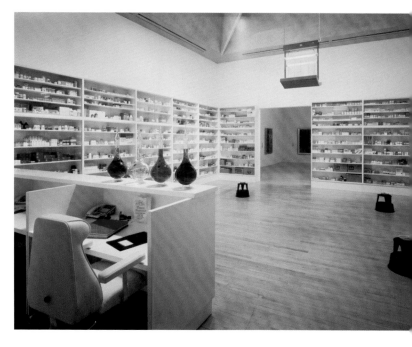

Fig. 25. DAMIEN HIRST (British, b. 1965), *Pharmacy*, 1992. Mixed media installation. Tate Modern, London, England. © Tate Gallery/Art Resource, New York.

fire, and water, respectively, greet the viewer who enters into a world of pharmaceutical revelation. In enshrining the viewer with walls of regulated, antiseptic shelves filled with carefully arranged boxes and bottles of drugs and other medical supplies, Hirst makes plain the prevalence and power of the materials housed inside of mass-produced packages designed to cure and heal. Like Pearson's prints, their appearances are infinite, circumscribed only by how we decide to stock our shelves of available victuals.

Trace Elements articulates how six artists negotiate intimate visions with universal concerns, and the art in this exhibition stands as testimony to their creative lives as both artists and professors. Indeed, these works evidence powerful connections between landscape(s) and the complex experiences informing their individual perspectives. Though they share the common ground of Oberlin, these artists in their work confirm the singularity of their circumstances, exposing their distinctive means of discovering, preserving, and recombining trace elements into objects that at once bind person to community, nature to artifice, past to present.

NOTES

Several individuals contributed advice, support, and criticism as I wrote this essay. I thank first of all Stephen Borys for giving me the opportunity to contribute to this exhibition. His curatorial vision, insightful comments, encouragement, and patience certainly enriched my own analysis of the works included in this discussion. Thanks are due as well to my friend and colleague Isabelle Wallace of the University of Georgia, whose incisive vision of contemporary art improved this essay. My former student Susanna Newbury has also assisted me tirelessly; her keen observations have taught me much about art, here and elsewhere. Thanks also to Elias Markolefas for his careful reading of this essay in its final stage. I thank Rian Brown, Johnny Coleman, Pipo Nguyen-duy, John Pearson, Sarah Schuster, and Nanette Yannuzzi-Macias; during my time at Oberlin, these six individuals shared not only their artistic visions but also their support and friendship, gifts that I will take with me to landscapes beyond. Lastly, I thank my parents, David and Laura Hirsh; I cannot imagine two more supportive and encouraging individuals.

1. Ovid, *Metamorphoses*, trans. Rolfe Humphries (Bloomington: Indiana University Press, 1983), 67–73.

2. Michael Fried, *Courbet's Realism* (Chicago: University of Chicago Press, 1990). The notion of the spectator's absorption by the image is central to Fried's writing here and elsewhere.

3. Although I read this image as a take on the Orpheus/Eurydice myth, equally compelling would be a reading of the female figure as Ophelia from Shakespeare's *Hamlet*. For Ovid's account of the myth, see Humphries, 259–61.

4. Arielle Pelenc, "Arielle Pelenc in Correspondence with Jeff Wall," interview in *Jeff Wall*, Thierry de Duve et al. (London: Phaidon, 2002), 6–22, esp. 16–22.

5. See, for example, Stephen D. Borys, *The Splendor of Ruins in French Landscape Painting, 1630–1800* (Oberlin: Allen Memorial Art Museum, 2005).

6. Isabelle Wallace, "From the Garden of Eden and Back Again: Pictures, People and the Problem of the Perfect Copy," *Angelaki* 9:3 (December 2004): 139–40; see also E. H. Gombrich, *Art and Illusion: A Study in the Psychology of Pictorial Representation* (Princeton: Princeton University Press, 1960); Hubert Damisch, *The Origin of Perspective* (Cambridge, MA: MIT Press, 1995).

7. Rosalind Krauss, "The Originality of the Avant-Garde: A Postmodern Repetition," in *Art After Modernism: Rethinking Representation*, ed. Brian Wallis (New York: New Museum of Contemporary Art, 1984), 13–30.

8. Ibid.

9. Gaston Bachelard, *Water and Dreams: An Essay on the Imagination of Matter*, trans. Edith R. Farrell (Dallas: Pegasus Foundation, 1999), 50.

10. Lisa Szczerba, "Rian Brown's *Presence of Water*," in *The Aesthetics of Self-Representations: Portrayals of Pregnancy and Childbirth in Autobiographical Film, Self-Portraiture, and Literary Autobiography* (Ph.D. diss., New York University, 2005), 112–43.

11. It should be noted that the "presence of water" refers as well to the ocean separating the film's protagonist living in Italy from her familiar home of the United States.

12. *Death of the Moth* (2003) engages directly with Virginia Woolf's story of the same name in a poetic vision that recalls as well the canonical beauty of a trapped moth shot by Stan Brakhage in his 1963 short film *Mothlight*. Virginia Woolf, "The Death of the Moth," in *The Death of the Moth and Other Essays* (London: Hogarth Press, 1981), 9–11. For its premiere, Brown's film was dramatically projected at 20 × 30 feet and accompanied by a live, sixteen-piece orchestral performance of acoustic and electronic music in Finney Chapel at Oberlin College on March 19, 2003, thus marking the night that the United States began its "shock and awe" campaign by bombing Baghdad, Iraq.

13. Jacob and William Grimm, "Hänsel and Gretel," in *Grimm's Fairy Tales*, trans. Margaret Hunt (New York: Pantheon Books, 1944), 86–94.

14. See, for example, *Maya Deren and the American Avant-garde*, ed. Bill Nichols (Berkeley: University of California Press, 2001).

15. The winding and unwinding of balls of yarn is yet another allusion to the work of Maya Deren, whose *At Land* (1944) famously memorializes a shot of two women linked by a thread that allows for symbolic transference.

16. Whitney Chadwick, *Women, Art, and Society* (New York: Thames and Hudson, 1990), 334–35; Ellen H. Johnson, "Introduction," in *Jackie Winsor*, ed. Hilton Kramer (New York: Museum of Modern Art, 1979), 11–13.

17. Anna Chave, "Minimalism and the Rhetoric of Power," *Arts Magazine* 64 (January 1990): 44–63; Hilton Kramer, "The Second Generation of Minimalists," *New York Times*, February 4, 1979.

18. Plato, *Symposium*, trans. Alexander Nehamas and Paul Woodruff (Indianapolis: Hackett, 1989).

19. Richard Ellis, *Deep Atlantic: Life, Death, and Exploration in the Abyss* (New York: Alfred A. Knopf, 1996).

20. Julia Kristeva, *Powers of Horror: An Essay on Abjection*, trans. Leon S. Roudiez (New York: Columbia University Press, 1982): 1–31. Schuster's *Replicants* are visually analogous to Kristeva's musings on the abject as defined in *Powers of Horror*. For Kristeva, abjection refers to that which threatens the coherence of the ego; in physical terms, bodies for whom the distinction between inside and outside is upset can be considered abject.

21. David Joselit et al., *Jenny Holzer* (London: Phaidon Press, 1998).

22. Norma Broude, "Miriam Schapiro and Femmage: Reflections on the Conflict Between Decoration and Abstraction in Twentieth-Century Art," in *Feminism and Art History: Questioning the Litany*, ed. Norma Broude and Mary D. Garrard (New York: Harper and Row, 1983), 315–31.

23. See Helen Molesworth, "House Work and Art Work," *October* 92 (Spring 2000): 70–97, for a discussion of artists at work in the 1990s who are indebted to the feminist vanguard of the 1970s.

24. Libby Otto, "RE: Production—Art and Medical Images of the Pregnant Body," *Queen's Feminist Review* 4 (1996): 79–86.

25. Julie Nicoletta, "Louise Bourgeois's *Femmes-Maisons*: Confronting Lacan" *Women's Art Journal* (Fall 1992/Winter 1993): 21–26. Specifically, this essay considers how Bourgeois's *Femmes-Maisons* explore sexual difference and problems of communication, two central preoccupations of Lacan's psychoanalytic work. Figure 71, a shot of Yannuzzi-Macias's studio, includes reproductions of some of Bourgeois's *Femmes-Maisons*.

26. Yannuzzi-Macias has been creating a series of "collections" for the past several years. The artist began with lint from clothes dryers and then continued to preserve her children's cut hair, lost teeth, and clipped fingernails, relics that allude not only to the 1970s postpartum projects of Mary Kelly but also to Yannuzzi-Macias's desire to articulate the sacred nature of maternal bonds. Her collection of her own and her son Ayo's shoes that she then spray-painted red is an ongoing piece to which she has added her daughter's worn-out shoes as well. This "collection" is distinct, however, in its link to the poem "Red," written by the late Calvin Hernton, a former Oberlin College professor, who performed the piece live in 2001 at the artist's installation.

27. In 1995, Janine Antoni created a performance piece to monitor her sleep and dreams *in the gallery space* at the Institute for Contemporary Art at the University of Pennsylvania in Philadelphia. For this piece, Antoni would sleep hooked up to monitors each night in order to record her brainwaves, an articulation of her dream state. During the day, she would then weave the patterns of her dreams using the threads of her nightgown on the gigantic, two-story loom installed in the gallery. See Judith Tannenbaum, *PerForms: Janine Antoni, Charles Ray, Jana Sterbek* (Philadelphia: Institute of Contemporary Art, 1995).

28. Kimberly Pinder, "Marked by the Body You Are In: An Interview with Johnny Coleman," *P-Form* 44 (Fall 1997/Winter 1998): 24–27. David Hammons's *Jesus Is the Light* (1991) has been noted by Coleman as a great influence, and it has inflected both his own animation of space as well as his teaching. Upon entering this darkened space, the viewer is confronted with one hundred illuminated icons of Jesus as Aretha Franklin's commanding voice announces that "Jesus Is the Light." But when the song has finished, the lights come on and the spectator is shocked to see that the 15-by-15-foot space is in a plywood box lined with pressed tin taken from a poor storefront in Harlem, one hundred cheaply manufactured plastic Jesus figurines, a dilapidated electric fan, and a boombox. The richness of the experience is not the visual at all; rather, it is the guidance delivered by the music and celestial lights that transports the visitor to a higher spiritual plane. Despite the fact that this piece has never been published, Coleman regularly incorporates a narrative description of this piece as a visualization exercise in his teaching of a course on the "Blues Aesthetic" at Oberlin College. Interview with the artist, May 27, 2005. The piece was shown in 1990–91, both at P.S. 1 in Queens, New York, and at the Institute of Contemporary Art at the University of Pennsylvania in Philadelphia, in the *Rousing the Rubble* exhibition of David Hammons's work: *Rousing the Rubble*, exh. cat. (Cambridge, MA: MIT Press, 1991). For a truly poetic description of this work, see also John Coleman, "Landscape(s) of the Mind: Psychic Space and Narrative Specificity (Notes from a Work in Progress)," in *Space Site Intervention: Situating Installation Art*, ed. Erika Suderburg (Minneapolis: University of Minnesota Press, 2000), 158–70, esp. 160–61.

29. Margo Crutchfield, *Material Witness* (Cleveland: Museum of Contemporary Art, 2004): 32–37.

30. Cheryl Finley, "The Mask of Memory: African Diaspora Artists and the Tradition of Remembrance," in *Imaging African Art: Documentation and Transformation*, ed. Daniell Cornell and Cheryl Finley (New Haven: Yale University Art Gallery): 9–12.

31. *Illustrations of British Flora: A Series of Wood Engravings, with Dissections*, drawn by W. H. Fitch with additions by W. G. Smith, 4th rev. ed., 2nd issue (London: L. Reeve & Co., Ltd., 1919).

32. Sherry Gaché, "Interview: Anish Kapoor," *Sculpture* 15, no. 2 (February 1996): 22–23.

RIAN BROWN

(B. 1971, ROANOKE, VIRGINIA)

Rian Brown's films play with the traditional boundaries of experimental, documentary, and narrative films, in their fluid incorporation of multimedia as well as in their debts to older forms of art, namely in the painterly construction of each frame. Her vertical filmmaking invokes the stories of sites, emotions, and experiences without falling victim to linear narration, an achievement that results in films more like poetry than prose. Brown's films cover a range of subjects, from gestation and childbirth to futuristic ruminations on urban sprawl and the depletion of natural resources. She follows close on the heels of Andrei Tarkovsky's pronouncement that true cinema represents the destruction of genre in her continual balancing of fiction and nonfiction, real-time and nostalgia.

Born in Roanoke, Virginia, in 1971, Brown received her B.F.A. from the Massachusetts College of Art and Design and an M.F.A. from the University of California at San Diego. Initially interested in painting, she turned to film as she began to realize the potential for visual and sensory exploration offered by time-based media. Her first works consisted of ethnographic documentaries, critical souvenirs of places she had visited. However, she soon became uncomfortable with such strict documentation and turned instead to a more expressively subjective mode of filmic communication.

While Brown has produced and screened films since 1994, she regards *Presence of Water* (1999; see figs. 5, 30) as her debut work. Edited from a vast archive of documentary film footage and audio feed collected during her first pregnancy, the piece tells the story of the birth of a son as well as the realization of becoming a parent through the interweaving of images and meditations on water. *Presence of Water* holds an interesting place among autobiographical films in its

Fig. 26 [detail, facing]. RIAN BROWN,
Oberlin, Ohio, May 2005. Photograph by John Seyfried.

intimate relation of gestation, birth, and deliverance into postpartum life, again in a lyric storyline that flows easily between personal documentary and fiction.

Brown took on more public themes with *The Settler* (2001; fig. 31), beginning a collaboration with composer Tom Lopez. Again centered on the theme of water, *The Settler* tells the story of the establishment of a colony on Mars and its search for an adequate water supply. With Earth overcrowded and her resources shot, humanity is forced into a new, outer-space landscape, and one remarkably and intentionally similar to that of Southern California where it was filmed. Though the film is cultural commentary, or at the very least fictional, Brown herself emerges in it, playing one of the anonymous travelers exploring ostensibly unfamiliar terrain.

The artist continued both her collaborative work and her cultural commentary in the 2003 digital video, *Death of the Moth* (see figs. 32, 33). The piece's stark allegory and compelling presentation in Oberlin's Finney Chapel, accompanied by sixteen-piece acoustic and electronic music, further underscored the filmmaker's intention of meditating on a historical moment's embodiment of humankind's fall from grace—the film was screened on the same day as the start of the U.S. invasion of Iraq. It was also an interesting point of departure for Brown, who remained absent from this abstract, nonfigurative video,

perhaps the work most closely aligned to the highly formal and visually stunning films of Stan Brakhage.

Presentation and installation have become all the more important to Brown since *Death of the Moth*. Her latest work, *Breadcrumbs* (see figs. 6, 7, 28, 29), featured in *Trace Elements*, is presented with multiple projections against an architectural form, reinforcing the film's various narrative threads. Landscape is a constant in her work, and in *Breadcrumbs* the idea of landscape links negative and positive space within the concept of the film. The artist is shown walking through landscapes, searching for home, and leaving breadcrumbs (alluding to the Brothers Grimm fairytale "Hänsel and Gretel"), which inevitably disappear when she retraces her steps. The negative space is the absence of the home that she searches for; the film recalls the artist's childhood spent moving from place to place, year by year, in a reflection on the emotional repercussions of physical transience. In rethinking the mythology of house and home, Brown addresses issues of rootlessness and restlessness as well as the place of a new pioneer. It is a characteristically genre-bending work incorporating film and video, autobiography and fiction, while it also explicitly introduces themes of place, experience, and memory. *Breadcrumbs* represents an elegant summation of this young filmmaker's work to date. [AG]

Fig. 27. RIAN BROWN,
Oberlin, Ohio, May 2005.
Photograph by John Seyfried.

The origins of how I work come from a tradition of experimental filmmaking, which tends to be linked to the history of poetry and painting as well as photography, and not so much to narrative filmmaking. I started off in art school as a painter, but found very soon that painting as a medium didn't have the component of time that was really essential to me. Film satisfied that need tenfold. It became very obvious that I needed to work with time, and with a medium that unfolds in time. I realize now that film is a magical and primal art form. It consists of light projected into darkness; and because it is intangible, it exists only as a memory or a dream for the viewer. I find it so powerful to work with the principles of montage, the collision of two or more images, to create a third idea. These visual and aural juxtapositions enable me to gradually "seep out" a multitude of ideas that evolve over the course of a piece. In all of my work I strive to create an experience in which there is an unfolding or blossoming which begins in the film and continues offscreen. —Rian Brown

Stephen D. Borys: I'd first like to start with an earlier discussion we had about experimental filmmaking—that's how you got started and that's the tradition from which you are emerging. Are you continuing in an experimental vein or are you moving toward a particular genre?

Rian Brown: Let's say that rather than consciously moving toward or away from narrative filmmaking, and going toward the so-called avant-garde or experimental film form, I really see myself as an artist who doesn't differentiate. Many forms influence me, and that may be viewed by some as indecision. I see it as a way of assimilating things, translating one form into another. As a painter refers to images—some from photographs, some from memory, some from classic paintings, and others from non-Western painting—I see my process as a filmmaker as one that takes from a wide range of historical traditions, skirting along the edges of genre. For that reason, I admire artists like Meredith Monk, who are always working between the cracks.

SDB: With the way film and video are evolving, it seems to be almost expected for new filmmakers, new videographers to do exactly what you're doing.

RB: I actually think that there's a plethora of video art being made today that derives from many origins, but to understand my influences you would have to go back about fifty years and look at the experimental films of Maya Deren, Jonas Mekas, or Stan Brakhage. These pioneers were in their own way responding to the history and language of cinema, by reinventing and developing the new languages within film. So I would say that my work refers more to the ideas of earlier experimentation in cinema history than to some of the new video art today, which comes out of performance. If there is one thing that I feel very, very strongly about, it is that working with time is magical. There's something enchanting, almost mystical about creating an experience that deals with time.

SDB: You've talked about the people you studied and worked with: Saul Levine, Dan Eisenberg, Mark Lapore. Were they coming out of that tradition of Stan Brakhage and his contemporaries from the 1960s and 1970s?

RB: They all come from that generation. Saul Levine and Dan Eisenberg inspired me to experiment with form. They taught me to

disobey the rules. But I also studied with Jean-Pierre Gorin, who is actually featured in *The Settler*. Gorin and Jean-Luc Godard were part of the Dziga Vertov group from the 1960s and 1970s. They were politically active filmmakers who turned filmmaking on its head with regard to the new form which Godard calls the "essay film."

SDB: What happened with your work when you moved across the country from Boston to California?

RB: I actually met Jean-Pierre Gorin in California. In terms of my work, that's when I started to dig deeper. I like to quote from Robert Bresson: "dig deeper . . . double triple bottom to things." So that's where I started to build new work with the vocabulary that I had acquired, and things started to take flight. I think it's when you're in exile, when you leave familiar terrain that things emerge artistically, maybe because you are out of your element. I went to California to find something that I hadn't yet discovered, as I did when I went to Italy to have my first son, Paolo.

SDB: You also quote Andrei Tarkovsky: "True cinema is built on the destruction of genre." Can you comment on how this idea applies to your filmmaking?

RB: A genre presents a set of boundaries, or rules, which are never set in stone. Let's go back even to science, like splitting cells or something as horrific and beautiful as splitting an atom. It's like crossing a boundary or breaking a rule, and when you're cutting across boundaries really unbelievable and interesting things happen. Cutting diagonally across symmetrical lines, cutting through established barriers and borders, it's like a fault line that slices through space, regardless of county or state line. And it creates this sort of turmoil, as well as new markers for the boundaries. When you understand genre, and understand it deeply, like the genre of the Western with all of its complex implications of gender and race, it's really interesting to cut at it so that something else opens up. If I'm interested in something, I'm interested in the opening up of spaces. It's like a rupture, which is a new opening. There's an essay in a book by Manny Farber, one of my favorite film critics from the 1960s and 1970s, who taught at UCSD where I went to graduate school. He's a painter, and he wrote this book entitled *Negative Space*, which includes an essay called "White Elephant vs. Termite Art," where he discusses these two forms of art-making processes. The "White Elephant" is the kind of art that is in fact what it set out to be when it began and follows its own system

until the end. Then there's "Termite Art," which refers to an artist who sets up a system and also eats away at it at the same time. Painters have done this forever with exploring, revealing the brushstrokes, revealing the underpainting, this kind of thing.

SDB: You've talked about cutting across barriers and boundaries, and you also refer to your work as "vertical filmmaking," perhaps best understood in *Presence of Water*. You start with a terrain and then you dig, often going back to the epicenter, exposing fault lines. And rather than unfolding a linear plot, you reveal layers so there is a vertical and a horizontal thrust to your process. Does this apply in terms of historicism and chronology?

RB: I think physically these two forces are happening concurrently. There is depth, but there also are new edges breaking apart from old boundaries, like plate tectonics. *Breadcrumbs* represents a fault line, where I have come to an edge and the terrain is changing. Making it into a film shown on three separate screens, it has spatially expanded, and the edit becomes a relationship between multiples, not just one cut juxtaposed to the next. The space becomes the zone within the matrix of the film and without. It becomes a very different form in a gallery space versus a screening room. In some ways I'm abandoning the purity of cinema as cinema, as a space unto itself. I'm blurring the edges between architecture in space and the architecture in the filmic plane, and it's both very exciting and a little risky.

SDB: When we first talked about *Breadcrumbs* for the *Trace Elements* exhibition, you proposed using a physical space—a four-sided construction—rather than a wall or screening room. You moved away from that idea, and began thinking about a façade with openings, thresholds.

RB: I'm really glad we had a dialogue about the evolution of the piece because in some ways our discussions have helped the piece to evolve. Our conversation about the four walls versus a flat façade was very helpful to me. Having walls embodies the concept of "house," and I imagined it being this floating house without any connection to the ground, a house that doesn't really exist—a figment. However, that is in fact what the film is doing already. The film is about rootlessness and transience, and searching for a home that is never found. If it were to be screened on four separate walls, cinematically it would disrupt our ability to see all planes simultaneously, because you would have to walk around the structure. Therefore it became very

obvious that that plan would in fact diminish the impact of what the film is doing. Instead, the structure as a single façade with three openings allows me to control the way the viewer experiences the piece—you don't have to choose what to see, which for me is too much of an abandonment of filmmaking. It's not like a website where you can go click here or click there, and the order doesn't have any meaning anymore.

SDB: The landscape is always emerging from your work, but in this particular film, it is front and center. In fact you've said that the figures are inserted more for scale. So why do you want to link it to something architectural, beyond the idea of a threshold?

RB: I see it as the connection between negative and positive space within the concept of the film. The positive space is what you see, the depiction of this figure who is not really a character, walking through landscapes, endlessly searching for home, leaving bread-crumbs, which inevitably will disappear when she retraces her steps. The negative space is the absence of the home that she is searching for. There isn't really a place, there isn't really a house, so the actual façade becomes a reference to the structure that is absent in the film. It becomes the frame of a landscape painting. The frame is an arbi-trary marker, and a frame on a landscape painting is, in fact, very odd. Why does it cut off right here, when it's a meadow that goes on in-definitely? These are artificial edges. So in some sense the house in the piece is a façade of thresholds—that refers to the negative space, or absence of the house.

SDB: Thresholds and vistas—is there a link in this instance?

RB: Certainly—I think "vista" implies nostalgia and the sublime; a vista is something you want to look at. In the film these are the land-scapes that I want to capture because they have emotional relevance to me. In some ways they become my own personal "vistas." For me, vista is linked to the sublime. I chose not to include any urban land-scapes—landscapes filled with debris and trucks and Vespas going by—because I wanted to dwell in this imagined landscape free of those things that determine time and location. So yes, they could be vistas, and that goes along with the idea of nostalgia, which runs through the film.

SDB: You mentioned that in this work the figure is just a line in the landscape, marking the space between point A and point B. Vista also involves looking for something that exists in your mind rather

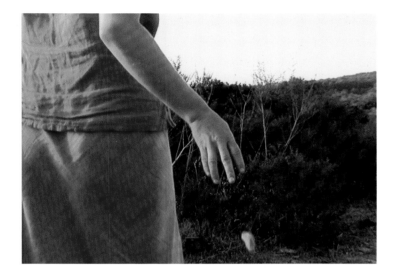

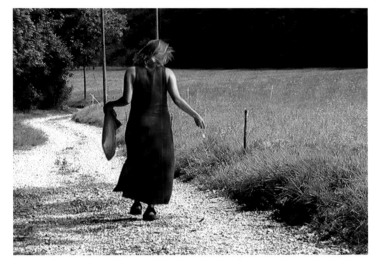

Fig. 28 (Cat. No. 1). RIAN BROWN, *Breadcrumbs*, 2005. Three stills. Triple video projection with sound, 16 min. Courtesy of the artist.

than as a place, but not a dreamscape because the physical landscape is present. It refers to ways of seeing.

RB: I think the way I address landscape is ritualistic to some degree. These are all landscapes that mark places that I've lived in or passed through. For me to retrace the steps in front of the camera is not only to provide a figure to mark or give scale to the landscape, but to capture a figure who is "remembering" that landscape. The figure functions both as a device, for the sake of the film, which is about rootlessness, searching and unraveling nostalgia, and as a document of ritual, as you've said. They're not movie sets—they are spaces that contain memory for me personally. This goes back to why I use my own figure, and not another actor's: it's like a pilgrimage—I am retracing the steps of the things and places that I want to understand.

SDB: In *Breadcrumbs* you film yourself as the young woman, but not the child or the elderly woman. Do you identify with all three ages in this particular work?

RB: I see them as one woman—they are one character at three stages of her existence. The woman that I portray is the woman who is searching, but doesn't find any answers. The older woman doesn't have to search in the landscape to find home, because it exists somewhere in her mind. The young girl is being fed—there is this house of gingerbread. You can't embody the idea of nostalgia more effectively than with a gingerbread house. It's a fantasy—a totally imaginary house, something that will never, ever be "real." And the child eats it; the old woman perpetuates it. In some ways it's a sappy image, but it gets at the heart of something for me: the impermanence of things.

SDB: In describing *Breadcrumbs*, you state: "It's not about homelessness, it's not about being kicked out. . . . It's about rootlessness and restlessness, which is really an American phenomenon."

RB: Yes, I think restlessness and rootlessness are inherently American traits. And through making this piece I am trying to understand them in relation to my own personal experience growing up in this country. Both my parents are sculptors, and when I was growing up, their mythology, which I understood as being the truth, was that they were modern pioneers and they didn't need a house. We moved every year and were never attached to the idea of home. I have come to understand that possessing a home is a very American thing. When I was growing up in the early 1970s my parents believed that anything was possible and that all traditions should be questioned—even the

idea of having a home. This film isn't so much a reaction to those ideas, but it is a contemplation of what they mean. But in terms of "restlessness" in America, we have this idea ingrained within us that there is always something better on the other side of the mountain.

SDB: You are a master of cuts and fades, and of utilizing tracks and layers in your work. *Breadcrumbs* seems like the ideal work, not so much to dissect, but to allow the viewer to see all of its layers.

RB: I would be lying if I said I knew what I was going to make before I started—I really didn't know where some of these images were taking me. What I do know is that in the editing process I begin to sculpt, to eliminate, and then the form begins to emerge. This is where my films evolve. It is a process of negotiating cuts, shots, and layering sound. The shooting process is very intuitive, and there's a lot of faith that I put into it. It's very interesting that you bring up the layers and the cuts, because that is where I feel my artfulness comes into play. Like the sound of late-night crickets in my backyard in Ohio overlapping an image of Corsica, with a voice-over about butterflies. Those strata evolve literally in the editing process. The way things bump up and rub against each other is beautiful to me. Filmmaking is about triggers and switches—you switch something on and something else off. If filmmaking is about thresholds, then the cut, which is an intersection, represents two ideas butting up against each other to create a third feeling. If you're interested in layering, film is the art form for you. With *Breadcrumbs*, at a certain point it became apparent to me that the work was very cyclical and should not be screened in a theater. When I had this realization and you and I discussed it, I began to imagine *Breadcrumbs* as an installation because it could be ongoing, never-ending.

SDB: In the course of a year, *Presence of Water* was screened and featured in over a dozen festivals and arts venues across the United States. What was it about this early work that led to such critical success?

RB: I think, looking back—and I couldn't have articulated this when I made it—that its success derived from its being so raw with emotion. It really opened up a bird's-eye view about becoming a mother. I think I somehow captured—and it's hard to repeat this—I captured a really palpable sense of uncertainty. And the film emotes this uncertainty. In order to do that, you have to take great risks as a filmmaker because you can reveal too much, or it can be very painful,

Fig. 29 (Cat. No. 1) [detail, facing]. RIAN BROWN, *Breadcrumbs*, 2005. Still. Triple video projection with sound, 16 min. Courtesy of the artist.

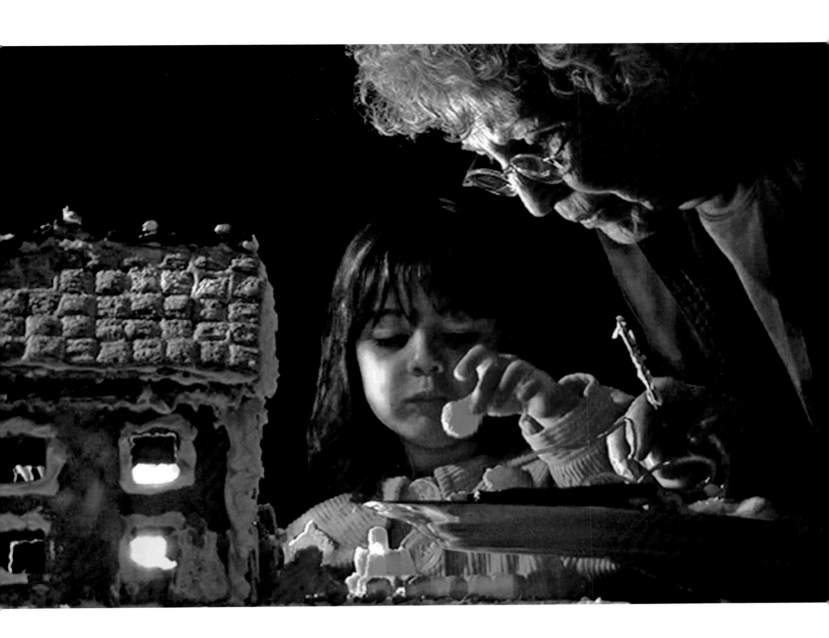

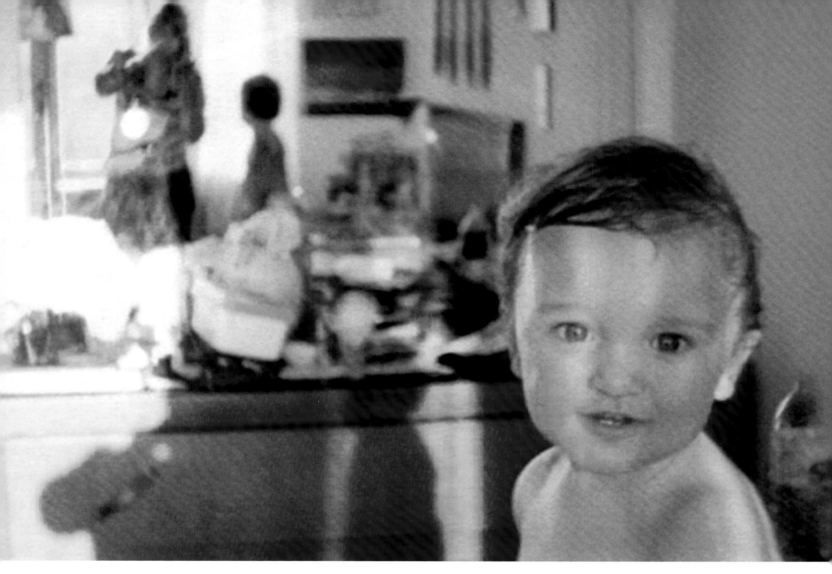

Fig. 30. **RIAN BROWN**, *Presence of Water*, 1999. Still. 16mm film, 27 min. Courtesy of the artist.

or it can appear as narcissistic, or confessional. I hate confessional filmmaking, I can't stand it, and it's what I would like to avoid at all costs. So I think the film was made on a razor's edge, because how can a mother make a film about her child without being sappy? It's impossible. It's an impossible proposition. A mother has no perspective, no distance from this issue. There's no way you can remove yourself emotionally from your children, so in that sense I went right into the lion's den, and made it about the pure uncertainty of emotion, and I think that's where the energy comes from in that film. That's really hard to repeat.

SDB: It was either you or your husband who said that you could never make another film like that.

RB: My husband said "I bet you'll never make another film, *after* that." And in some ways, I'll never give birth to another film that was made purely in the subconscious like that. If that makes sense. So maybe he's right, unless I have another revelation. I've become more aware of my voice, and how to articulate it, than I was then, which came from this wonderfully amorphous, dark, sort of cave space that is purely intuitive. How do you put that in a bottle? I don't know.

SDB: This is an autobiographical diary film; it's also an essay film, a documentary, and a fiction. In a way that may be its primary appeal. But you also back into the film: it doesn't evolve out of a script, and this seems to be one of the ways it draws in the viewer.

RB: I think that to be an artist, which is a big title, you have to be both completely in tune with your subconscious, and at the same time completely aware of how to *capture* your subconscious through a process, which, in the case of film, requires the conscious mind. I can see compositions and images. But how to stay tapped into the

subconscious simultaneously—that is the great challenge. And if you're too cerebral, you'll lose that. Filmmaking is very technical, and you have to be very aware of the lens, and the mechanics of the camera, the exposure, the film stock, the tape stock, and the sound levels, and that's all very cerebral. At the same time you have to be very unconscious. That's why I talk about the lens as a very metaphorical thing. It's both a tool and a threshold. Because the lens is the frame, the lens is the thing through which you can capture this kind of emotional, delicate, connected, magical stuff, through something incredibly material and technical. The camera is a very peculiar threshold, different from the pen and the paper, which are more physical markers and therefore more connected to the body.

SDB: In *Presence of Water* you also equate water with the lens: the film is suspended in this medium. You have talked about the water shifting, representing the bodies of water between two countries, and water as the amniotic fluid. Is there more to this iconography—a sense of cleansing, renewal, submergence?

RB: All of my films deal somehow with water. And with *Presence of Water*, it became something that I could articulate both intellectually and emotionally. From that point it seemed very clear that all my work had some component of water. Every film or work that evolves in time has some component that it is suspended in, whether it is air or water or rhythm. So when I imagine a film, I imagine what is its, let's say, its spine? I ask, what is its skeletal structure? But then, what is that skeletal structure suspended in? *Presence of Water* is suspended in water. It's a formal component. Why water? It is both: the lens of a camera has a surface that you can see through, and which can reflect things, like water—a lens allows you to see multiple planes. When you look in a pond, for example, you can choose what you wish to see. You can see the surface of the pond, which reflects the sky, as a lens, or a refraction. You can see the pond and what is suspended in its water; you can see the bottom. This concept is drawn from Gaston Bachelard's *Water and Dreams*. The lens is an extension of that concept, because you can choose what to see and what not to see. You frame out and you frame in things. Your eye is a lens looking through this other eye. Water is also a very scary thing: you can drown in water. When I swim in the ocean at night I think it's one of the most scary, exciting, and exhilarating experiences. You're surrounded by this substance but you can't navigate in any direction, you're weightless,

you're kind of consumed by dark water. And then water can also be a sound, soothing, like a creek, or a trickle of water, kind of nostalgic water. It can be amniotic fluid, which is in fact where life begins. And with the absence of water, there is no life. *The Settler* is about searching for water on Mars, because of the absence of water in California. It has to do with life and death, seeing, not seeing, fear, primordial fear, primordial origins of our love and where we come from. The mother is water; it's a feminine substance in that sense. I'm very attached to it as the thing that life springs from, and in *Presence of Water*, I am the thing that life springs from; and as the filmmaker, it's a double fertility act.

SDB: There is an image of your husband jumping into the water—the scene takes place right before the baby is born—and it is profoundly moving.

RB: He is jumping, and if there's any scene that is worthwhile in that whole film, it's that scene, which contains parallel editing back and forth between an image of my pregnant belly, writing a letter to the child that will be born, and speaking about my husband, who is, in fact, also jumping into unknown waters. It's almost like a birth. It's a transformation for him as well. I say in the voice-over, "It must be lonely being a man, because you'll never share oxygen, water, blood, with our son." I make this differentiation between the male and female body and water. They're simultaneously jumping into the water, so in that sense it's very metaphorical. He never comes out—you see him jump in the water, but you don't see him come out, because he's immersed. The river has taken him away. And there is a thunderstorm at the same time the child is born. The sky is opening up and there's water.

SDB: You compare the camera to a paintbrush, and I wonder how this applies to your teaching. Your students get into filmmaking very quickly with only rudimentary preparation. Keeping the analogy of the paintbrush, before you paint, do you ever sketch—make film sketches? You have said that your goal as a teacher is to try to help people become enamored of the process, and to find a voice through making rather than spending lots of time intellectualizing. How do you get across this process and your technique to your students?

RB: I'm very glad you're asking these questions. I think that in order to learn how to see, you have to look. And you have to vigorously observe everything. And you can't look by thinking about looking. You

have to look by looking. You look through a camera, and by the act of looking through a camera you are selecting, and framing out. Filmmaking is about what you frame in and how you move with it. To be a filmmaker you have to be a dancer, because you have to learn how to move, and see while moving. And that can only be learned by doing. So the camera becomes an extension of the body. Not just the eye, but also the body, and the heart. My feeling is that unless you learn how to see and move, you cannot bog yourself down with the text and the characters, because it's top-heavy. Let's be realistic: if you want to be a screenwriter, then be a screenwriter. But screenwriters don't shoot the films. If you're interested in visual language then you have to learn by actually engaging with the process. So my students, who are all incredibly intellectual, literary, and text-based, sometimes find it offensive when I say, "Don't think, shoot." But by the time they've made their third film in their introduction to filmmaking class, they understand that the language of cinema is different from that of the written word. And unless you learn to feel it, see it, and know it, through doing, you will never achieve it through the writing. And so I believe that you have to break students down, and have them unlearn their preconceived ideas about filmmaking. We have to shoot a lot, and edit a lot, in order to understand. Then, I tell them to go back to writing.

SDB: Aside from teaching, what is it like working as a filmmaker in Oberlin?

RB: The primary benefit is working across disciplines more flu-idly by engaging composers, and dancers, and other filmmakers. There are so many opportunities for cross-pollination and interesting interactions at Oberlin. I've co-taught with two different dance professors, faculty from the Conservatory of Music, taught classes that dealt with video site-specific installation, sound design for film, movement for the camera, and performance. I just finished teaching a new course in which I invited Meredith Monk to work extensively with students as an artist-in-residence. She came for a week to teach her methodologies of voice, performance, and composition to my students who were writers, filmmakers, composers, sculptors, dancers, and musicians. Meredith is a leader in interdisciplinary art, who sees no boundaries between dance, music, composition, film, and performance—for her they're all one, and so she has this wonderful sense of multidimensionality. That kind of plurality, where there are no discrete, separate worlds, was important for me to show the students, and they were forced to take a lot of risks.

SDB: You refer to yourself as a filmmaker because you identify with that history. However, you now shoot in video, in fact, digital video. And when I mentioned "new media," you called it a faulty term because there's nothing new about it. But it seems like you really fall into this latter category.

RB: "New media" is a discipline that is defining itself in real time as we speak, so I wouldn't want to contain it by giving it a label. But, if you're defining new media as a breaking down of barriers between disciplines, and being able to interact with media and dance, and me-

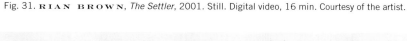

Fig. 31. RIAN BROWN, *The Settler*, 2001. Still. Digital video, 16 min. Courtesy of the artist.

dia and theater, and writing and performance and sound, then that is a definition of new media that I would wholeheartedly embrace.

SDB: It's usually not the definition that is applied, however.

RB: No—I think the term "new media" is a chameleon. I believe that new media isn't new, exploration isn't new, and working across disciplines isn't new. Just because it's digital doesn't mean that it is new. Digital media comes from a history of film, or graphic design, or architecture—it's just another tool that makes it easier to work across those disciplines. New media has the potential to be new, depending on what you do with it.

SDB: In your work, you are a writer, director, editor, choreographer, and narrator. Could you see yourself working with someone else who is providing the narrative or doing the editing? I know you worked with Tom Lopez on *Death of the Moth*.

RB: Absolutely. I love collaborating. It's hard to find someone who also loves to collaborate. I like arguing; I like finding that center; I like negotiating collaboration; and I like mining other people's talents and then being able to also bring to them things that I have. I would love to work with a screenwriter. I have lots of ideas for screenplays. I work and think in images, not in words.

SDB: You have this fascination with California, and I'm thinking in particular of *The Settler*. You've talked about this idea of Southern California as artificially engineered, and of course the film addresses some of those things. Is this a bigger comment on urban sprawl, the film industry, waste, an adjusted humanity?

RB: California is the dragon. It's the dragon that I have to slay. California represents Hollywood. California represents the history of filmmaking. California represents the American dream. Anything is possible. It's also a dystopia. It's also the land of illusions. What you see is not what you get. Los Angeles is a façade: the projection

Fig. 32 [above]. RIAN BROWN, *Death of the Moth*, 2003. Still. Digital video performance with live acoustic and electronic music, 15 min. Music by Tom Lopez. Courtesy of the artists.

Fig. 33. **RIAN BROWN**, *Death of the Moth*, 2003.
Still. Digital video performance with live acoustic and electronic
music, 15 min. Music by Tom Lopez. Courtesy of the artists.

outward of the city is in fact the opposite of what it really is. Its projection is glamorous and beautiful and lush. It's in fact a rambling smoggy mess of endlessly interesting people, sprawled forever; people who are hostile, and people who live separate from one another in their cars. And so, what does that mean? It's a fascinating landscape and a problem. Sociologically, historically, geographically, it's loaded for me. It's the sunshine noir. It's the illusion, and it represents a lot of things for me. And it has been the subject of countless films, painters, and writers because of that dichotomy. It's already post-apocalyptic. It's an acceleration of the way things are going to be. The mini-mall phenomenon is already on its third generation. But it's also the place where there's incredible creativity and fountains, geysers of excitement—real creativity on top of this crazy place. So yes, California is a landscape—it's not a landscape of my personal world. It's foreign. It's exotic. It's the other.

SDB: *Western Avenue* is filmed in Los Angeles, but instead of producing a film you made painted scrolls after the stills, and that's actually what you exhibited rather than the footage.

RB: I'd like to return to it in a new work, after *Breadcrumbs*. There's something very interesting about the aesthetic of film in another medium. What is film? It takes place in time, it unfolds in a linear fashion, and it's a chain of frames that intersect: these formal things are interesting to think about and explore. I've always loved Chinese scroll painting because I think it is a pre-cinematic form. You see this landscape evolving as you unfold it like a film. I've always been interested in proto-cinematic devices like magic lanterns. The will to project an image on a wall is really the essence of why I came to filmmaking. Animation comes from painted images that look like they're moving—zoetropes, kinetoscopes, the early cinematic devices of Lumière and Edison. I think these are all interesting formal structures to explore outside of film itself.

SDB: You have chosen filmmaking as your art. In some ways you're an outsider, and in other ways you are coming out of these old traditions into new media.

RB: I chose to be a filmmaker because of its plurality, because it's never just one thing; it's always a few things and sometimes many things. As an artist, I like to explore dilemmas like "searching for home" or "the implications of terraforming Mars," but not necessarily to provide any answers or solutions. I guess that's what I mean about being a can-opener artist. I like to open up cans of worms.

SDB: Your work is an evolution of sorts, a lineage of events and emotions.

RB: Every piece of every work is hinged onto a whole chapter of my life, and they read like a story, one after the other. As a young woman with children, and as an artist, there will never be a moment where I am doing just one thing. I don't have a single moment in my life where I am not multitasking to a point that it's on the verge of insanity. So yes, my work is embracing that, too. I work in fragments, I work deeply, but in short fragments that evolve over time because I can't go into the studio for two weeks and have a finished body of work. It takes two years of fragmented time. I've finally learned to start to embrace the kind of intersections between life and making art as my lifestyle. I used to think that in order to make art I needed to be like a monk, hermetically sealed off from my hectic life so that I could create work. But if I did that, I wouldn't make a thing, because I wouldn't have the thing that fuels me, which is this constant backpressure. Taking care of my kids, and negotiating my imagination, and my body in relation to all those things—I think there is nothing more fragmented than being a woman filmmaker. Filmmaking is a masochistic, long, and excruciating endeavor that takes lots and lots of time and concentration, and if you don't have lots of time and focus, your films are going to become this kind of kaleidoscope that mimics and responds to life. And rather than fighting it, I've embraced that. That's why I shoot these diaries all the time, because I stay connected to the camera. And that connection is the work. My life is wrapped into my work, and my work is responding to my surroundings. And the film, like *Presence of Water*, I thought would never be a film. I thought I'd never make films again when I had children. But that act reinvigorated and deepened me enough to realize that, in fact, this is the film. Life is the film. And that translation of life is the beauty of the work. I still fight it. I have fantasies of going to the top of a mountain to be alone, but I think I would just jump off, and I don't think I'd make any work. I think I'm bound to things. I'm bound to things around me, and they eat away at me, and they give me something at the same time.

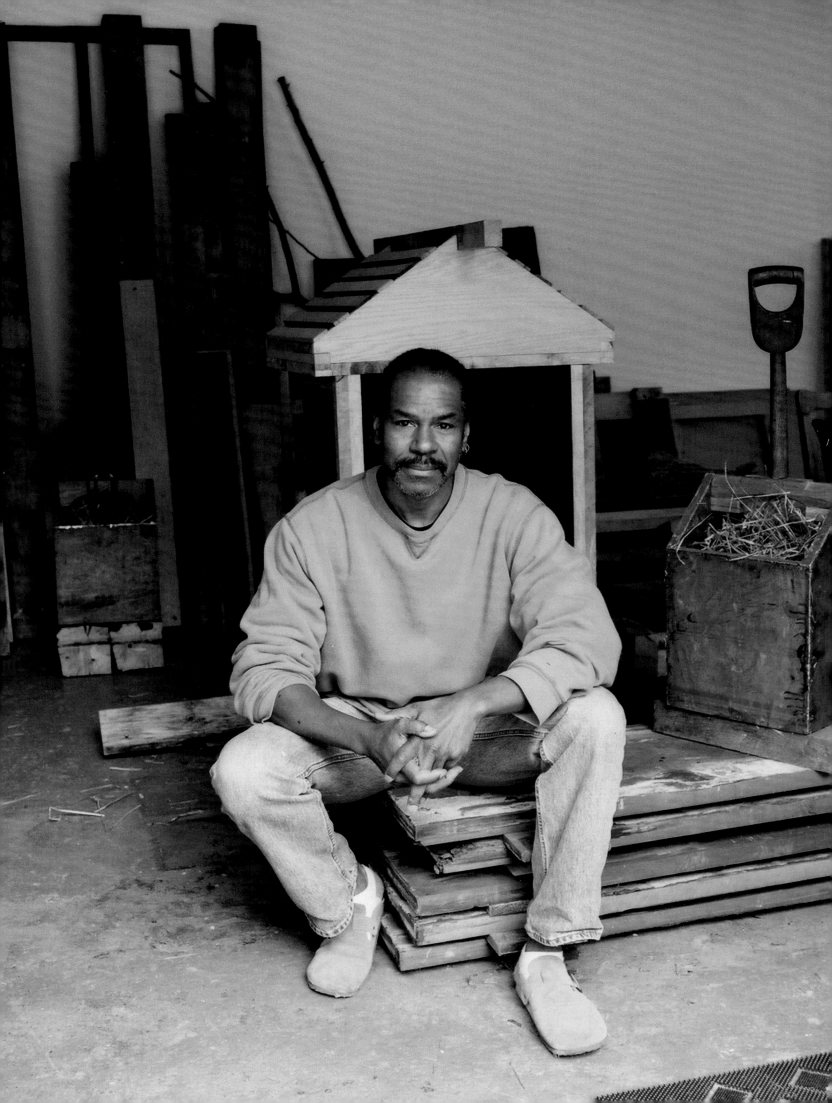

JOHNNY COLEMAN

(B. 1958, SAUGUS, MASSACHUSETTS)

Every component of Johnny Coleman's art tells a story. The barn oak found across Ohio, the corn and the hay, the shovel handles: all of course compose the physical landscape of site and installation, but represent also the interior landscape of the African diaspora. Coleman's work transmits these physical realities and spiritual legacies through the visceral communication of his specific artistic mediation. His active aesthetic process includes the capacity for transformation, be it the decomposition of materials, the passage of voice, or even quieter personal revelation, all the while considering the question: How are you remembering the present for those who will live twenty years from now? Engaging in the call-and-response of geographic location, community, and personal narrative, Coleman's deeply human artwork remembers the present by entering into a dialogue with its ancestral legacy.

Born outside Boston in 1958, Coleman has spent most of his life in and around Los Angeles. Along with the pain and unrest of the Civil Rights era came the flourishing of the Black Arts movement, which penetrated the inner city as an expressive and evocative avenue of empowerment. Coleman cites the murals of Charles White and of the Chicano arts scene as his primary and most influential exposure to art in his childhood, and it was another media and performance artist, Coleman's mentor Ulysses Jenkins, who posed the questions that would direct his art from there on: Whom are you speaking to? What is the nature of the dialogue? What is your intent? For Coleman, these questions helped frame the role of the artist as similar to that of the preacher: to engage a present public in tandem with its past, and to foster the spirituality that connects the two.

Coleman was based in San Diego, and his mother and aunt in Los

Fig. 34 [detail, facing]. JOHNNY COLEMAN,
Oberlin, Ohio, May 2005. Photograph by John Seyfried.

Angeles, when the Rodney King verdict came back and L.A. burned. That April night in 1992, the artist dreamed of a homeless man he knew and watched over holding the egg of a chick as it was born. This tense interior moment between birth and death, whether a moment between hope and despair or between innocence and crushing reality, struck him as an embodiment of his own experience in that historical moment. From it was born *Ruminations* (1992; fig. 36), which told that story through the sensory evocation of deep sadness—the sound of sweeping broken glass, spoken revelation of the dream, conversations with the homeless man, and the smell of fire.

Since 1993, Coleman has been living in the foreign landscape of Ohio, which he was better able to connect with after it had become an inextricable part of his life history. The conception of his children in this place made his telling of the present moment all the more important, and his work shifted in a way, expanding his own stories to reflect those of his children. In *A Prayer for My Son and Myself* (1997; fig. 37) Coleman constructed a piece for his son, Ayo, in which his repeated formal motifs—circles, crossroads, altars—combined with personal artifacts and audio narrative to create a space for dialogue between father and son. It was, as Coleman says, a site-specific interior landscape, a site which was not only about geographic location,

but also about a social, cultural, and political location—about the complex challenge of growing up black, male, and American.

Coleman continues to probe the contemporary landscape to reveal its innate spirituality. For *A Landscape Convinced: For Nyima* (2001; see fig. 39), he constructed an environment of beeswax, hay, flowers, seedpods, and the sounds of his daughter's young life in northeast Ohio, inlaid with a specific narrative from Toni Morrison's *Beloved*. Much in the same vein, with *Station to Station* (2004; see fig. 17) the artist reverently placed his mother within a "legacy of warriors" who, against a backdrop of the unspeakable, imagined the possibility of freedom. The resulting structure, a post-and-beam "safe house," enshrined a monument that traced their histories through physical material and the embodied structural evidence of their journeys as, for example, in the lineage of the shotgun house traceable from Louisiana to the Caribbean and back to West African domestic architecture. His work for *Trace Elements*, *A Promise of Blue in Green: For My Mother* (2005; see fig. 41), continues his familial prayer cycles and accustomed motifs within a built environment, but more generally reaffirms his admiration for the power of the visceral that has been central to his mission to reveal spirituality in even the most commonplace things. [S N]

Fig. 35. JOHNNY COLEMAN, Oberlin, Ohio, May 2005. Photograph by John Seyfried.

I am composing narrative environments that reveal the woven sounds, aromas, textures, and colors of the components of the liminal spaces of memory, dream, and prayer. I think of these spaces as interior landscapes in which architectural interior/ exterior relationships mark thresholds within and between the personal, the cultural, and the political. These "interior landscapes" have occupied my work for the past fifteen years. An example of how I'm using interior landscapes in my work is with one particular piece that I did in 1992 called *Ruminations*. *Ruminations* was a very personal response to a recurring dream that I had following the outcome of the trial resulting from the beating of Rodney King at the hands of the Los Angeles County Sheriff's Department. Los Angeles was and continues to be the space that I consider home. When the city erupted following the verdict, I was in graduate school in San Diego, two hours south of Los Angeles. As the city burned, I was faced with a convergence of conflicted responses: shock, rage, numbing sadness, the desire to be alone, and an overwhelming need to reach my mother and aunt who were living together in the center of the storm. What emerged within the space of the dream was a painful quiet meditation that revealed a fragile, but deeply rooted, sense of hope.

—Johnny Coleman

Stephen D. Borys: I want to start with something you said last time we met: "The way I think about my work, it's all been ritual-based, based in prayer, and it's also always been interior, the inside of my head. I'm not looking to illustrate a historical event, I'm trying to get inside the event, but really personally." Can you talk about how you address, or how you engage, the idea of space in your work?

Johnny Coleman: To answer from one specific piece, in 1997, I did *A Prayer for My Son and Myself*, and the space I was addressing geographically I was also trying to address socially, culturally, politically, and personally. We were in Chicago, it was August 1995. I guess I was around thirty-seven at the time, and I had on my chest a boy who was literally weeks old, and I'm all over the city, literally all over the streets. All kinds of people commented on the image of myself and this young brown-skinned boy, but especially and most expressively, with the most personal engagement, were the black folks who responded to us. The responses resonated with me because of the need I feel within an African American culture for the presence of young men to be actively involved in the guidance and raising of family and the participation within family. The way in which I responded to the way Ayo and I were received was really located culturally as well as geographically.

There were other things going on at the time. Mumia Abu Jamal was scheduled to be executed very shortly after we were there. We were there through August 12th, and I believe that the date of execution was sometime in the middle of that month. And so across the country, communities of activists were in the streets, including Chicago. Right after we were in Chicago there was a rally that had been advertised all over the city. Los Angeles, the same was happening; Philly where Jamal had been accused and incarcerated; New York City; all over the country. So I responded to the efforts to gain a stay of execution. Mumia called up once again the question of the way in which the black male body is marked. Here's this young brown-skinned child, Ayo, who is going to have to live that legacy unless things profoundly change—and they haven't. I was reflecting both what was physically present on the street, and the signs articulating that this is an action that we need to take in order to attempt to save

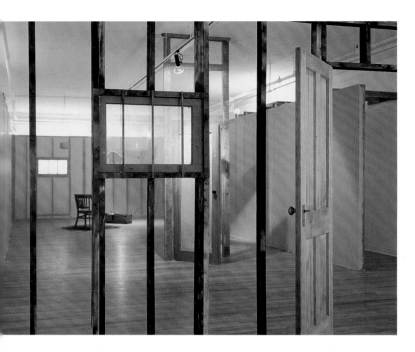

Fig. 36 [above]. **JOHNNY COLEMAN**, *Ruminations*, 1992. Wooden doors, window, wall frame, steel bar, ashes, ostrich egg, compass, plumb bob, butcher paper, chair, copper-lined crate, sound, 1200 sq. ft. installation (approx.). Courtesy of the artist.

Fig. 37 [facing]. **JOHNNY COLEMAN**, *A Prayer for My Son and Myself*, 1997. Toolbox, chairs, enamel basin, copper, slate, wood, barber shears, cedar mulch, inner tubes, black-eyed peas, drums, plumb bob, neckties, sound, 1000 sq. ft. installation (approx.). Courtesy of the artist.

this man's life. There was so much implied by the accusation that he had murdered an officer; the kind of relationship between his body and my body. I am fortunate that I have not seen the inside of a jail or a prison—I'm an exception, a very rare exception. And yet, I've been in the back of police cars. I've had guns to my head. I've been handcuffed. I have been pulled over multiple, multiple times. So I have a history with that legacy. I'm referring again in *A Prayer for My Son* to that sad historical legacy.

But in the prayer I'm responding to the reality of those legacies with the hope that I myself won't become calcified and paralyzed. I am attempting to model for my son a way of responding to the world other than out of anger, fear, and paralysis—like the capacity to love, take chances, acknowledging your vulnerability, but choosing to live anyway. So, in each of those instances, the geographic location of site, the social and cultural and political site, and that personal site, I'm trying to deal with all of these in one location, one gesture, one ritual. Other projects attempted to do the same. One example is the piece that I did in response to what happened in my head as a result of Rodney King. In another project, *Black Fathers and Sons*, we took the real experiences from each of the men who collaborated in bringing that ritual about. Albert Chong, Keith Antar Mason and the Hittite Empire, Quincy Troupe, Prentiss Slaughter, myself, we worked to weave our own stories into the stories of black men who had entered into dialogues with Albert and me over the period of a year.

SDB: You mentioned the Rodney King verdict, and I'd like to talk about *Ruminations*, which documents your emotions and responses to the verdict. You talked about going from outright shock to numbness, and then overwhelming anger. In the end, what emotion comes out the strongest in that work?

JC: It wasn't anger so much as it was sadness. After the initial shock, a really thick, palpable sadness. The numbness and paralysis came in the first few hours following the news when I did not respond at all to the event. I think I blanked it out of my head. Then coming back home later that evening, turning on the television, there was no place you could go that did not document what was happening in Los Angeles. The paralysis was instantaneous, but the anger was focused on the continued vulnerability and the kind of impunity with which this black man's body was so brutalized and dehumanized, even publicly. And then when legally interrogated, it came back to shock me.

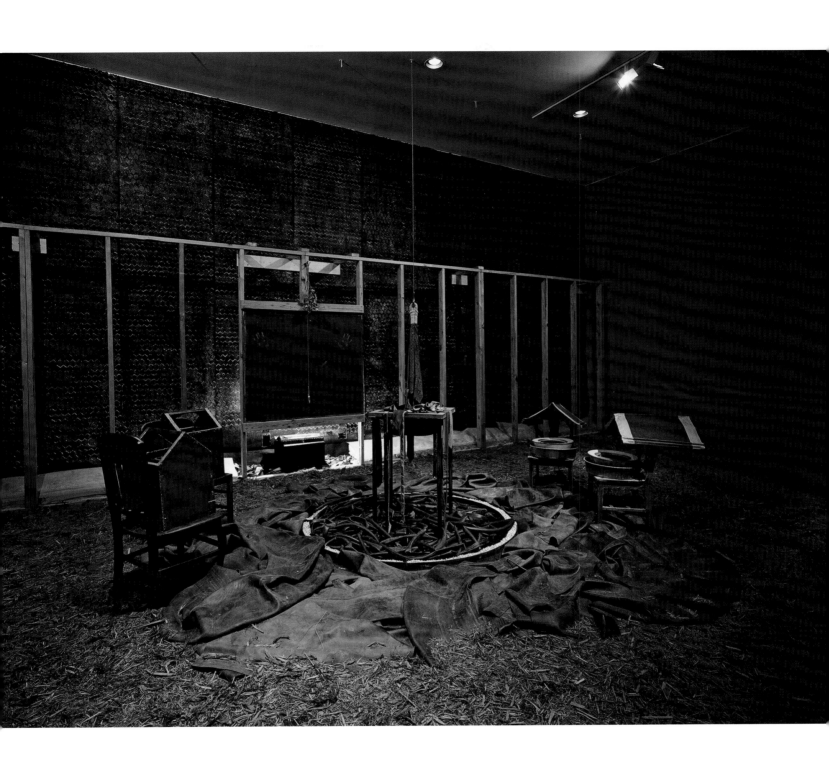

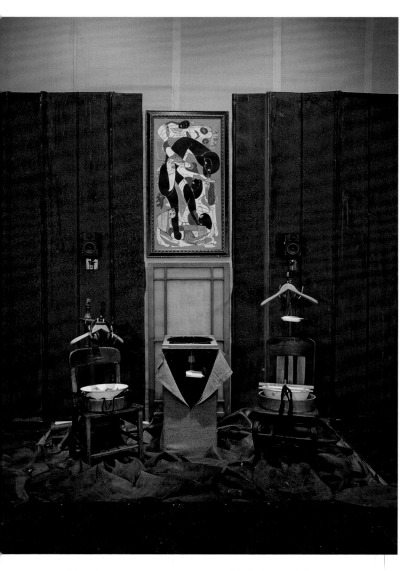

Fig. 38. JOHNNY COLEMAN, *A Gathering of Brothers*,
2000. Tin, felt, rubber, water, wool, oak, bowl, window,
leaves, dreadlocks, monkey wrench, paper airplane,
700 sq. ft. installation (approx.). Courtesy of the artist.

I don't think I was all that naïve about it, but it was just unfathomable. I couldn't imagine the possibility of an innocence verdict—that was so dehumanizing. There was anger, and shock, but below that was just an unbelievable sadness. And so that piece was constructed out of that space and that sadness: the dream. And I'm not sure I understand, because there was a hopefulness embedded in that dream.

SDB: That recurring dream gave shape to *Ruminations*, and it is a very hopeful image. In your dream you mention a homeless man who finds an egg on the sidewalk and realizes there is a chick inside, struggling for life. Last time we met, you recounted: "Dennis cradles the egg in his two hands. And when it starts to hatch, he assists by removing the shells, and when the bird is out of the egg he rests its head and neck between his thumb and forefinger, and the rest of the bird's body is very small and still wet and coated with the albumen. And he squeezes gently and releases. And the bird takes a long breath. That's my dream."

JC: That's the end of the dream right there. We don't know if the bird survived or not, but it could have.

SDB: When you describe Dennis removing the shells to help the bird, I keep thinking of your vivid references to personal histories as well as collective histories, and your own role and responsibility.

JC: I guess that I do feel a responsibility. There was a professor of art history where I grew up named Samella Lewis, and I first read her work twenty-five years ago. She articulated an insight into a black aesthetic. One of the things she said was that the black artist has a responsibility to history, and given the miseducation—I'm paraphrasing—that is rampant in our school systems and the lack of acknowledgment of what our histories are, our responsibility is to refer to those histories and to offer a means of reflecting the richness and struggle of those histories within the present. And a responsibility I've always felt challenged to participate in is to work toward a means of becoming more whole: a healing process. All of that was really framed for me by Ulysses Jenkins. The kinds of questions he asked me, the challenges he posed, the feedback he gave, and the way in which he involved me in work he was doing. He allowed me to participate in some of the questions that he was asking about intent and community and legacy.

I think my process is not so much driven by what I feel I should do because others expect it, but is probably a lot more organic and

related to the literature that was surrounding my brother and me at home, from James Baldwin to Richard Wright, Ralph Ellison, Maya Angelou, and the kinds of ideas they explored and expressed. And with my relative ignorance of contemporary African American artistic practices when I was growing up, limited primarily to Charlie White and Jacob Lawrence, my frame of reference was their process, their practice, and their intentionality. I'd grown up with White's work in the pages of *Ebony* magazine, on the covers of *Jet* magazine, and on the wall at the barbershop. Their work was telling stories: illustrations related to black folks that I recognized and that made sense and were generative. So I think more than my process being a response to a sense of obligation, that my process has been an organic outgrowth of what I was surrounded by through my parents' efforts, and the culture there.

SDB: That one event—the King verdict—and all that followed, seemed to spawn a number of works, and, in particular, a couple of discrete pieces. Did images from your dream reemerge in these other works?

JC: Yes. The dream never went away. Reading the written account of my dream, I'm seeing it so clearly; it's never gone away. I don't remember the last time I had the dream, but it was so vivid that for at least two weeks, I had the dream every night. From the very first time I had it, the dream became kind of an emotional blueprint. What happened in the time between the verdict and the explosion and smoldering, and just to see a place that I really love on fire, that was another emotionally painful thing for me. I didn't find any release in it—only sadness.

So what was I doing in terms of art in that interim? I don't remember. Thematically, the liminal space of the crossroads was emerging as the most salient and recurring metaphor in my work. I remember two responses to *Ruminations*. One person at the opening asked me, "Why is it so pretty? Why is it so elegant? What about the events that happened was so pretty or so elegant?" And that really stayed with me. The other was someone wrote in the comment book that he found my having done that project to be a kind of exploitation. He felt that I was taking a very difficult and painful event that was a public event and seeking to capitalize on it. And that also stayed with me. But there was a period of a year between the dream and when this piece emerged, and that period also reflects a time in which inSITE as

an institution and an event was being formed along the San Diego–Tijuana border. I had the opportunity a year later to do the piece. I don't know if the piece would have been the same if I had made it in the weeks or months immediately following the event.

SDB: Do you see some of these personal experiences becoming part of a collective history in terms of African American culture?

JC: Yes, absolutely, profoundly. In examining the experiences that shape me, part of my own growth is recognized and reflected in those connections to other black people. And it's much larger than the community as a whole. Telling stories, we're actually providing opportunities to connect ourselves from here to a larger network of human relationships.

SDB: Recalling that comment in the gallery book about the beauty of *Ruminations*—going from such a dark event to something that is aesthetically pleasing—is there an effort on your part to memorialize, or to address something that has been presented incorrectly?

JC: Not in that piece. I was trying to be really honest about a dream. I wasn't trying to make a pretty statement. I think the reason this question stuck with me was I received it as a really honest, direct challenge to me to identify what I was trying to do. You know: Why would you make something so pretty out of something so ugly? I don't remember how I responded to her, but I wasn't trying to duplicate the event, or to exploit the circumstances; I was trying to invoke the space of that dream. It was not a documentary. *Ruminations* was an intimate and emotional space of sadness, a reflection upon my own response.

But the larger question you ask yourself is, Am I attempting to memorialize and join a historical kind of legacy, or to place myself or my comments in a larger space? I'm reflecting upon what I've witnessed and experienced, then framing that in a larger context. With *A Prayer for My Son and Myself*, I was not only talking about Ayo and me. I was talking about the fact that so many men that look like me are exceedingly vulnerable targets, and that it is possible for us to recede into ourselves, to become self-destructive, to become distant, to become abusive. It is also necessary for the survival of all of us as a community to choose to respond differently. And trying to acknowledge that struggle within myself, trying to take what my father offered me and recognize the strengths and the values of the gifts he offered me, and at the same time, to recognize the mistakes that he made and

not repeat them. I am part of a generation of black men who are trying to grow further than our fathers grew. I am trying to become a generative model so that my son can take that and do better than I've done. To my mind that connects me to a legacy of black men who are connected to a legacy of black women, and a history of how we came to be here in the Americas. What responsibility we have to the people who survived by force of will to make it possible for us to even ponder these questions.

SDB: I'd like to talk about *A Landscape Convinced: For Nyima*. You were able to connect a very violent and painful moment in Toni Morrison's *Beloved* to the birth of your own daughter. You bring together the tremendous miracle of birth from your experience and a sense of redemption from the story. It is a remarkably expectant image.

JC: To my mind, the passage in the story is fiction; it's something that Morrison put together to get into the intent and understand, not explain, but to witness what she thought the motivation of Margaret Garner, the character Sethe was based on. She opens it up as an opera on the page, and now an opera on the stage. What happened when she moved from such graphic descriptions of brutalities, unspeakable suffering, and the way in which she talks about the dehumanization of a woman's body without saying "rape," and made it palpable, was that you could begin to imagine it again. Against that backdrop, for her to speak about the delicacy of the blue fern spores along the river, and light, and a generation of seeds, "each one convinced of the possibility of a future," that for me was baptismal. And that child there became almost like an original ancestor: the one born in that liminal space between, that all of the rest of us come from.

SDB: *Landscape Convinced* includes a rowboat with a beeswax hull, locks of your own hair, birds, a large sunflower, herbs, and the sound of Nyima splashing in the water, playing with her mother as she's receiving her bath. Can you comment on the significance of these elements?

JC: Around the time that Nyima was conceived, I cut my hair for the first time in fourteen years. My grandmother died within a few days of her own birthday, about 102 years later. I thought I was marking her birthday, but also Nyima had just been conceived. Those dreadlocks were there, and it was kind of an internal process that I needed to go through: I needed to shed something. I referred to my locks as a gar-

den. So I was planting a new garden when I cut them. Along with my locks, there are herbs in the boat that came out of our garden. When my son was conceived I planted a garden full of collard greens, basil, tomatoes, and other herbs, including sage. I've maintained a garden since my paternal grandmother passed. When she was no longer able to plant a garden, I started planting the things that she always did. I planted a garden through my son's conception, birth, and early life; and the same process was going on in Nyima's life. The sunflower, that big one in the boat, was a volunteer in the garden. The herbs in the boat are the basil and sage. The gesture is really about planting seeds of intentionality and care, and nourishment: providing love. There's a shoe form in there, and then these shells, cowrie shells, and they mark the importance of an individual; they also mark currency. They were there as another way of stating value. But that sense of joy and play and happiness is all Nyima in the water. The water bears that connection to the old, old ritual of baptism, where one is taken from this standing position and moved below the surface; the symbology that someone has died and been pulled up, born again. The sound of water that one hears in the uterus, the birthing in water, all of that was what I was thinking about. A celebration. Warm in terms of color, in terms of feel, touch—I meant it to be a warm welcome and celebration, and to be a counter to what Morrison describes as a broken boat on the edge of the muddy water, current hell-bent for the Mississippi. So, I meant it to be the other side, to take what she said about those sun shots and blue ferns and kind of enter into it from my own place.

SDB: The Ohio River is in the story—is there any physical link to this locale, any sense of a specific landscape that you feel must be brought out?

JC: That link is directly connected to where we are right now. Coming from northern Kentucky, the river is the Mason-Dixon line. That's what Sethe was trying to do; she was trying to get across the border. We are on the other side of the border and Oberlin is a space that was profoundly conceived of by enslaved people as a destination. Over one hundred years ago there were better than a hundred Black folks here, some of them "free," some not, who felt safe in this place. This space is directly tied to that space; it's the other side.

SDB: Were any of the cultural histories that have come out of Oberlin and northeast Ohio linked to your artistic processes before you moved here?

Fig. 39 [facing]. JOHNNY COLEMAN, *A Landscape Convinced: For Nyima* (detail), 2001. Rocks, flowers, herbs, sunflowers, leaves, shoes, slate, hair, flour scoop, rowboat, beeswax, toolboxes, shovel handles, sound, 500 sq. ft. installation (approx.). Photograph © Joseph Levack. Courtesy of the artist.

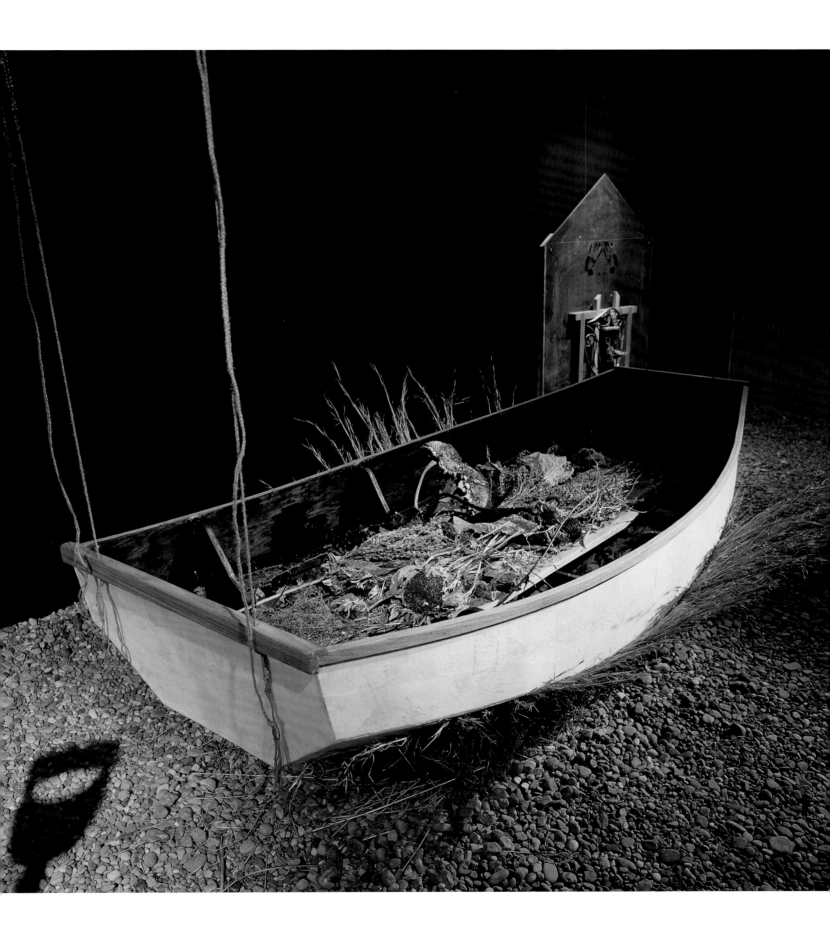

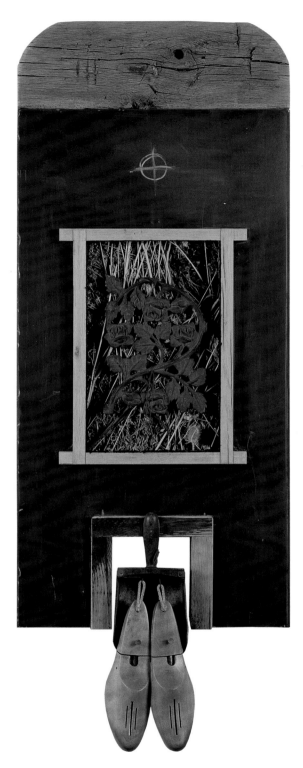

Fig. 40. JOHNNY COLEMAN, *Her Marks* (*Beloved* series),
2003. Slate, oak, wildflowers, tar, iron, wooden shoe stretchers,
wooden flour scoop, 42 × 24 × 3 in. Private collection.

JC: Yes, but those linkages were incredibly intensified in terms of the sense of the presence of the past. I'm from a completely different landscape. And the presence of the past is different here than it was there. Maybe it's because when I came here, I was older and more mature. I was ready to receive and to respond more than I may have been earlier. But coming here, the impact of these ghosts, these spirits, the Underground Railroad, we're on top of it and it impacted me in a way that has further informed my work. I've been dealing with memory, and for some time now, I've been reaching beyond the immediately personal to a larger cultural history. Coming here, the immediacy of that history, there's just something about Oberlin that sharpened it for me.

SDB: The element of prayer in your work is both audible and private, written and recited, incorporating the voice and music. In *A Landscape Convinced*, you recall the first reaction of your son to the birth of his sister: "He peeked through the curtains and said, 'You smell like something sweet,'" and this phrase is repeated over and over. In *A Prayer for My Son* you work with a Nigerian drummer who sets up a rhythm and counter-rhythm, and he calls back to your son, whom he helped name. How have you structured these recitations, or this liturgy, in the pieces?

JC: In *A Landscape Convinced* it's a call-and-response. It is a recurring phrase in the structure of the prayer. Ayo's response defines the beauty of the moment. It is also a request for guidance: a listening for the ways in which that prayer reveals something to me and hopefully is shared. But most organically and intuitively, it comes from the music. It's my heart. Jazz is the music that I am most touched by. I can listen to John Coltrane, I can listen to Miles Davis, and the clarity they achieve and the emotional impact that their work contains, that's really the model for me. I am trying to achieve the clarity of African American music, and the honesty of the blues.

SDB: There are other types of sound, other kinds of music, and different senses that play strongly in your work, and in your landscapes.

JC: Scent is almost always there, from *Ruminations* onward. Right now, we smell this old wood and straw in the studio, and our bodies respond to it. All of that to me is music. So, when I'm listening to a musician who's responding to an environment, whether it's the environment of a conversation, or a relationship, or the street or

the countryside, for me they're responding to all of it. What I'm hearing, what I'm smelling, what I'm tasting, what I'm feeling emotionally, all of those things are components of what is called up for me. I'm not distinguishing between formally structured music and sound. That sound is music. All these materials and the way in which surface and color and light and shadow and sound are all really musical expressions—it's just a poetry that I keep calling music. I'm really trying to use all of those languages to get to something, and conduct those languages in a manner that is informed by the sensitivity of artists like John Coltrane, Pharoah Sanders, Elvin Jones, Herbie Hancock, Miles Davis.

SDB: You almost have to be an audio technician or sound engineer to do what you're doing.

JC: My father was an audio communications specialist stationed in Korea, so I grew up with the finest audio equipment. We weren't folks who had money, but on leaves in Tokyo fifty years ago, my father was buying very sophisticated equipment. I grew up with that. I played guitar, and I learned very early on how to wire very fine speakers that he, for whatever reason, allowed me to use. Somehow I learned it. I think my father's generation was part of a historical moment that was embedded in the Depression. And one of the things that came out of that Depression-era mentality was that you fixed things yourself. Self-reliance is something I really respond to in this landscape. The technological and the sound technician thing were in a large part organic to me because of my father.

But the other thing I kind of stumbled on in graduate school was a four-track cassette deck, and I was trying to find the way to bring in the sounds of my family in a prayer that I did for my brother. Some years ago, on a trip to the East Coast, I spent several hours just talking to my grandmother. She and I, my father's mother, were really close—I spent hours just sitting and talking to her, and she just sat and held the microphone in her hand and talked. Across the room my brother was talking to our uncle, her oldest son, and I knew that this was a document I wanted to have for my family. I also knew somehow that I needed that document to come alive in a space that was real for my brother. I made a mistake by plugging the stereo recording of those conversations into one channel on a mixing board. I plugged a stereo signal into a mono track, and what happened was it went into the track out of phase. The result was that the sound kept flipping and created

a kind of reverberating sonic ghost. It was a mistake, but it was in fact a way of weaving sound that I discovered completely by accident. Trying to learn how to work with that multitrack process fifteen years ago has evolved to the point now where I'll take a laptop into a forest to record. Using very sophisticated software, I'll go stand in a river and record the river holding microphones three or four inches above a set of rocks where water is flowing. It's never been about the technology. It's about seeking to reveal space as sentient and articulate. It's not about 24-bit resolution; it's about clarity.

SDB: Do you want your audience to be aware of this technical side of your work, or is it kept as a discrete component of the installation?

JC: I once had a conversation with a healer who was talking to me about my work a couple of months after I had made the piece for my brother. She kept talking about electronics and wiring, and I kept telling her that it couldn't be farther from what my work's about. I use soil, wood, organic materials, and then it dawned on me, that the whole piece had been wired for sound. It went right past me. When I think about the work I don't think about the technology. Technology allows me to bring another aspect of language in, to try to create the environments I need to compose.

SDB: The piece you're doing for the exhibition, *A Promise of Blue in Green: For My Mother*, is coming out of a work you made for your mother, *Station to Station*, with the safe house or straw barn. The new space also references the playhouse you built for your children, the birdhouses, and the sounds of your children playing.

JC: The last time my children saw my mother, my brother brought his twins and his three-year-old son, and Nanette and I brought our kids, and we went to my aunt's house. My mother was living with her at the time—and she had the chance to spend three or four days with them. I didn't record it then with the intention of doing this piece. I'm always gathering sound, and sometimes it is incorporated into a prayer. Other times I'm gathering it because I know I can turn around and put a disc together with the sound of the ocean or rain, and that it will be really soothing. My mother went to sleep every night for the nine months preceding her death, much of which I spent with her, listening to Andy Bey on the stereo, or to a recording that I made her of the ocean. So I gathered those sounds in order to have a document of my kids and their cousins and their grandmother in order to hold onto

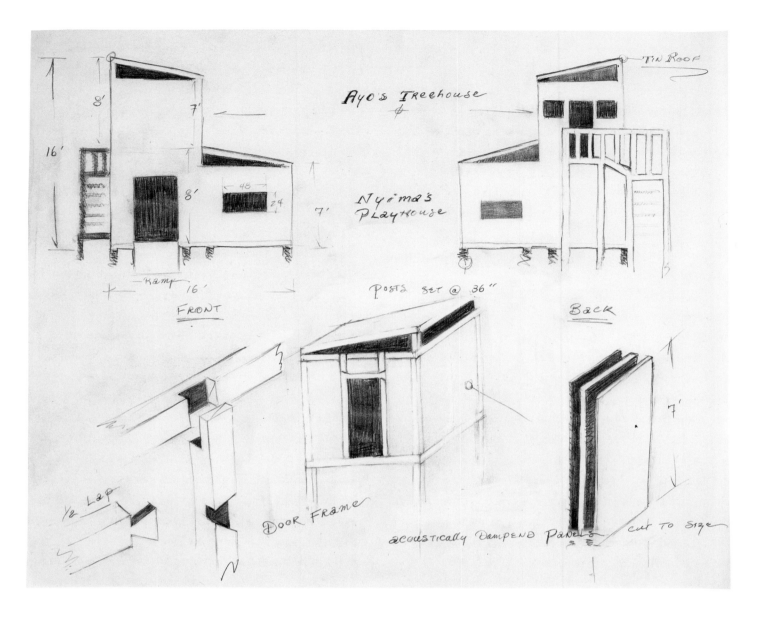

Fig. 41. JOHNNY COLEMAN, Sketch for *A Promise of Blue in Green: For My Mother*, 2005. Graphite on paper, 14 × 17 in. Courtesy of the artist.

the moment. We knew that she was dying. I've been doing that kind of documentation for almost twenty years.

SDB: For this new work you have talked about creating a piece that is less of a cultural legacy and more about family. It's also a structure that combines a playhouse and a tree house.

JC: Maybe the two buildings will be combined together in some way. They have very similar elements: the same floor plan, the same roof pitch, and the size and location of the windows. For Ayo's space the floor is 11 feet up, and for Nyima's space the floor is 2 feet up. I don't know which one, or if it's going to be a combination of the two or a distillation of the two.

SDB: Can you discuss some of the other components and overall design for the piece?

JC: I'm doing a series of drawings that will assist me in translat-

ing the structure that exists into a prefabricated series of components that will very easily be put together in the space. And there are questions. Where are the voices of the kids? Is there anything else in the space sonically? How am I going to have blue radiate in that space? I started two pieces already that are emerging in a series that is a response to color for my mother. The first one was *A Patch of Blue*, which is in Los Angeles at the moment, the second, *Remembrance of the Color Blue*, which is in the Pomerene Center for the Arts, here in Ohio. For the museum piece, I'm feeling compelled to continue exploring the theme of color.

SDB: What about the physical construction of this house? You mentioned earlier that you wanted to include some used timber you had collected.

JC: I would love it if it did; I would love to do this house as a post-and-beam structure. Post-and-beam is very heavy and I would need to put footers onto a floor and secure those footers, so I will have to build a platform, too. I'm not sure I'm going to do that. What I'm thinking about is panels that are insulated and very light and will connect together and allow for sound to exist in the space without impacting the other work in the show. I don't want everyone else's space responding or having to engage whatever sound is coming out of my piece.

SDB: The color blue seems to be a key element in this work. Is it connected to your mother and California, the Greek revival house in Ohio, the birdhouse? Is it an arbitrary color?

JC: No, blue is very intentional. I'm not sure I understand yet. The first thing I did, coming home to California recently, after getting off the plane was I went to the ocean. I went exactly to the spot where my mother and I would go for weeks over and over again before she passed. And what we were looking at was the sky and the water, and people coming by. We could have walked out her front door and been in a park, and watched people, but we drove for thirty-five or forty minutes in traffic down Pico to the Pacific Coast Highway just above Malibu. We'd go to this one state park, and go right to the same bench. When I went this time I got really sick; it was the first time I'd been

back since my mother passed. And I really couldn't be there. So I put my head down on the steering wheel and just sat there in the car. I was sitting for about two hours and I really struggled to get across town to my friend's house. There's something about the color that is a reminder of the sky that I miss, and the sky that we looked at, and the water. She loves the water, she really loved the water. She loved the blue.

SDB: You have said your art is centered upon themes of crossroads—a focal point, a center of challenge and transformation. What are some of the themes emerging from these junctures in your work?

JC: Every one of the works we've discussed is a crossroads, and where are we going to go from here? We have another opportunity. We've been talking about growing ethically, morally as a nation for two hundred plus years, but clearly we're still facing some really basic challenges, so where are we going to go from here? Black masculinity and fatherhood, we're definitely at the crossroads, and hopefully we're making some choices consciously. The birth of a daughter and my own experience of fatherhood and the metaphors that are active for me are within the things that I chose to initiate that series of prayers, the trilogy, *Landscape Convinced*. Sethe was at a crossroads, at the liminal border, at a space of possibility and shifting fugitive flow. In each of those pieces it's profoundly present for me. In *Black Fathers and Sons*, the ritual at the Brooklyn Academy of Music again, we were doing the crossroads. Losing my mother, for the rest of my life I won't have a mother. How am I changed? I don't know. What does it mean? How am I going to maintain my connection with her? I've never been without my mother before, so I'm finding out what that is like right now. I did have a chance to be with both my grandmothers just prior to their passing. I spent time with each of them, so I'd experienced that transition, but this is a step closer. So what is it going to mean from here in my life and what does it mean for me to try to model something for my kids about this transition in life? And hopefully say something to my mother. The concept of crossroads is one of opportunity and challenge. I'm trying to reflect that, frame it.

PIPO NGUYEN-DUY

(B. 1962, HUE, VIETNAM)

Pipo Nguyen-duy's art is inherently tied to (trans)location—in the ephemeral boundaries of opposing values (the beautiful and the disturbing, the comedic and the tragic, the precious and the real) as well as of site. Born in 1962 in Hue, Vietnam, Nguyen-duy witnessed some of the worst atrocities of the Vietnam War as his town and family were ravaged during the 1968 Tet Offensive. Since arriving in the United States as a refugee in 1975, the artist has been interested in boundaries, dislocation, and cultural appropriation as an attempt to identify a transcultural identity. Having studied economics at Carleton College, Nguyen-duy came late to photography, beginning a masters program at the University of New Mexico at age twenty-eight. His art picks up the project of navigating an uncertain cultural environment, whether in self-portraiture, landscape, or mis-en-scène.

The shock of immigration and the pressures of cultural assimilation in the United States assumed the focus of Nguyen-duy's earliest projects: *Assimulation* (1995–98) and *AnOther Western* (1998–present; fig. 44), both black-and-white portrait series that superimpose the historical trappings of Western art and culture on an Asian subject. In *Assimulation*, the artist restages the familiar themes of "high art" in Old Master paintings with the visual vocabulary of Asian theater. With his own body as subject, he concocts a photographic tragicomedy of confounded cultural legacy and contemporary identity. Again in *AnOther Western*, Nguyen-duy focuses on the colonized body in a setting made familiar by artists like Yinka Shonibare, in this case using the nineteenth-century garb of the American West. Still deeply engaged in site and the politics of identity and collective history, this series also saw the beginning of the artist's interrogation of a historical mindset, the romanticism and obsession with classification of the

Fig. 42 [detail, facing]. PIPO NGUYEN-DUY, Oberlin, Ohio, May 2005. Photograph by John Seyfried.

nineteenth century and its aesthetics. The questioning continues to this day in his *East of Eden* series (2001–present; see figs. 1, 2, 45–47) and *The Garden* (2004–present; see figs. 4, 48a, 48b, 49a, 49b), both of which are shown in *Trace Elements*.

In these more recent photographs, however, Nguyen-duy's focus has shifted from an investigation into the back-story of landscape to that of its present reality, a shift that was largely prompted by the events of September 11, 2001. While the widespread anxiety pervading the country seemed to many the fallout from the jarring realization of national insecurity, for the artist it resonated as a familiar state of mind. Using the metaphor of 2001 as the point of the United States' expulsion from its ideological Garden of Eden, Nguyen-duy began staging scenes from a mythical but particular place in this post-paradise of knowledge, somewhere poetically to the east of Eden.

White-clad fencers in the sharp perspective of camera and a winter forest of straight trees (see fig. 46), dejected marching band members by a creek bed, the surreal juxtaposition of his young son's delicately articulated back against the burning landscape of a West Coast summer: each image from *East of Eden* embodies the eerie disjuncture between fiction and reality, humor and sorrow, nature and humanity. Though his earlier work functioned as lessons on identity and cultural difference, the artist now turns to a more open-ended visual narrative while maintaining a precise and compelling aesthetic. This open-endedness is largely located in Nguyen-duy's commitment to specific landscapes, to preserving the nature of the site, a commitment which distinguishes his work from that of contemporaries like Jeff Wall and Gregory Crewdson. As if documenting the physical evidence of this state of mind, Nguyen-duy's photographs are as equally expressive in their range as in their precious composition and vivid color.

Precedent for *The Garden* was set in the 1998 *AnOther Exhibition*, a planned installation of over 200 images of the plants, water, soil, and other natural elements of Monet's garden in Giverny, France, where the artist had held a residency. Though the project's intentions were closer to earlier didactic and political portraits, it was also the beginning of Nguyen-duy's current interest in the surveyed landscape. *The Garden*, over 250 large-format C-print photographs of abandoned greenhouses near Oberlin, Ohio, witnesses the subtle transformations of a particular ruined landscape fortnight-by-fortnight over the course of two years. In an attempt to use the camera as a minimally subjective analytical tool, the artist's quasi-scientific project charts the structures as they collect the traces of human passage and the vegetal progress of seasons. Still interested in the fluid interactions of people and landscape, Nguyen-duy utilizes his previous means of atmospheric drama, visual saturation, and compelling composition to new ends—an open field on the frontier of the uncertain from which viewers may glean what they may. [S N]

Fig. 43. **PIPO NGUYEN-DUY,** Oberlin, Ohio, May 2005. Photograph by John Seyfried.

In order to talk about the work I'm doing now it's necessary to talk about my arrival here as a Vietnamese refugee in 1975. Coming to the United States was a drastic move for me in terms of both my personal life and my cultural life. And it seems that for the last twenty-eight years, my life and work have been a constant process of assimilating into this country. I became an artist at a relatively late age, so I would say that I have only started exploring these issues of cultural assimilation in the last ten years. I developed an obsession with my personal experience of assimilation, and my work became both political and subversive. But after September 11, 2001, I felt it was not the right time to be doing this kind of work—not because I felt people would judge me but because my responsibility was to work toward a more common narrative. With September 11th, the idea of universal fear and anxiety became very similar to my thoughts and my reactions while living in Vietnam during the war. That is, at any given time, something is going to go wrong. Life is always kind of foreboding, something is looming, about to happen, and you're not sure what it is.

In Vietnam when I was growing up I remember we'd all sit around and say, "Oh, well, it's a time of war." And my attitude about my current work—the garden, the American landscape, Eden—is kind of like that. It's just the event, the place, it's just the time. For me, it's not about the bad, or the good, or the hopeful, but about the way that these abandoned gardens really are, the way that they change. People still celebrate and they still mourn, and they still go to get their hair cut at the barber, even in the time of war. And that to me is what is really beautiful about people, about humanity. We do the things regardless of whether it's a peaceful time or war. Life goes on, whether or not something horrific is about to happen.

—Pipo Nguyen-duy

Stephen D. Borys: Your sudden move to the United States from Vietnam just after the war had a profound impact on your personal and family life. How did these traumatic events affect and shape your vision as an artist?

Pipo Nguyen-duy: This is almost a roundabout way of answering your question, because I don't have the background to react as a visual artist. My background growing up was in Vietnam, where literature is regarded as art, and I think the visual took a back seat as a vehicle to mimic something from the past. My biggest adjustment was dealing with the fact that I was handicapped in terms of my ability to communicate via words because my linguistic background is French, Vietnamese, and English, and I never really mastered one language. But I discovered that my visual language could transcend all of my limitations across these cultures. French, Vietnamese, English—they became tools that I could utilize to talk about my own experience as well as issues that have a universal application. It was a great realization for me, that you can make work that is visual. When I was growing up, and even until I was in my late twenties, my relationship to the visual culture was something of a disdain because I came out of an Eastern background. So it took me a little time to adjust, but I think once I found that as a tool, I was able to really embrace it, and begin to study the Western structure of that visual language.

SDB: Can you comment on some of the experiences and cultural motifs that were part of your life growing up in Vietnam?

PND: The motifs come from growing up within thirty kilometers of the 18th Parallel, which was the Demilitarized Zone. I grew up with a sense of instability. I heard gunshots every day of my life. I have relatives that have been killed. There are events that change the way I think and function today. One of the earliest of these events took place when I was six years old, during the Tet Offensive. My father came to whisk me away from my uncle's house—I was going to spend the night there—and took me home because of the curfew. The following day a bomb fell on my uncle's house and killed everyone. So there's that lingering question: What is the purpose, the sense of all this? What do I do, why am I here, is it my role to tell stories about where I come from and the people that are missing from my life? That sensibility

Fig. 44. **PIPO NGUYEN-DUY**, *AnOther Western: Man with Antlers*, 1998. Toned gelatin silver print, 10 × 8 in. Courtesy of the artist.

has always permeated my work, whether it's the work I'm doing now, or the work I did in the past. I can give a very specific sort of reference to that, *Assimulation*, the work that dealt with the Renaissance. I embraced the Dante narrative and used it as a way of off-handedly dealing with the psyche that I have developed from living in Vietnam through these years. And with my current work, I see it when I photograph my children, when I photograph strangers. I really see my sensibility, that is, the angst, the worry, and in some way an acceptance of it at the same time.

SDB: You describe your earlier work of the 1990s as being didactic: "This sort of thesis that I would make about cultural assimilation, cultural viewpoint . . . either you get it or you don't get it."

PND: I think first of all I have to stand up for the work I've done before. I want to clarify that even though the work has always stemmed from the strategy of dealing with cultural assimilation in the grander narrative—the larger sort of Western story—my work has never claimed that the author is some type of victim. My work has always been about the subversion of the grand narrative by specifically utilizing its own vocabulary and visual syntax. For instance, I think I immersed myself in the Renaissance not claiming to be a victim, but sort of trying to find the kind of roles that allow me to return my gaze upon the Western viewer. In *AnOther Western*, which was the series in which I dressed up and mimicked the nineteenth-century portraits of the American West, I see it as a way of using that language with irony and humor, trying to return the gaze as well as to subvert the typical representation of Asian immigrants at the time. When I talk about a thesis, what I mean is that when you read the work it's about cultural assimilation and subverting the narrative. And when I say "You either get it or you don't get it," I mean it has this one channel that you can reach into. Whereas, with the new work, I think viewers can look at it and form their own conclusion, instead of having to fit it into my intent. My intent is there, but at the same time, it's almost irrelevant in some sense. I want to give the mood, but I want the narrative to be open.

SDB: Aside from the satire, the mimicking, does this earlier work have a weightier, more serious tone, especially in terms of a cultural history?

PND: Absolutely. I would compare the sensibility there to the film *Harold and Maude*. The kind of humor that seems to appear through-

out the movie only points to the serious nature and the kind of tragedy that exists within that particular story. So I think that this work, though it deals with humor and irony, came from very specific experiences. I don't like to call them painful because I think it's in the work. It's not about the victim, but about my own experience and how I can tell that particular story.

SDB: Your first university degree is in economics, and your graduate work is in fine arts. How did this transition toward art-making take place?

PND: My family is very well educated, and, coming to the United States, it seemed that of all the "respectable" fields, aside from medicine, economics was the most interesting to me. I'm somebody who is actually very conscientious about social change, and I really thought it would be something I'd be doing. But I was disappointed in that because I was studying under a Keynesian influence. The point when I began to think about an artistic career, or a creative career, came about with my own interaction with the art world during the 1980s when I was living in New York. I was working as a bartender, and then as a nightclub manager. I didn't just jump in and begin making art, but my friends were all artists, so we talked. People like Don Cherry and Keith Haring would come into the bar, and I would have conversations with them and figure out what their lives were like. I didn't think I would pursue it, but it gave me the kind of confidence and hope that one could actually explore one's own depths, and that it was possible to exist while doing this. Coming to the States in some sense has been really liberating. I would not be able to do what I'm doing now otherwise. And literally, it's from living in the East Village in the 1980s, which was the crux of creativity in New York.

SDB: When you made the shift to fine arts in graduate school at the University of New Mexico, did you go right into photography?

PND: I came in as a photographer, but I actually studied installation, sculpture, and printmaking, and completely disregarded photography for a long time, until maybe the last two years of graduate school. I love the medium, but at the same time, I feel like my research has been rooted in so many other kinds of art, such as sculpture and performance. I'm just scratching the surface with what I feel like I can really do with the medium.

SDB: If we jump ahead to your work after September 11th, you talk about it having a narrative that is open-ended in order for your au-

dience to get as much as possible from it, and that everyone should be able to choose their own narrative. Does this apply to your two most recent series, *East of Eden* and *The Garden*?

PND: Yes. I do have a sense of narrative within each one of these works, but sometimes their success has to do with how ambiguous they can be as well. That ambiguity is what I'd hoped I could offer the audience. I chose "the garden" because of a particular sense of stasis; the architectural details remain unchanged. The landscape and the life within it seem to be the variables, which always change. And I've also chosen them for their artificiality, the idea of the man-made Garden of Eden of the nineteenth-century West. What I'm trying to get at is not to talk about one thing but to explore the many things that contribute to that one thing. This is a transition from the obviously staged scenes to the documents of real life. When I feel like something is working, this is when I'm not so sure about the narrative. I love Raymond Carver. His stories are amazing, and his stories are so open that you can read into these people's lives without being forced one way or the other.

SDB: *East of Eden* deals with humanity in the context of the post-apocalyptic—in your metaphor, the post–September 11th landscape. The images of hope and despair appear to be split evenly through the series, and you have no difficulty showing the darker side of the landscape. Did you consciously try to show the good and the bad?

PND: Yes, I've tried to show both. And I think in some pieces it would be amazing to have those two sensibilities occupying the same space. But what I really hope for is that, as a body of work, the sense that you get from each image gets balanced out in the end. The good and the bad can happen within the landscape. Some works I would love to show together, and other pieces I know it's just too difficult to make it all work.

SDB: There is a major shift of perspective in the *East of Eden* series, something you describe as moving from an "autobiographical postcolonial discourse" to the "contemporary political and social and psychic landscape." A strong personal narrative is also present.

PND: That's my observation of the contemporary landscape. My narratives and sensibilities are things brought with me from Vietnam during the war. Some of my students and my kids may have this fear that something's about to happen, but they don't have the experience of seeing it take place constantly around them. And I think that's what

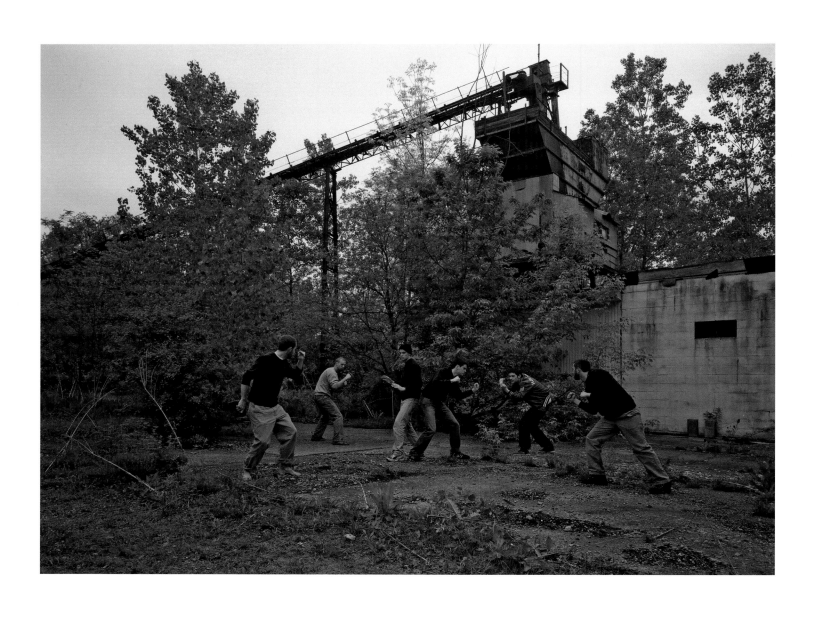

Fig. 45 (Cat. No. 7) [above]. PIPO NGUYEN-DUY, *East of Eden: Fighting Twins*, 2003. C-print, 30 × 40 in. Courtesy of the artist.

Fig. 46 (Cat. No. 8) [facing]. PIPO NGUYEN-DUY, *East of Eden: Swordmen*, 2003. C-print, 30 × 40 in. Courtesy of the artist.

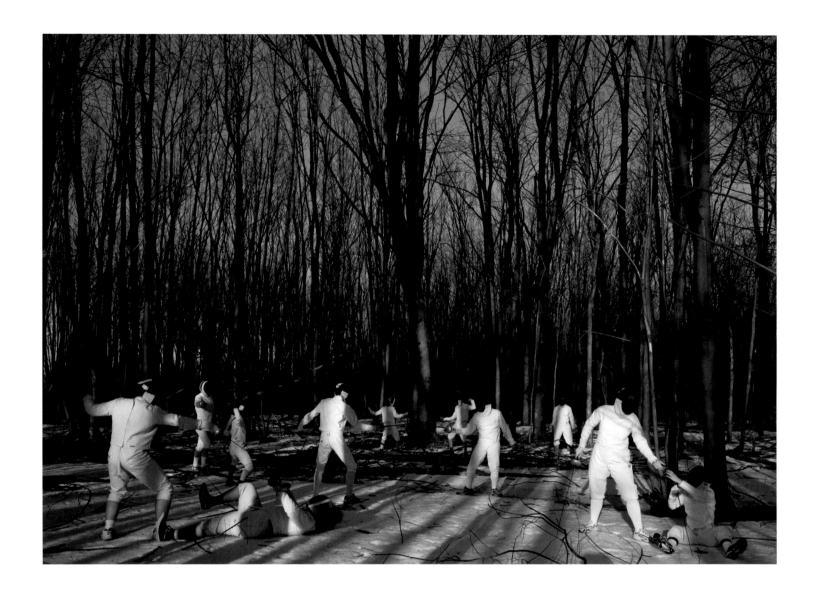

I'm trying to bring to the work—something of my personal narrative; looking at it, and giving it a universal tone. As for my children's presence in the work, it's autobiographical in the sense that they become kind of a metaphor for my own observations of the kind of landscape we inhabit.

SDB: One of your sources is the literary idea of "East of Eden," but you also were informed by the pictorial representation of the subject, mainly in the paintings of the Hudson River School and their European counterparts working in the first half of the nineteenth century. The geography of the Hudson River School is easily identified and understood; people who know the American landscape can iden-

tify these sites. You have chosen to present a landscape that is often unknown at least in terms of a recognizable topography or specific place.

PND: I don't see this as a specific landscape, I feel these are more—I hate to use the words "psychic" or "metaphorical"—like the landscapes that can exist anywhere. In the work I'm going to do this summer in Vietnam, I hope to achieve the same thing: creating a kind of landscape that's pervasive everywhere, not identifiable as an Oregon landscape or an Ohio landscape, but as an anonymous landscape. And the people participate in this sort of anonymous yet universally recognized landscape.

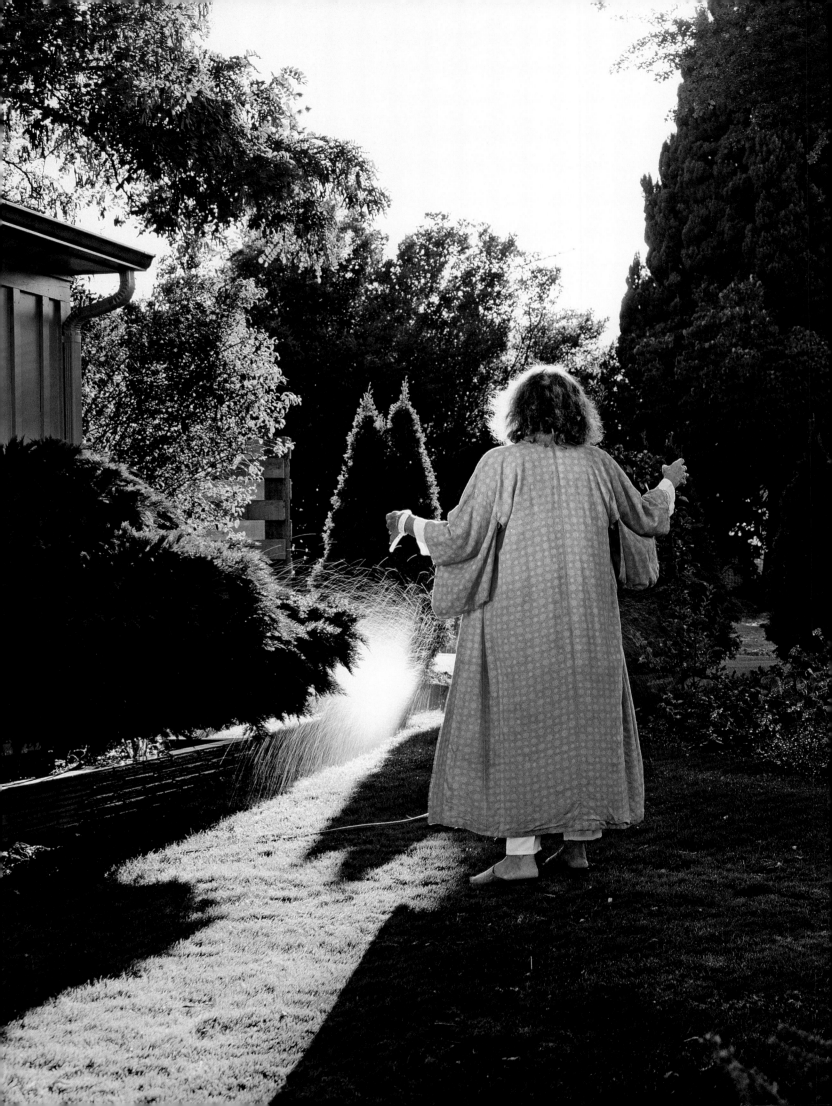

SDB: In *East of Eden* you talk about having this contrast of people celebrating in the context of a ruined landscape where it's all about beautiful things within a rustic setting.

PND: I think in a way they're comforting themselves more than celebrating. It's not about the celebration of the landscape, it's more about, "Well, we got stuck in this landscape, so what are we going to do here?"

SDB: It is a big jump from the Eden of the nineteenth century in terms of American landscape painting, where the figure is overwhelmed by presence of nature. Your Eden is often populated with figures, and the landscape is very much about humanity.

PND: My vision is Caspar David Friedrich. I mean, for me it's almost like taking Friedrich's paintings and sticking them into a nineteenth-century Western painting and then having some fire burning. That's how I see the work. It achieves a success with a particular Nordic figure set within this contemporary landscape. I'm drawn to those paintings and their sensibility.

SDB: With Friedrich and many of his German and Baltic contemporaries there is a strong Romantic attachment to the landscape, and their figures are clearly linked to these naturalistic passages. Do your subjects share this connection?

PND: It's more of my personal link to the landscape rather than the connection of any one figure to the landscape. The direct link is really my entry into the Garden of Eden. I see my relationship to the landscape—the American landscape—as an immigrant, and this is where that vision comes from. I have always seen this as beautiful landscape, and my narrative is about what has happened to this garden.

SDB: Your idea of *East of Eden* seems to be firmly established in your mind, and you simply have to find the players for each setting or episode.

PND: Yes. You know, it's planned, but there's some chance that happens, which I welcome and I love. I look at the landscape and in some ways it's already in my head. I know where the figures go and what kind of gestures they're going to make. I think I have done research enough in my mind, in my notebooks, that any time I go into a landscape, I already have an idea or an image. Sometimes it's a matter of stumbling by chance and collaborating. But even though I have planned these shots out in my mind, for a long time, often it's just the people I come across, and their reaction and how they deal with me,

and how they can understand what I want to do within a space of five or ten minutes. And for me the best example I can give you is my *Three Graces* from the *East of Eden*—the three ladies I ran into in Alabama. Of course I had the idea for the three graces in my mind, but I never had the right kind of people to do them until that time. The moment I saw them I knew, and I thought it was fantastic.

SDB: You seem to be looking more at painting than photography in your compositions.

PND: I am considering both. I look at Eastern European photography quite a bit. I look at Josef Koudelka—his work is just amazing. And I look at a lot of Czech and Russian photographers, because they're often different from the Western European tradition and from the American photographers. There's a sense of humanity and of the depth of inhumanity that lives side by side within their photography. For me the best example is Koudelka's gypsies; there's poverty but at the same time there's a celebration of these people, and it's incredible how those two things play out. The photograph is most successful when it obscures that particular line where beauty and horror, real and staged, are usually divided. How do you stage the work so there's always that lingering question—is that staged or is it real? Is it beautiful or is it horrific? Those are things I like to deal with in my work.

SDB: We've talked before about the element of staging in your work and how it relates to the Canadian artist Jeff Wall, but what about the approach taken by Diane Arbus? With the recent New York shows, there has been a rethinking of her intent and the process in which she arrived at her final images: the publishing of her contact sheets and the disclosure that many of these works were staged and carefully thought out beforehand. Do you want your audience to know? Is it a concern of yours—the issues of chance or staging?

PND: For me it's irrelevant. That doesn't really play into my work much. I think that what it comes down to is the image. If someone asks me if they're staged or not staged, I tell them. It's not really an issue for me—it's a sketch. Photography is not something that's still, but something you can manipulate. Like painting, you can just pick up the figure and move it.

SDB: Another famous garden you've explored in your work is Claude Monet's garden at Giverny, France. Can you talk about what you did there and how you approached this historical space with your photography?

PND: Initially I received the grant to produce the work I had laid

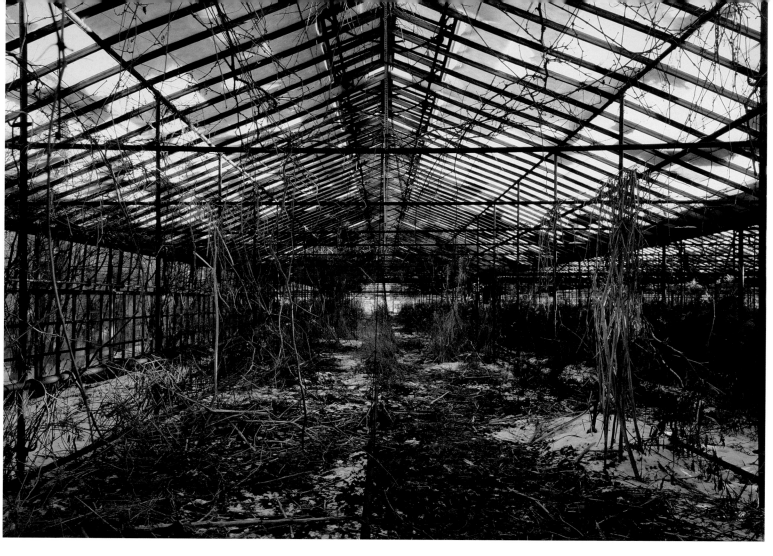
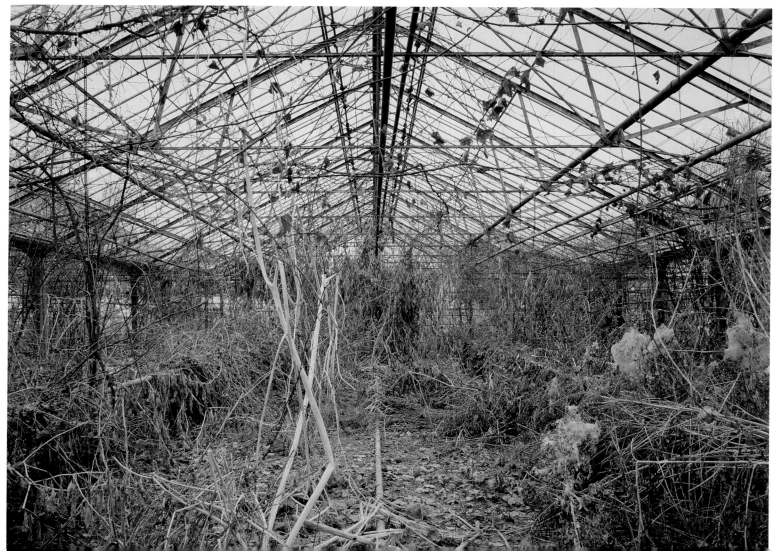

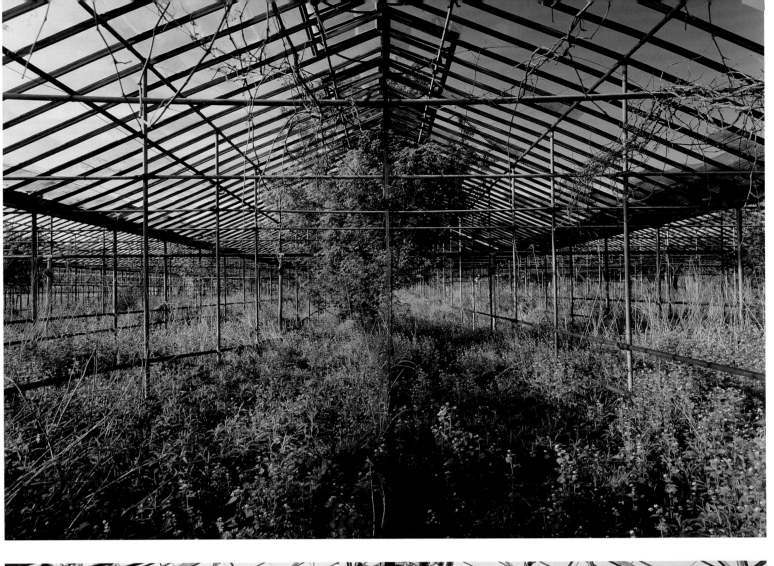

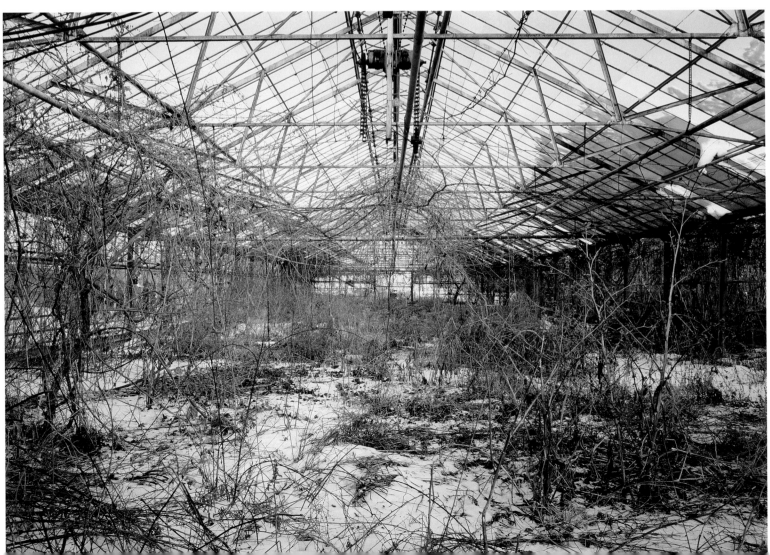

out. I thought it would be great to stage the East versus West conflict within this garden, the Western icon being Monet's garden. When I arrived, I realized there was a lot more than that, and I thought my work should be a political gesture rather than just a creative act. As an ex-colonial subject of France, I wanted to talk about colonialism in this French garden. My whole strategy has always been about taking someone's language and subverting it, and so I imagined creating a colonial expedition, but with a Vietnamese going to France. How would he deal with the theft and the raping of his culture, and what would be the metaphor for it? My metaphor would be a nineteenth-century installation of this expedition, shown along with objects, specimens, and samples that have been collected. Physical specimens would be gathered in France, especially in Monet's garden, because it's such a popular cultural destination. To document these specimens, I used cyanotype prints, the blue prints that were invented by Fox Talbot, and used by the scientific community to collect specimens. I ended up making 1,200 prints. I also collected seed samples, water samples, and earth samples. How can you steal Monet's garden by collecting the water, the seeds, and the earth, and then show the scientific application of photography, which was something used as a colonial tool? Because for me, it's not an accident that photography came along just at that cusp of the full colonial interest of the West during the nineteenth century.

SDB: The next garden in your work is the one you discovered in a group of abandoned greenhouses situated not far from Oberlin, Ohio. Is this how *The Garden* series began?

PND: I discovered this greenhouse when I was scouting for locations to photograph for *East of Eden*, and it really intrigued me. At first I was drawn into it as a background, but eventually I found the ruined structure itself so amazing with its grid-like steel architecture. There was this contrast between the man-made and nature. My interest is not only in the dead and the ruin, but also in the idea of how life begins in and alters a place through time. So the project has been continuous. It started in the winter of 2004, and it has been shot continuously with those thirty or forty abandoned structures almost weekly throughout all the seasons. Every time I go out there I take anywhere between fifteen and twenty photographs, and I now have about 250 images from the project. I use a 4 × 5 large-format camera because I need that kind of resolution to document them. And it was really amazing—after the second year I began to see the changes I wasn't able to detect earlier. Normally I would go out there once a week, so the change would be so subtle. I tried to be very scientific, keeping my tripod at the same height, using the same lens with the focus on the same depth. What really interested me was that aside from serving as a metaphorical way of looking at the landscape, these greenhouses represented something that was vanishing from the landscape. It's not just about an art project for me; it's about a scientific project. There's something in my background that keeps me intrigued by the nineteenth-century obsessiveness with specimens, and the desire to document things. It also goes back to work I did at Giverny in Monet's garden.

SDB: The *East of Eden* compositions are staged but there's also a voyeuristic quality to them. And now you've come to an actual garden in *The Garden* series, and it becomes the focus. Is this perspective or fixation rooted in your *East of Eden*?

PND: Absolutely. I see them as two projects that are completely parallel to each other. As you say, one is the absence of the figure, and the other is about the figure. And I think it's kind of strange because in *East of Eden*, although it's about the figure, it's always in reference to landscape. Whereas in *The Garden*, it's about the environment and the landscape; however, this always implies the human presence. What I think is more apparent about the current body of work with the abandoned greenhouse is the implied presence of the photographer. I go out to the garden—to these greenhouses—in the winter when things aren't growing, when it's all dead, and there's a kind of sensibility I try to distill from that, and try to inject it into the *East of Eden* work. And when I go there in the summer, and it's lush and full of life in these abandoned settings, there's a particular sensibility that I try to work through with my figurative work. When I go to the garden I get the chance to observe my work. In a way, I'm watching the objects that I'm trying to translate into figurative works.

SDB: Now after two years of production on both series, you are considering bringing the two gardens together.

PND: Yes, and it starts with bringing the image of one of my sons into the greenhouse. One of my sons is on the mountain facing the fire in *East of Eden*, and so I wanted to place my other son in this abandoned Eden—a garden that's about to grow and about to die. But I'm not so sure when will be the appropriate time.

SDB: *The Garden* is tied to the laboratory specimens of Monet's garden and your field work as a Vietnamese "scientist." This garden is an interior space—it's a greenhouse, a series of greenhouses abandoned and left to decay. And ironically there is more naturalism, more realism in these cultivated spaces than the whole of *East of Eden*.

PND: You're right in your observations. In *East of Eden* the figures are central, and the landscape serves as a backdrop. And when I go to the greenhouses I feel like I'm a landscape photographer, even though the landscape is all contained within these decaying structures. It's very much about the exterior space for me—almost like having my studio outside. In a way, the two series are the reverse of each other.

SDB: You present the different times of day, seasons, and weather conditions. Are you consciously trying to create a range of physical states in the series?

PND: Yes, I am trying to create as much of a range as possible—for the viewer to see both the changes and the process. There's the process of an individual simply observing, and one who is recording, and I hope the two work together. When I began working on the project, the changes in the landscape were very subtle, and only well into the project did I begin to see the changes.

SDB: Will *The Garden* continue to evolve, or does it end with the introduction of the figure?

PND: I don't feel like it's time to finish it up yet because it's still changing. It's that obsessive-compulsive nature and the need to see more. One thing that connects my work is this idea of the epic, which deals with duration and commitment. I'm inspired by people like Kurosawa who always feel that sense of epic. I've been working on this a lot and so obsessively, but there's still much I have yet to discover. I haven't gotten *that one* yet. I don't think it's going to be *that one*, but it's more like a lot of them that can make up the particular body of work I'm thinking about.

SDB: I want to talk about your role as a teacher, and what aspects of your work you want to get across to your students.

PND: I don't have a specific vision for my students. The students here have such rich and engaging visions. But what I've really tried to do is help them understand the commitment to sustaining the profound idea, so that it's not only about the sentence they write, but about a paragraph, a document communicating this concept. And for me, it's about the absolute perfection of achieving the image as a painting itself. If there's something slightly wrong with an image, a detail, it needs to go back and be reworked. The photograph is rarely finished on the first take; it serves as a base and after that you come back to refine it and refine it until it achieves its own life. It's not until you realize that you didn't do that work, and it's just beyond you—that's when it actually works, when it breathes and has its own life, and exists independently of your authorship. In a way, I have a very selfish reason to work with these students because I want them to be my colleagues, and reach the place where we can get excited about our lives, by what we do, how we create, what we make.

SDB: Do you think it's necessary to be exposing them to your own work?

PND: Absolutely not. I try to avoid it, though it's really difficult because I work alongside my students so much. They see my work, but I don't think they try to get their own sensibility from it. I think they do get the obsessive nature of the way I work. They see me leaving at four o'clock in the morning. They know they can always call me, they know that I'm excited when I look at their work or when they have questions. I don't really have a strategy for teaching because I am a student myself. Teaching is really an extension of my studio, and I can't separate the two. I can't see the line between my studio and my classroom.

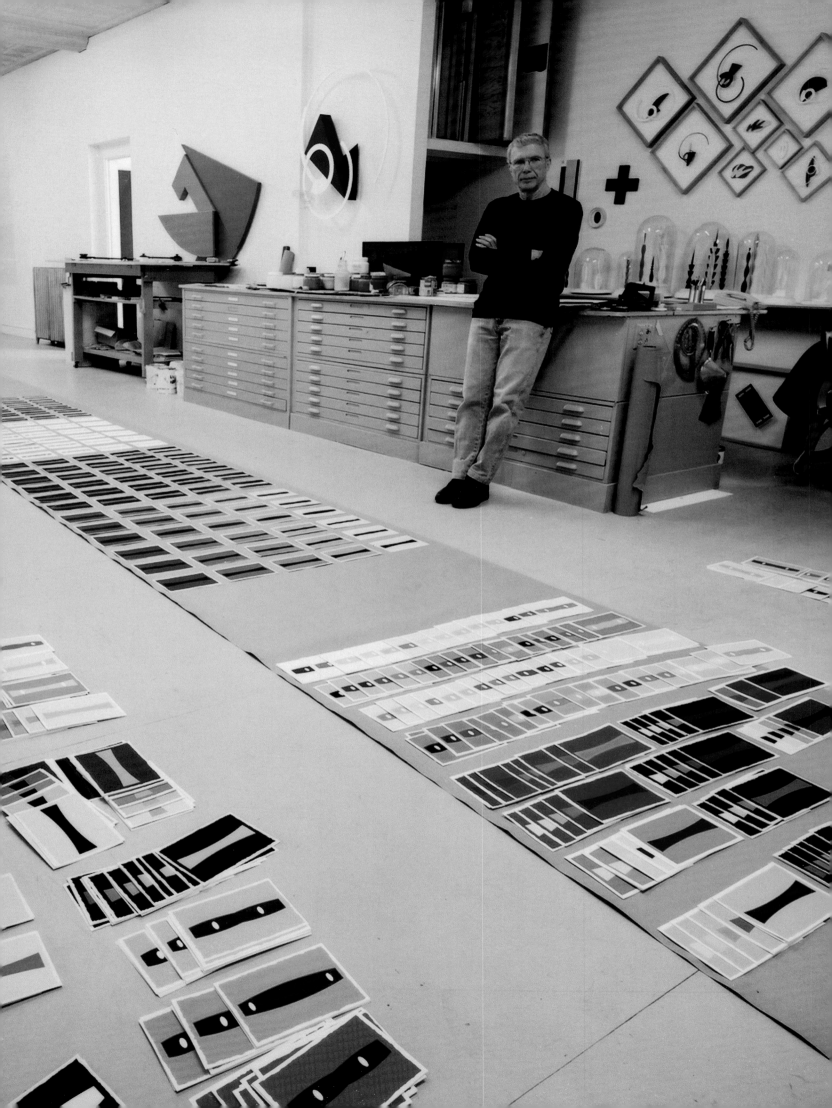

JOHN PEARSON

(B. 1940, BOROUGHBRIDGE, ENGLAND)

John Pearson uses visual experience to access what is intangible and universal about the human condition. His transcendental outlook places him somewhere outside the art historical categories traditionally assigned to his generation, namely Minimalism and Conceptual art. The deconstructive projects, political themes, and identity politics that occupied artists in the last quarter of the twentieth century have had little effect on his work. Shrugging off the developments in the visual arts most often termed "Postmodern," Pearson stands firmly invested in the aesthetics and ideology of Modernism. That is, he attempts to express his personal relationship to the world—both spiritual and physical—using the systematic analysis of natural structures. However, unlike many of his systematic and conceptual contemporaries, Pearson has retained the expressive craftsmanship of a modern painter, and is intimately involved with the creation of beautiful objects.

Pearson was born in 1940 in the small town of Boroughbridge in North Yorkshire, England. In 1960, he relocated to London to enroll in the Royal Academy Schools. There he worked alongside David Hockney, with whom he shared a fascination with the retinal experience of color and surface. A well-received exhibition at the Institute of Contemporary Art in London led to a research fellowship at the Akademie der Bildenden Kunst in Munich, and after a period of travel through Europe he moved to the United States in 1964. He earned his M.F.A. in 1965 from Northern Illinois University, and from 1966 to 1968 he held a teaching position at the University of New Mexico. In 1968 Pearson left the United States for the Nova Scotia College of Art and Design in Halifax. In his capacity as the head of the painting department from 1968 to 1970, he contributed to the institution's construction of a more theoretical program of study, which would earn it a reputation as one of the most progressive schools in Canada and

Fig. 50 [detail, facing]. JOHN PEARSON,
Oberlin, Ohio, May 2005. Photograph by John Seyfried.

as a widely recognized center for Conceptual art. After a residency at the Cleveland Institute of Art from 1970 to 1972, he came to Oberlin College, where he has taught since 1972.

Pearson's artistic sensibility reflects his early years in the North Country of England and his sensitivity to the lyric potential of nature: the cyclical rhythms of rural life persist throughout his work. At the Royal Academy in London, he was heavily influenced by the Abstract Expressionist tradition, and was concerned primarily with the expressive nature of color up until 1977, drawing inspiration from the works of, among others, Mark Rothko and Piet Mondrian. A fascination with science and mathematics as a means of understanding the spiritual universe led him to experiment with complex mathematical systems that determined the formal qualities of his paintings. Grappling with the revelations of Heisenbergian quantum theory, he explored serial processes not unlike those employed by twentieth-century composers such as Iannis Xenakis. Using "open systems," which provided a mathematical framework but allowed for deviations resulting from the participation of the artist, he began to employ silkscreen printing in the 1970s as a method for applying pigment efficiently to large canvases (see fig. 52). Such work summoned the beauty of mathematical truth in nature, recalling both the intricate formal qualities of a Pollock painting and the compulsive order of Mondrian.

Travel has always been an integral part of Pearson's process. An initial interest in Zen Buddhism led him to Japan in the 1990s, where he would eventually find himself more aligned with Shintoism. Although his direct involvement with Eastern religions has been somewhat arbitrary and spasmodic, his artistic development over the past fifteen years is marked by a simplification of form whose roots lie in Zen and Shinto foundations. The cut reliefs of *Japan Passage* (2000; see fig. 54), reflect his interest in twentieth-century formal constructs as expressed by the Bauhaus, De Stijl, and later painters like Frank Stella. His work in the last five years has continued his interest in nature's balance of infinity and uniqueness. Extending from his earlier serial works, *Yorkshire Series: Regeneration-Continuum: AMAM Series* (2005; see figs. 24, 55), Pearson's latest silkscreen-print series, made for *Trace Elements*, comprises 150 prints each hand-printed by the artist. While these sets are geometric and utilize mathematical sequences, they retain the evidence of the artist's enduring concern with craftsmanship and its power to serve poetic expression. [AG]

Fig. 51. JOHN PEARSON, Oberlin, Ohio, May 2005. Photograph by John Seyfried.

I'll start with the obvious. The most obvious thing about my work is that it fits very neatly into what I would regard as a Modernist as opposed to a Postmodernist tradition. I'm not comfortable with the labels that get placed on the various movements, their growths, and the pendulum swings of fashion within the art world. I wasn't comfortable with the idea of the term "Modernism," and I'm certainly not comfortable with the term "Postmodernism," because it's very hard to pin down. But one aspect of Modernism that was a theme for the artists that I was particularly interested in—the De Stijl group, the artists that were around the Bauhaus, the Russian Constructivists, and also certain works that go back as far as early Renaissance painting—is the idea of the spirit; how elusive that is. The essence of spirituality that is projected from that work and that which was ultimately distilled, refined, and projected by Mondrian, is the core, the root of where I come from, and that's what my work grows out of. So I see my work and my attitude positioned within that Modernist tradition, and the aspect of that tradition I see being very closely linked to is this idea of addressing the intangible. The intangible being referred to by such terms as "the spiritual" and "presence," which was the kind of term that was used for Rothko—and elusive presence that's there but not there. There's something there but you can't pin it down. I'm very much interested in those aspects of the human condition that are universal, that everybody feels. We all feel kinship with certain things. We feel kinship, we fall in love, we have children, and we have certain attachments. There are emotional attachments to those kinds of circumstances that don't have an image. It's not something that one could point to, like a tree or a landscape. But when one looks at the landscape, the things that make it beautiful, the things that make it compelling and attractive to look at, are the same things that are compelling and attractive within a work of art. They are intangible, they are indefinable. The atmosphere seems right, the light seems right, the time feels right, one's mood is correct, and so on. —John Pearson

Stephen D. Borys: Your work fits very neatly into what you see as "a Modernist as opposed to a Postmodernist tradition." You've also managed to steer away from labels, but you acknowledge the influence of De Stijl, the Bauhaus, and the Constructivists in your work. Is there a lineage in your artistic production and thinking?

John Pearson: Well, because I'm totally absorbed with art, I'm constantly going to galleries and museums, and I used to look at all the magazines. I don't read the art magazines anymore—there's just too many fancy theories and words, and they use incredible words and lengthy sentences to say the simplest of things. Leonardo da Vinci once said if you can't communicate simply then it's not worth communicating. So I quit reading. Instead I expose myself to a tremendous number of images. I travel a lot, and whenever I travel I go to museums. I'm fascinated by art from all periods of time, and art from all over the world. I tend not to think about, and I don't know when I was last influenced directly by, somebody's work or ideas. I get excited by too many things. You mentioned earlier Damien Hirst: I've been a huge supporter of Hirst. I just love his work. There is a general assumption in the art world that if you work in a particular way, that's the kind of art you must be interested in. That isn't true. The Sienese and Florentine painters of the Renaissance were incredibly influential for me in terms of the kind of austere silence they managed to project. There's a beautiful Piero della Francesca in Munich, a tiny painting that has incredible power, but which is extremely silent. I tend to let the artwork speak for itself. I look at somebody's work for a long time before I read about it. I don't want to know what the artist is doing, or what people have to say about it—I want my own take on it. Sometimes I'm off-the-wall, and not really there in terms of where they're coming from. But I read the work the way it impacts me; you can tell, my house is full of all kinds of stuff.

SDB: Beyond those early Modernist roots, what happened in the 1960s when you were in London, and then after with your move to the United States?

JP: The people I hung out with in London were all the Pop artists—David Hockney, Alan Jones, Dick Smith, Joe Tilson, and people like that. They were my cronies. I was fascinated by the painting

Fig. 52. JOHN PEARSON, *Mondrian Area Series: CM: W*, 1977. Oil inks on acrylic ground on canvas, 84 × 84 in. Allen Memorial Art Museum, Oberlin College, Ohio. Gift of Jane N. Nord, 2004.14.

of Morris Louis and Kenneth Noland, and I was influenced by the Impressionist paintings I saw there. Interestingly enough, the artist who was slowest to come to me was Seurat. You would think that because of the way I work, that I would have really gotten him, but I found his work really stiff and often heavy-handed. I do like the scintillating quality of his work, especially with his drawings—the docks and ports with ships and villages by the water. When I was in London I was also introduced to the monumental scale of American painting, and that was fantastic. Even though I'd been used to seeing huge paintings by Rubens and the Old Masters, there was such a power in the necessity of this scale, because they were pure abstract paintings. I also remember encountering the first Jasper Johns—an all-gray painting with three rectangles that had been cut in it.

SDB: Linking all of these personalities and images—from the Renaissance painters to Damien Hirst—it seems to come down to something as simple as forms, especially when you get beyond the spiritual and the intellectual. Your work is almost a hybrid response to these, or maybe a distillation of the forms and ideas.

JP: There is a distillation. I'm constantly looking for a purity of form, a simplicity of statement, and I spend a long time thinking visually. That means doodling: doing little drawings, and diagrams, and trying things and testing things, and not thinking intellectually about it. I can be inspired by a bird's egg, or a flower, or just the way the clouds are formed. Something will catch my eye and make me travel somewhat. The impact I always want is that sense of silence, and that sense of presence. But no, you're right, I really do like to play around with formal elements. Some of my students have called me a dirty formalist. I can grasp a painting or a sculpture, in terms of its formal language, immediately. And the things that always catch my attention are things that I can't figure out. It took me a while to come to Duchamp once he became "Duchamp" and got away from Cubism and Futurism and things of that nature. When he got to the idea of the ready-mades, I mean, it threw me for a loop, and it took me a long time to understand it because it's not formal, it's not about form. A lot of his things are very beautiful, but they're not about form. And like Fluxus, I mean, Fluxus is a total enigma to me: I find it very hard to understand. I enjoy it, but I can't quite grasp it because I can't come to it formally. So yes, I am very much involved with the idea of formal construction and the formal language.

SDB: When you say that nature repeats itself over and over, but in a unique way every time, are you looking at all of these different images and artistic forces, or are you taking them all separately?

JP: What I'm working with right now is the whole idea of metamorphosis. Nature is all about systems, or we can analyze it in terms of how it's structured in terms of systems. The stages of growth, or stages of change that things go through, have fascinated me. I'm interested in taking a simple form, and then seeing what you can do with it. Think about Islamic patterning—it stems from the radius of a circle, and it becomes infinite in its possibilities of pattern. To me that's just a mirror or an echo of the way nature functions.

SDB: When you get into these systems or multiples based on one form, are you still interested in reconciling the essence of each work, engaging in each component of the whole?

JP: Well, this is where I had a big issue with Sol LeWitt. Sol and I were friends for a while, and I invited him to Halifax when I was at Nova Scotia College of Art and Design (NSCAD), and later I invited him to Cleveland. He basically says the idea is the art. It's the idea of system that is the art, and it doesn't really matter how it turns out. My question was, "Then why bother making it in the first place?" For me that's a mental exercise. Frankly, I think he really does care about the way something looks. An important part of setting parameters is that you know that setting parameters is going to work aesthetically or formally, or it's going to have that kind of character and presence. Interestingly enough, the reason I like LeWitt's work has nothing to do with his ideas. I love the ideas of the grids and the layering of the grids. When I first got to know him he was already doing drawings, and I found them very beautiful. It was the same with Joe Kosuth, and his idea about art as idea. Their work is just as traditional as any other kind of work, and it's going to survive because it has a visual impact, not an intellectual impact. It must have both!

SDB: But Sol LeWitt is coming into his work the same way you have approached some of your work.

JP: Yes, when I look at the work—I just bought a copy of his retrospective catalogue—it was interesting to see the early, clumsy beginnings of his sculpture. They were like mine, or rather we were on parallel paths. I made these sculptures that didn't work: they were stemming from trying to combine painting and sculpture, and make the painting ideas structural. He was a sculptor who moved toward flatness, but the very early things, when he's working with these cubes with stripes on them, I was doing the same thing in the early 1960s. And it was fascinating for me to kind of discover those things of Sol's. If he had his way, he'd probably get rid of it. Well, I did, and I destroyed them all.

SDB: Then there is someone like Allan McCollum, but there appears to be more of a divergence here.

JP: I like McCollum's work because it has a similarity to the things that I've done, or that I do. That's why I've identified with him. I can imagine when people see my pieces in the museum, they're going to say "You must be influenced by McCollum," but I was dealing with systems long before McCollum. In 1961 I was making panels that rotated, and that was because of the influence of Stella—not so much because he was using panels that moved, but that he took one idea and did variations on it. I tell my students that we can work in certain ways because artists have shown us the way or given us the license to do it. They've given us permission. We can make paintings that repeat images over and over again because Warhol said it's okay to do that. You can make optical paintings like Bridget Reilly. They've shown us a way of thinking, of visual thinking. Carl Andre put it best when he said that when you live in the shadow of artists, you're going to be affected by them. And they're affected by you.

SDB: Perhaps what separates you from some of these personalities is that you are still physically and intimately involved with every stage of the production of your work regardless of the size or scale.

JP: Yes, each piece that I do, each one of those drawings that I do, I'm ruminating. I'll go through a whole series, because I develop a sequence. I'm a painter at heart. I still need that direct, tactile sense. I could have had somebody else print all those pieces that I've just printed, but somehow doing them myself, as I'm doing them, mistakes happen. Strange things happen. I'll print something upside-down, or I'll print wrong colors, or it bleeds. Sometimes they're better than what I'd planned or I'm excited because there's a mistake.

SDB: How did you come about screen-printing right onto the canvas?

JP: I got that from Warhol. There's another aspect of taking from other artists and influencing one another. I saw Warhol's work in London and I thought that was an interesting idea. I never really considered using it myself until I started to create layers of grids. I wanted

to layer the grids in such a way that each successive layer affected the color underneath so it was like optical mixture. It took a long time for me to refine the width of the line, and the density of the color, and the surface area. It was like doing a lot of visual research and a lot of drawing on canvas. I was in Nova Scotia at that time, and there was a printmaker there whom I was talking to about the tedious side of this production, and he suggested I try silkscreen, so I taught myself how to use silkscreen. Initially it was just awful and I hated it: I couldn't control it, it was insensitive, it didn't do what I wanted and I almost gave it up. But when I came to Cleveland, I went to Advanced Process and Supply (because Oberlin asked me to teach silkscreening) and worked there for a couple of weekends, and they showed me technically how to do everything. Then I figured out how to make the inks chemically bond with acrylic, and it became very quick and efficient. I could do a very large painting, a 10-foot square painting, in a day that looked like it would have taken two years to make. I did some huge pieces, including one work in Cleveland that was actually 17 by 55 feet, in six panels. That was my opus—that was it, and I'm over with that set of ideas (see fig. 52).

SDB: Looking at the 150-print series for the museum show, *Yorkshire Series: Regeneration-Continuum*, I immediately thought about Gary Kennedy's work, especially his palette. What was your relationship like with Kennedy when you were both at NSCAD?

JP: Gary Kennedy was my boss. He was president of NSCAD when I was there, and he hired me to come up and develop their painting program. He had been there two years, put up a new building, and he hired a whole bunch of new design people from Toronto and Montréal, and I was being kicked out of the States. So I just wrote to the eleven places I knew in Canada to see if there was anything. Less than a week after I sent my letter to Nova Scotia I got a phone call from Kennedy saying, this is what we're doing up here, it's a new school, we're trying to start something, and I'd like you to come up and head up our painting program.

SDB: NSCAD became a leader in Conceptual art.

JP: Yes, and that's why I left: it became a "Conceptual academy" within two years. I don't like academies—they reduce vision and risk-taking. Among the many visiting artists I invited up there were Kosuth, LeWitt, Andre, and Weiner. Joseph Beuys had never been to North America, and he wouldn't go to the United States because of Vietnam,

but we got him to come to Nova Scotia with Jan Dibbets. It was a very exciting, very dynamic time, but I was being drawn more and more away from the studio. Gary Kennedy loved it, because he was a Duchamp person, and so he grasped it all. Andre and LeWitt I understood, while I didn't totally grasp what Kosuth and Weiner were doing, conceptually, but they offered a fresh approach to art and extended Duchamp's ideas. I embraced them very early, as I did Hirst. After two years I was tired of saying, "Painting is not dead, and the reason you're saying it's dead is because you don't realize that it is really one of the biggest challenges." There's no way painting is going to die.

SDB: Have you ever had any desire to pursue large installations *in situ*, but not on the canvas?

JP: No. When I do something, I do it . . . I'm a painter, I put it on canvas. And in a way, it's because I want to do the work. When I did these huge paintings, 140 feet long, and 14 feet high, and they were these incredibly complex paintings, I did them myself. And I did them in a very short time. I couldn't see hiring out because I'm never happy with what anybody else does with my work.

SDB: Was there a silkscreen program when you came to Oberlin?

JP: They didn't have any silkscreening. What happened is that Paul Arnold and Forbes Whiteside were going on sabbatical in consecutive years, so it gave them an opportunity to hire somebody for a two-year period. I was already in Cleveland, and they asked me to come down and teach a drawing course. Then they asked if I would take this position to teach painting one year, and silkscreen the following year. That's when I came in and set up very rudimentary silkscreen and photo silkscreen facilities. After that, they asked me to stay. I developed the silkscreen program, and also later introduced photography and a new media program. Over the years, I've taught everything but sculpture in formal classes, although I've taught it on an individual basis.

SDB: In recent years you made the decision to not teach a painting course except for when you instruct students individually.

JP: When I taught painting, a lot of really exciting things happened. But I don't teach painting anymore because it's too demanding—it requires too much of the students that they're not prepared to give. With silkscreen, there's an intermediary process: they can see it, they can get results fairly quickly, and then they can play with those results. And I can deal with ideas much more rapidly, whereas with

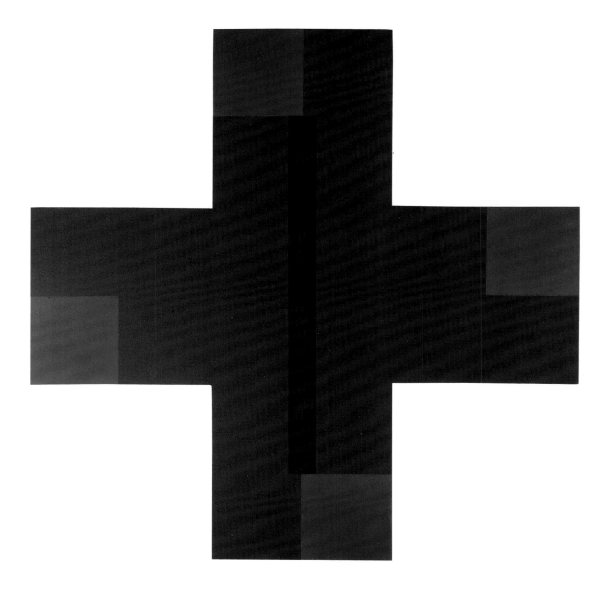

painting it's a much slower process. They get bogged down in the technical side, and they're not prepared to learn some of the rudimentary things they need to know. I used to enjoy teaching painting. I did a program in Nova Scotia, one in New Mexico, and I revitalized the painting program for the Art Institute in Cleveland. Students should also have the space where if they feel like doing a painting that's 12 feet long they should be able to do that. This is hardly possible here because of cramped space. Not teaching painting has nothing to do with painting per se, it's just the circumstances here at Oberlin.

SDB: You've also worked a lot with wood, especially natural wood and grains, a tradition that is closely linked to Japan.

JP: There are so many things about Japan that fascinate me, and one of them is its art's use of natural materials, their use of bamboo, of wood. I got back from one trip and wanted to make some pieces that echoed the kinds of experiences that I'd had, and I bought all kinds of different paint, some of them children's paint, some with glitter, and I was mixing that with acrylics and trying to get very exotic surfaces, like the surfaces I experienced in Japan. I made quite a few pieces, two that I thought were successful, and I showed them once and then buried them, put them away, and won't let anybody see them. Then I started to play with different surfaces, with no concrete shapes, and the old shapes didn't seem to apply anymore. I wanted

Fig. 53 [above]. **JOHN PEARSON**, *Shinto Series: X #2*, 1996. Acrylic on birch, 14$^1/_2$ × 14$^1/_2$ × 1 in. Collection of Audra Skuodas.

to make some relief pieces, which is what I had been making before I went to Japan. I had these pieces of plywood lying around, birch plywood, and thinking about Japan, and thinking why am I looking at this plywood, why don't I find some other material? And for the first time I became aware of the incredible beauty of the grain of the wood, which is what I'd seen in Japan. So I basically just cut out these pieces of wood into the shape of the grain, and I realized that the grain is a product of the way the wood grows, a product of two things—time and growth. The grain became another metaphor for me. This led me into an incredibly renewed energy—taking that metaphor and playing with it as an idea. Then by incising shapes into the wood, I was able to further evoke my experiences in Japan. The idea of the raindrop shape came from the fact that it does rain a lot there, and candles are everywhere, which led to my introducing the flame as both an incised shape or a freestanding shape.

SDB: Do you see these works more as paintings, or as sculptures?

JP: I just see them as objects. The things I'm working on are in-between, if one is using those traditional definitions. Sculpture for me is something that exists in the round, that you walk around, and it has a different appearance from various points of view. It surprises you; it grows as you move around it. It's not static. I did a lot of sculpture in the round, but these pieces are on the wall; they're relief. They have physical form and I tend to think of them as objects.

SDB: Some of your richest spiritual and metaphysical experiences have taken place in Japan. I'm interested in what the country has offered you—given you—in terms of the people, the culture, and the landscape. You always seem ready to go back.

JP: One of the reasons that I went to Japan initially was because of my interest in Zen Buddhism—the way I thought and felt seemed related to what I understood Zen to be about. Mondrian was very interested in Zen. The kind of work that I identify with has a sort of transcendental character to it. I went to all the wonderful shrines and temples. This was about ten years ago. I found them beautiful, but it was like I was expecting to experience something transcendental when I came to these shrines and gardens, and it didn't happen at all. They looked interesting, but what I discovered was Shinto. I liked the belief that everything has a spirit, a presence. Everything is interrelated. It was practical. There's the belief that everything has a place, and it has a function, and it has its dignity. It is an incredible way of re-specting life. When I consider my work, I like to think that everything that I put in it has meaning. There is nothing arbitrary. Anything arbitrary has got to be removed. They say that mathematicians know when they've got it wrong because the theory is not beautiful, it's not symmetrical. In a way I think the same. I know that I haven't arrived when it still doesn't hit me right, there's something out of place. At a certain point it is all intuitive.

There are two things about Japan that I find fascinating and that I think relate to my own personality. One is, the Japanese have the capacity to communicate so much beauty and silence and presence with the most simple of means. So they're extremely reductive in their building methods, at a very refined level. In their arts, there is a dignity that I really identify with. There is also a silence within that dignity, and there are many things that revolve around that. It is all about discipline, presence, and understanding, awareness of other people, and not being deferential to others. There is the capacity for extreme tranquility there, and I find that compelling. But there's the flip side. Because of this discipline and restraint, and the way they function in everything, many other aspects of the human condition just burst forth in the most incredibly bizarre and strange ways. The Japanese create the best science fiction movies and science fiction toys. They have the weirdest sexual situations. Their bars, and their karaoke: the environment is full of this bizarre, quirky, crazy quality. These two extremes. I'm kind of like that myself. There's something about my nature that coincides with things that I identify with in Japan. It's not just the art and the landscape, it's also that spectrum.

SDB: You have compared the natural landscape of Japan, especially the coastline, to your native Yorkshire in England.

JP: When I'm in Japan, I don't understand the language—everything is totally alien. Except the landscape is not so alien. The coastline is not so different from the Yorkshire coastline that I grew up with. But Yorkshire doesn't have volcanoes. It has mountains. It doesn't have the charred black, or the lush, rich subtropical vegetation. So there are incredible contrasts there. These tortured, black, charred volcanic coastlines—in places it's black as soot—and then you look beyond the coastline and everything is rich, green, verdant, and full of life. There is this residue of a particular kind of activity: volcanic activity has its own life, it lives and dies, and there is nothing more fertile than volcanic soil. I like the fact that I can be by myself with

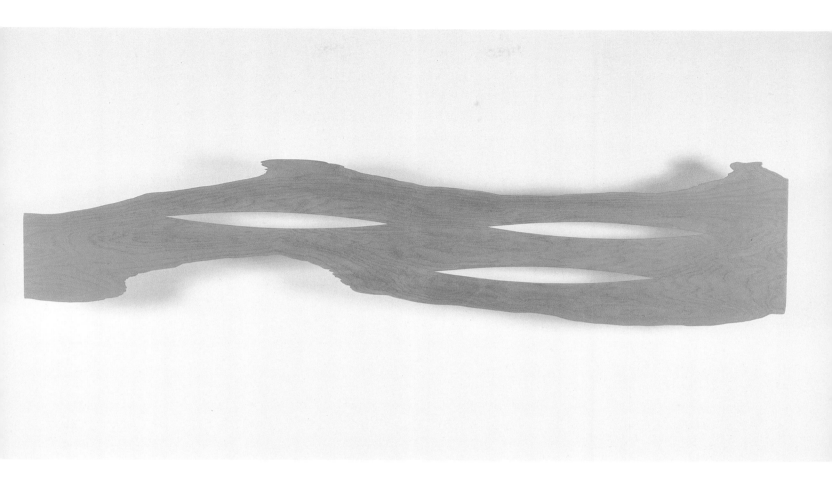

the landscape. I go to remote places where very few people hike, and this allows me to get into myself.

SDB: Nature and its rhythms are a constant in your work.

JP: Growing up in a tiny farming village surrounded by farmers, the whole rhythm of life was determined by the rhythm of nature. So, the four seasons, the time of day, morning, night, the sequence of events is determined by a system that is in a rhythm. That was a powerful driving force in the work that I started to think about—how to capture that sense of rhythm, repetition. Nature repeats itself over and over again, but it repeats itself in very unique ways. Every time a child is born it's unique. It's a unique experience. One doesn't just say, "oh, another baby"—there's something magical about that whole idea of life continuing in these strange and miraculous ways. That's what interests me—much more than issues that are political that come and go. I'd like to uplift somebody's spirit, and I don't want to

illuminate a narrow slice of life, although some artists do that very effectively. And that doesn't mean I don't respect that position in other artists. But I am personally more interested in something that's much more timeless and universal, like gravity. Gravity is always there. We're always aware of the fragility of life and the continuation of life.

SDB: In nature there is also the matter of regeneration, renewal, and constant change, which clearly plays out in your work.

JP: I often thought about that—life continuing, and the energy of it continuing. A few years ago when I went back to England to see my parents, I visited a small antiquarian bookshop and came across a book on North Country flowers and plants, probably early twentieth century, so all the reproductions were hand drawn. There were drawings of the wildflowers, and there were drawings of the stems and stamens and pistils, and then there were small drawings of seeds and seedpods. Seeds facilitate life's regeneration. Thus I saw the idea of

Fig. 54 (Cat. No. 19) [above]. **JOHN PEARSON**, *Japan Passage: Fuji #2: Silence*, 2000. Polyurethane, acrylic, and glitter on birch, 84 × 22 × 6 in. Courtesy of the artist and Meli Solomon Fine Arts.

Fig. 55 (Cat. No. 22) [facing and above]. JOHN PEARSON,
*Yorkshire Series: Regeneration-Continuum: AMAM Series: 150,
Panels A–K* (detail), 2005. Panels A, C, G, and J. Silkscreen inks
and pencil on paper, each 7³/₄ × 5¹/₄ in. Courtesy of the artist.

a seed, the form of a seed, became the metaphor for the continuation of life. I came back to the studio and started drawing flowers and seedpods. And out of that came these simple shapes, and, again taking my cue from Mondrian, I realized that I didn't need to start with the actual seeds and pods: I could make my own. At a certain point I don't even think about it, I just start playing with the shapes and the forms, and I become excited about it formally, start trying to make poetry with these images I've created.

SDB: You've talked before about two particular events during your time in Japan that became two of the most transcendental experiences in your life.

JP: People talk about metaphysical states and higher states of consciousness and I don't know exactly what they mean by that. But there were these two experiences that I had in two locations—one on the top of Mount Fuji and the other on the island of Sado. I went up Mount Fuji in the late evening and most people go in the early morning so nobody was there. I had the whole cone of Fuji to myself. It was bitterly cold up there—you're at a very high elevation and there's a lot of wind. The only respite from the wind is to go down into the cone, which sounds dangerous, but it's not. It's like walking into a little valley—wind doesn't get there. Everything inside the cone is warm, but it's not because it's a volcano; it's because the sun can warm it up and the wind doesn't cool it off. So you can lie on rocks and get warm again. But it was very cold, almost too cold to take photographs. I could hardly move my hands. I felt so connected, like everything was extremely real. Everything was tangible. Emotions were tangible; there are no words to describe the feeling. The other experience was on a remote part of the island of Sado off the west coast. There was a fine drizzle, not rain, which put moisture on everything. And I came upon these village shrines that people had built, and there was this grotto by a little stream. It was totally silent except for the gurgling of a stream and these sea kites, fisher hawks that make these strange wailing shrieks. And there was another bird making this haunting sound, almost like it was asking you to leave. Just these three sounds, and all in this late afternoon so it wasn't bright light, and this mist and haze that covered everything with water droplets. Everything was so alive, and yet there were these stone Buddhas in this shrine. I was

there for about two hours, and every time I tried to leave I couldn't. It was like I was transfixed, and it was a very deep emotional state of being absolutely aware of everything. Those are the things that fascinate me about Japan, and I keep wanting to go back because I want to encounter those kinds of experiences again. But I don't think one finds them; I think they just happen.

SDB: Have you produced much work in Japan?

JP: I don't do much work there; I take a lot of slides. I think about a lot of things, and make notes and little sketches, but I don't actually make much work. I'm just renewing myself, and when I come back I just explode into work. But being there is like I'm living that Modernist tradition—my Modernist roots as an artist.

SDB: I want to end with something we touched on last time. You were talking about parameters and the necessity of setting limits to keep everything manageable in your art-making. For you it becomes a discipline. Then I think about the hundreds of prints you are creating for the museum series—as of now you've made over 1700 and are contemplating several thousand more. How does this all fit into your philosophy of art-making, and the idea of boundaries and expansion?

JP: It's like everything, it comes in waves. It's like the tide coming in and going out. I really didn't think ten thousand prints. When I got started I was thinking a hundred pieces. And as I began working, my mind took over. I'm not sure about the process yet. Basically I wanted to reveal this idea of metamorphosis, transformation, growth, change, and it seemed like 100 was a large number. Once I started playing with the options, I worked through the calculations and was already up to 10,000. On a previous major project, I was going to make 100 unique shapes, which also dealt with the idea of transformation. I got to about 40 shapes and thought, this is getting tough—I'm never going to get to 100. But by the time I got to 100, I could see it was going to be endless. And before I was done, before I knew what had happened, I had made 1250 unique shapes, and that was just the tip of the iceberg. Initially it seemed impossible. The only thing that's changed in the most recent piece is I started with three shapes and it grew so that now I've got twelve shapes, and a seemingly infinite range of colors. And the color allows me to create poetic transcendent moods.

Fig. 56 (Cat. No. 20) [facing]. JOHN PEARSON, *Yorkshire Series: HH 1/3; 2/3; 3/3*, 2003. Acrylic on birch, 3 panels, each 96 × 15 × 5 1/8 in. Courtesy of the artist and Meli Solomon Fine Arts.

SARAH SCHUSTER

(B. 1957, BOSTON, MASSACHUSETTS)

Born and raised in Boston, Massachusetts, Sarah Schuster attended Boston University as an undergraduate, where she received a classical training heavily weighted on figure drawing and painting, as well as rigorous technical instruction in traditional media. With little institutional exposure to contemporary art, Schuster found her greatest inspiration in the collections at the Museum of Fine Arts, Boston, and at the Gardner Museum, studying paintings by Titian, El Greco, and other European masters. Though she struggled with the figure as an undergraduate, it has remained her primary subject throughout her career. Moving from self-portraiture to what the artist calls "psychological portraiture and narrative," and eventually to the nude, her work is meditatively introspective, a membrane between the mind and the external world that manifests itself in the human figure as well as in nature.

Schuster's passion for the history of Western art and her knowledge of traditional painting techniques infuse her work with a sense of nostalgia. This purposeful fusion of contemporary ideas with traditional techniques enforces the art historical references with which her work is constantly in dialogue. She states that the content of her work —desire, longing, and creation—is constant, even as the apparent subject may change. These states of being are all involved with human activity and human relationships, but, most important, they have become essential to her art-making process.

Schuster began teaching at Oberlin College in 1988, at which point she encountered a group of women who would profoundly change her outlook and artistic direction. At a particularly vital time for feminist theory in art history, she found an entirely new perspective in the writings and research of her Oberlin colleagues Pat Mathews

Fig. 57 [detail, facing]. SARAH SCHUSTER, Oberlin, Ohio, May 2005. Photograph by John Seyfried.

and Athena Tacha. Schuster became particularly preoccupied with the historical meaning of the representation of the female nude, an inquiry that prompted her deeper examination of painterly representation on the whole. In the end, she embraced the genre as a way of utilizing her formal training while exploring the artistic possibilities of rendering desire and longing. Her most recent figurative style represents a solution to her perception of the tradition of violently appropriating the female form in the singular perspective of the masculine gaze (see fig. 9). Using the vocabulary of Hindu figurative sculpture, Schuster exhibits multiple points of view in sinuous, spiraling forms oriented on an invisible axis, masculine and feminine parts intertwined.

In her most recent body of work, the artist explores her concern with nature in compositions that arise from patterns that had previously served as grounds for her figure pairs. She indicates the human order imposed on nature in her consistent employment of decorative painting techniques, such as stamping and stenciling. In her newest works exhibited in *Trace Elements*, *Replicants* (2005; see figs. 10, 59, 61) and *Cultivations* (2005; see figs. 11, 60, 62), the contrast between synthetic order and natural occurrence is embodied in her highly crafted, yet ambiguous, objects. Images of deep-sea creatures taken from a science book and roses from Pierre-Joseph Redouté's botanical prints are transferred to block-sized gessoed panels and fin-ished with a palette resembling stone, minerals, crushed petals, and pollen. Schuster combines Renaissance painting techniques with contemporary reproductive processes like tracing and printing, deliberately employing a time- and labor-intensive process in quiet artistic remonstration against what has become an all-consuming period in time and living.

Presented with the tracings, carbon paper, pencil drawings, and printed images that inspired and spawned the artist's labored craftsmanship, alongside the finished panels of otherworldly creatures and the familiar rose, the viewer is exposed to the process of finding, transferring, and reconfiguring life and reproduction. One also becomes aware of the artist's desire to distance herself from the act of creation, naturally and artistically. This art is more about tending to, acknowledging the evolution of form, organism, and species, but also maintaining a distance through the reworking of an image detached from its original, life-giving source. Schuster sees this part of her art-making as a kind of anonymity. Instead of creating a personal mark or leaving a signature, she cultivates an image, and turns the act of representation into an act of devotion that seeks to preserve the very sanctity of the natural world. The intentional and masterful confusion of painting and craft echoes her existence in a world that has allowed for the dissolution of the confines of the self. [AG]

Fig. 58. SARAH SCHUSTER,
Oberlin, Ohio, May 2005.
Photograph by John Seyfried.

I'm constantly aware that anything you do to a painting is present to the bitter end. That, on some level, nothing disappears. I love that about painting, the mapping of how your mind works, and that there's a little trace element of it in everything you do. I've been thinking about that ever since you asked me, "Why painting?" I thought about the time that it requires to paint an image, and what the connection is between time and representational art, and what does it mean to be a representational artist? They say with Olympic runners that they can have the thought of running it a second faster, but then there's the reality of doing it a second faster. They've found that if a person can imagine—get a picture in their mind—doing it a second faster, they're able to make it happen. Painting is unique because it's a membrane between what is intellectual or imagined and that which is actual. Out of all the methods of image-making, it plays a really unique role because it hovers the most between those two. It sits on the surface of the actual rather than underneath it. Instead of a video image or a photographic image, which are behind the surface, there is the physical stuff of paint sitting on the object, which is the painting. And that object has these unique attributes: it can be illusionistic, and it can pull that image through the object into the realm of the imagination and also pull the image up to the surface of the painted object. This process is really important to me, in terms of how it all fits with representation. What is it about representation? Why does someone take something like a rose and then make a painting of that rose? I think that's where the process comes in. The thing that is being meditated upon or actualized is, for me, the process itself. The process is one of tenderness, or attending to. So that attending to, or tending to, the image is what the painting is about. And that's what I'm trying to bring into being, or to bring attention to at some level. —Sarah Schuster

Stephen D. Borys: I want to start by talking about your studies at Boston University, a traditional training in studio art that was very much based on the figure.

Sarah Schuster: Boston University was an unusually traditional school that prided itself on keeping figurative representational painting alive at a time when it wasn't popular. It was a very specific kind of figurative painting that grew out of European Expressionism. While most people of my generation had very little figure painting—their formal training was usually in Abstract Expressionism and maybe color theory—mine was drawing from the model, painting from the model, sculpting from the model, taking anatomy, all of those very conventional things. We didn't set up the model, the teachers did, and I don't think we were allowed to work from the figure much in our first year. Primarily we worked from cones, spheres, and cubes—really basic ideas about light, cast shadows, things like that. And only after that did we begin working from the figure. The first experience I always had was to fall in love with the model. A teacher I studied with in graduate school, Gretna Campbell, once said to me, "Students always love the thing they paint." I think that's really true. And you can imagine the wide range of creatures, people, that you get to paint in a city school, but I attended carefully to whatever body came in; it became a subject for admiration. At that stage, I didn't have very many preconceptions about it; I just loved the history of painting that I was being introduced to and the challenge of the task. It was difficult, and I wasn't a particularly gifted or facile artist. So it sort of surprised me later in life that, because of my training, and because of the way I struggled with it, people sometimes thought of me as being kind of virtuosic, but I never was that way by nature. There were always the kids in the class that were wonderfully gifted, and everything came to them easily. But I loved the struggle, the chasing after something that was impossible to grasp.

SDB: With the figure, representation was big for you, and has continued to be a primary force in your work.

SS: I think without knowing it those were always important to me on some level. I went to graduate school at Yale, directly out of undergraduate school, which was not a very good thing for me. I'd never

had a studio by myself, and I never had my own agenda. I hadn't really seen much abstract painting and other kinds of work—painted sculpture, things that challenged the picture plane, and all that stuff—and suddenly I got to graduate school and loved everything I saw but had no context for looking at it. I had no idea why I was doing what I was doing. I continued to do every kind of work imaginable, took a year off from school, and then returned to working from the figure because it grounded me. I was very interested in Matisse and Picasso and Cubism, which was about as modern as I could get at that point. I do remember that color was always really important to me.

I wasn't really taught what the context was for Abstract Expressionism or Minimalism. I was told sort of vaguely by my teachers that first you learned how to draw from the figure, and when you could do that well it would evolve into other things. For one thing, this isn't necessarily true. You didn't have to learn to do perceptual work before "evolving." You could actually be a Conceptual artist from the very beginning. I don't even think I was aware of Conceptual art at the time, and I hadn't studied any contemporary art history up to that point. So the education I ultimately received about drawing from the figure was drawing perceptually—where you were making illusionistic spaces and so on—and it did not necessarily prepare me for how to evaluate quality in terms of the work that my peers were doing. I remember one of the pieces I loved was a white-on-white painting, white squares that were barely perceptible against the gallery walls. John Gasper, a graduate student, did it, and it was totally magical to me. I might have loved it more than a still life, but I would never have known how to proceed to make that kind of painting. It would have been too great a leap from my artistic foundation.

Boston was a rather conservative community, and when it did show contemporary art, it was a very moderate kind. The Museum of Fine Arts didn't even have a contemporary exhibition gallery when I was growing up and going to school. I ended up spending a lot of time at the Gardner Museum, the Fogg, and the Museum of Fine Arts—places that had wonderful collections that went up to the early twentieth century, but not much beyond 1950. Philip Guston was teaching at Boston University, and he was probably the most significant contemporary—at the time—influence on my work. By the time I came under his spell he was making paintings with recognizable images referencing Krazy Kat cartoons and the black humor of Franz Kafka.

SDB: You said that the canvas was always the best way to work things out for you, but you have also moved on to, or at least considered, other surfaces.

SS: When I was young, I couldn't stand the hardness. If the surface didn't give a little bit, it felt like I was working on metal, and I hated that. As I've gotten older, I've grown to prefer the resistance, the tightness of a very hard, slick surface against the paintbrush. So I don't know, I guess it just evolves and depends what you're doing, and the kind of thing you like. I still love both of them.

SDB: The technical nature in your current work reflects a wide range and understanding in art-making techniques and methods. Was technique important in your early painting, and have you tried to maintain this connection to the physical side of your production?

SS: I was one of the students who was actually bored with techniques class when I took it, disinterested. I did it like I did a math class. I did well because I was a good student, but in an obligatory way. I never really gave technique much thought and was rather careless about it at the outset. But the more interested I became in color, the more necessary it became to be aware of technique, and this changed things for me. I began to think of what kinds of grounds would allow the color to stay on the surface and be more vibrant, what kinds of paints would give me more vibrant color, what kinds of medium would do that for you, and so on. This all became more and more important in my work. And the older I get, the more obsessed I get with it. The process is important, and I think the further the world seemed to get away from the art of painting, the more I appreciated it. For a while there was a big push toward bad painting, and it was all the rage to do painting that really did look like bad painting. I remember thinking I didn't want to do that.

SDB: The idea of process and layers seems to fit nicely into your idea of representational painting, especially when you consider the object and its place on the surface of the canvas.

SS: Painting representationally is a fascinating thing to decide to do. It's a really weird thing and it gets weirder every year with technology, photography, and all the other options. Why would one do it? What is it that painting does that other things don't do? I like to think about that. You have an object out in the world, and there's a tension between what we see and what we know, and whether we know it first and then see it, or whether we see it first and then know it. Then we decide to make a picture of it, which is a negotiation between you and

the world you live in. Painting maps that negotiation, and then when the painting is complete and seen by another person the image is negotiated again with reproduction on top. It's an amazing process. I mean, why do we represent something? We've had this obsession, especially in the West. What is it—the idea of representing the world around us? What is so important about it? I think it's as close as you can come to knowing without being.

SDB: Your perspective as an artist and as a woman is crucial to this process, but at the same time you are constantly engaging the viewer, and considering elements and emotions outside of your experience.

SS: I guess one of the problems I had with some Postmodern criticism is the idea that you can never know something from another person's point of view. Obviously, I can never speak for another person, but I wouldn't be a painter if I didn't think I could be empathetic to another situation. Part of the mapping is about that empathetic process. Again, it's about desire, and my concept of desire is not just about sexual desire; it's also about creative desire. Like the way in which the Greeks talk about Eros, that idea of love, greater love, of longing to be outside oneself. Longing to be with something else. Perhaps the mapping is the map of the dance that we do in trying to find ourselves in relation to the world around us. And that's what knowing that thing is, or representing that thing is—it's not picturing it. It's not saying this image is real, or this looks like that thing. That can be part of it, but the thing that interests me in painting is that it's not only the image, but it's that tracing of the process of finding oneself in relation to it.

SDB: In your current body of work included in *Trace Elements— Replicants* and *Cultivations*—the physical act of painting has been checked or at least restrained when compared to earlier pieces.

SS: When I feel like I'm limited by the series I'll add something else to them. So far, I don't feel that way. I take things away and I add something, and then I may change it again. But for these works, I was interested in exploring what it means to map a reproduced image. How does one come to know that thing through the image itself? Does it mean I don't know that deep-sea fish because I've never seen it before and probably will never see or touch it? I know my relationship to that creature would change if I dove down and faced it head on, or touched it with my hands. But I can't say I have no relationship to it now that I've danced this dance with its reproduction. And what is the meaning of that? What is the reality of that fish that I've come to know through that image?

SDB: What are the sources for these painted panels?

SS: I love that period of the 1800s when people were illustrating the natural world—the plant and animal kingdoms, insects, shells. I think of the time and the care of representing each detail for the sake of distinguishing species. They're very stark images, and in a way so unnatural, and yet so realistic. That dilemma continues to move me. I'm always looking for books with this type of imagery; I always look at the nature sections in bookstores, and at the Audubon books. Sometimes I look at children's coloring books that have reproductions of wildflowers in them, or instructions on how to draw spiders. One day I was looking through a book and saw the white-on-black sea creature illustrations and was struck by how they were such a clear picture of the deep sea. These figures creating their own light far beneath the water—it was an inversion of what we usually expect in a rendered image, and in life. The deep-sea fish are so bizarre-looking, and what fascinates me is the fact that they're the origin of the world according to one theory, and that they're fish, they're monsters with their teeth, and their openings, and their orifices. They're so dark that they can't be lit. The light of day can't even hit them, which is a great metaphor for the most ancient parts of our psyches.

SDB: How did you arrive at gessoed panels as the ground for these series?

SS: I've been using the panels for a long time. When you sand gesso, the panel actually feels like a baby's bottom, silky and soft, like skin. It's also slightly porous, so the paint is embedded as well as sitting on the surface. Even when you try to finish the surface it doesn't sit just on the top, it sinks in a bit. I think in terms of color, so it's like creating a world through which the images float or exist. The image becomes part of the support. Painting on these gessoed panels allows me to compress the Renaissance methods with contemporary processes. It seems revolutionary in the quietest way imaginable, to use such a time-intensive process, and it mocks all the expectations placed on me by this particular historical moment I'm living in.

SDB: The images of the roses are taken from Redouté's botanical prints, but did you look at the different species in the flesh?

SS: I've seen roses, but I haven't seen those actual roses or those actual drawings. And I could have applied for grants to go see Redouté's drawings but didn't. I decided not to because I really had no

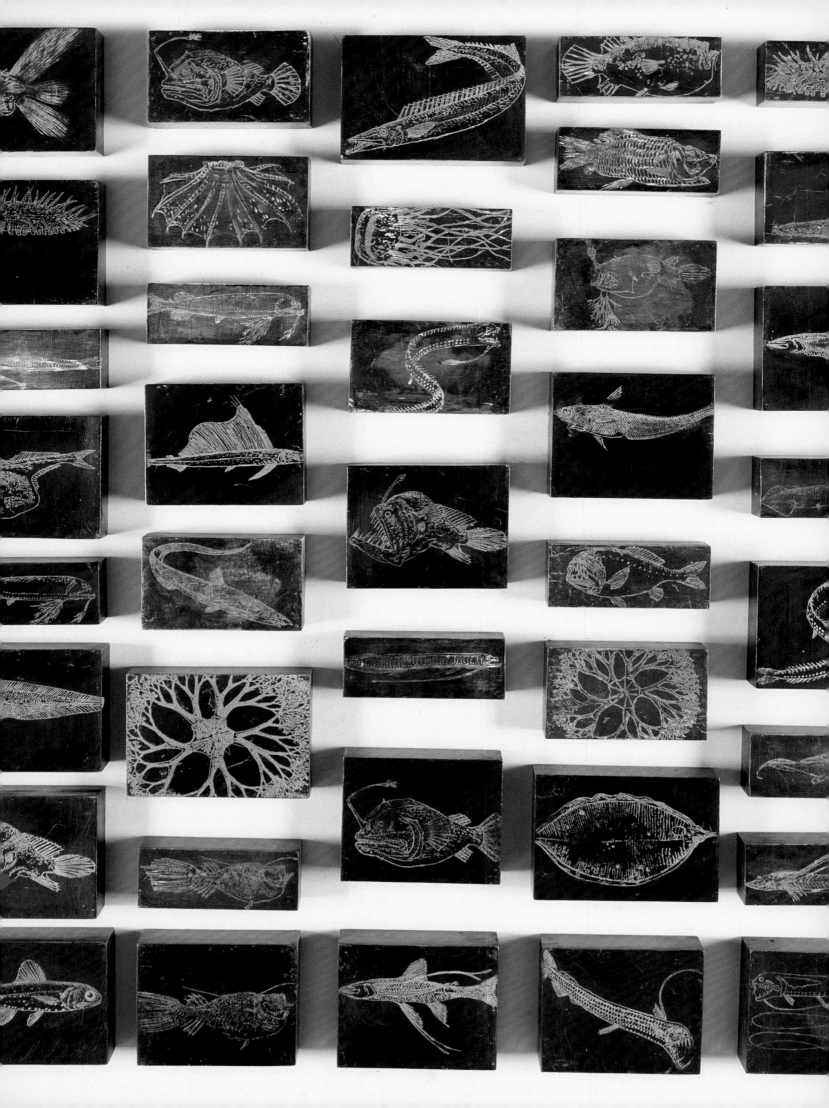

desire to see the real drawings in this process. I wanted only to know them as these postcards, and come to know them through the process of painting them. In a way, I wanted to continue to compare my experience of painting directly from the postcard to what it would be like to paint from the actual rose.

SDB: How do you feel about exhibiting the tracings, carbon paper, the pencil drawings, and the actual postcards of these roses, along with the finished painted panels?

SS: I think it should all be exhibited—it's all about my process. I was also thinking about why the process is so important to me. I use images and figures in my work, and because of my interest in representation, these are the things that I often talk about rather than the process. But the process of making blocks is very much about tending to something. It's not about identifying my mark on the world—there's a kind of anonymity to this process. There is something about trying to distance myself from the creation. It's not the grand gesture, not the great signature, not the big personality. Using the model of a garden and gardener, I am growing an image. This intention turns the act of representing nature into an act of devotion and defends against a taste for the possession of nature that image-making can also excite.

SDB: When I first saw *Replicants* and *Cultivations*, I had little idea as to how you actually made them or any sense of the process involved.

SS: I think process is mysterious, but I don't have a need to make a mystery out of my process. In fact, one of the things I enjoy about painting is that you can put all of your cards on the table and still no one else can do the same thing, usually. I started doing all of this work fully intending to put figures and images on top of them, until the day you came to my studio and you said that I was on to something, even without them. To me, they were totally about sex, and I was going to superimpose images of a sexual nature on top of them. Whether they were little vignettes, or little body parts, or they were figures, I didn't know. Athena Tacha once told me that I was going to get to a point where what I was doing underneath the figures was what the paintings were all about. And when you came in and said that, I thought, It's so funny, I spend so much time on this part of the painting, what am I doing? I must be crazy.

SDB: Do you still see these works as complete, as finished, even without the presence of the human figure superimposed?

SS: I never see anything as complete and I see everything in the studio as interrelated. I would have no problem if you installed them in the gallery and asked me to draw some of those double figures on the wall above them—I could do it. It's all interconnected to me as the artist.

SDB: I want to return to our discussion about the figure and the nature of portraiture in your painting. You talked about a psychological narrative and a psychological self-portraiture. Did you move from portraiture to self-examination or the other way around?

SS: I moved from self-portraiture to portraiture. Working on life-sized portraits of friends and acquaintances became a way to bring the two sides together. One of the few female painters I knew was Alice Neel, and by combining some of the things I had loved about Matisse with what I loved about her work, it allowed me to have some fun with my painting and move out of some of the tradition I'd been steeped in. And this enabled me to move a little closer to my own vision. All my work has to do with self-investigation of some sort. And I don't mean autobiographical, but it's all an inward journey of some kind or other. My husband, Greg Little, said to me once that you're always painting yourself into your painting and then painting yourself out of your painting. I have to agree.

SDB: You have singled out three male artists—Matisse, Picasso, and previously Courbet—as influential painters of the female nude. Are you interested in addressing their particular representation, or are you reacting in terms of the way you deal with the female nude?

SS: I have always been drawn toward the genre of the female nude from Giorgione up to the present, and if I had all the time in the world I'd probably still be painting copies of every great painting by every painter I can think of, male and female. I don't mind art about art, and the nude is a subject about art. I don't think you can choose the nude as your subject matter and not have your work be about the history of the nude. In graduate school, we were educated to think that Picasso and Matisse were the true, great forefathers of the tradition we were being trained in, and that it was going to take at least a hundred years for us to know what the outgrowth of their influence truly was. And the great dilemma was whether they could be brought together, since one was about color and idealization, and the other was about narrative and drawing. How could you have a painter be about both things? The affinity I felt for Courbet's work was of a different sort and sidled by an equally fervent affinity for the painter Frida Kahlo. They offered up to me an alternative way of dealing with

Fig. 59 (Cat. No. 24) [detail, facing]. SARAH SCHUSTER, *Replicants*, 2005. Oil and carbon transfer on birch panel, 125 panels (approx.), $2 \times 2 \times 1^{1}/_{2}$ in. to $4 \times 5^{1}/_{2} \times 1^{1}/_{2}$ in. (varied). Courtesy of the artist.

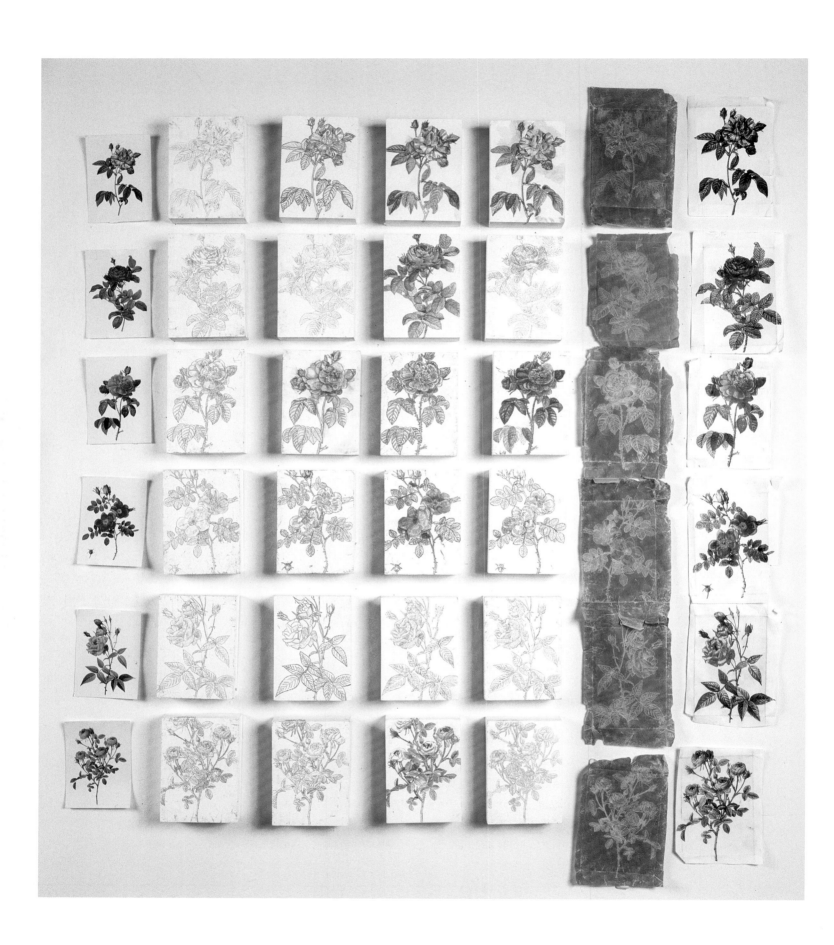

Fig. 60 (Cat. Nos. 25, 25a–c). SARAH SCHUSTER, *Cultivations*,
2005. Oil and carbon transfer on birch panel, 24 panels, each 7 × 5 × 1¹/₂ in.;
red transfer paper, 7¹/₂ × 6 in. to 10 × 6 in. (varied); xerox copy, 7¹/₂ × 6 in.
to 10 × 6 in. (varied); museum postcards, 6 × 4 in. Courtesy of the artist.

the female body and the female nude. The body could contain something and not simply be a surface.

SDB: What about Courbet and his women—what attracted you to these nudes?

SS: I was drawn to the moistness, and the fact that his figures had body hair. They had things that were usually removed from most of the idealized painted images of woman that I had seen. They felt real to me. I understand the critiques about the way Courbet's paintings objectify women, but they were a source of great inspiration and passion for me. They are absolutely beautiful, sensuous, sexy paintings. He's also a really tough painter, and seeing the Brooklyn Museum show in the 1980s just made me appreciate him even more. The painting of the two women on the banks of the Seine is an extraordinary work, and it's such a bizarre composition. They're lying down, but there's something very strange about their proportions. Nothing actually works, and it still seems like the most perfect painting in the world to me. Manet is a lot like that, too.

SDB: When you came to Oberlin and met different professors and artists, it led to a shift in your painting, a shift toward female sexuality and something you've referred to as the female gaze over the male gaze.

SS: I guess I want to be cautious here, because it wasn't my goal to divide things into male and female gaze or male and female sexuality—that's probably too simplistic. I've come to think of sexuality as circular, and that we're all on a continuum. Imagine a circle that contains male and female, and that some women have more male and less female, and some women have more female and less male, and some men the same thing, and so on. What I would say is that I was interested in painting the female body intermingled with her masculine attributes, full of her own erotic, or, better still, generative energy and presence. You know, not waiting for permission to be energized; not seeking acknowledgment from some outside source, male, female, whatever.

SDB: Can you talk about the nude and the viewer, and how the gaze plays into this relationship?

SS: I have tried to convey my experience of being in my body in relation to the world. I close the eyes of my figures so that they're not open to the viewer, but then I am cautious that the figures don't look like they are being peered at. I also give them multiple limbs and feet,

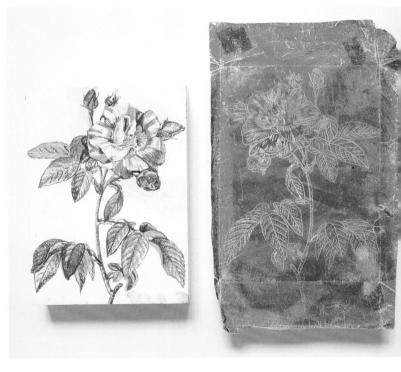

Fig. 61 (Cat. No. 24) [top]. SARAH SCHUSTER, *Replicants* (detail), 2005. Oil and carbon transfer on birch panel, 3 × 4 × 1¹/₂ in. Courtesy of the artist.

Fig. 62 (Cat. Nos. 25, 25a) [bottom]. SARAH SCHUSTER, *Cultivations* (detail), 2005. Oil and carbon transfer on birch panel, 7 × 5 × 1¹/₂ in.; red transfer paper, 7¹/₂ × 6 in. to 10 × 6 in. (varied). Courtesy of the artist.

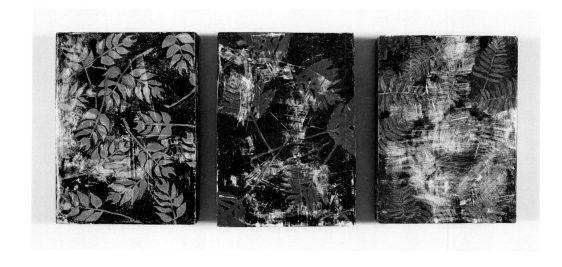

whereas in many paintings, like Courbet's *The Origin of the World*, the limbs are cut off, the head is cut off, and the woman has no agency to get up and get out of the picture. I also studied Indian figurative sculpture, and I went to Khajuraho, where the temples are covered with what we call erotic sculpture, but they are actually tantric positions and postures. I have used this twisting, serpentine line to manipulate my figures since it gives the bodies a more sensuous feeling while allowing you to look at them from different points of view. Picasso's *Les Demoiselles d'Avignon* is another painting I have studied and admired, but I was trying not to do that violence to the form. I also worked to make the one body into two. My intention is to envision the masculine and feminine parts of the self trying to create or give birth to a fuller self.

SDB: You've said that moving the figure outside and into the landscape involves mythology, but also has to do with implanting the landscape with a sexual charge. Did you have a specific landscape in mind when you began this process?

SS: I've always had in my head something represented by Courbet—not a deep primeval forest, but a young wooded area, tangled and mossy and damp, not easy to get into or out of, like a thicket, and in the process of decay. The kind of thing that if you were to lie down on that moss it would feel really good, but you'd have a weird feeling that you didn't know if you were giving yourself over to worms and decay. I also think about playing with the connection between desire and death, and our own human impulses and their connection to our own mortality. My life is about creativity, and my work is about creation, and the taking of the figures outside is about that as well—that kind of mythology. This is not just the creation of a self, or the copulation and birth of creatures, but the creation of the universe, or the emergence of life—the making of a painting. I see creation and desire as very interchangeable, and as essential to painting—well, to making of any kind.

SDB: You became obsessed with how to put the body into nature, and it's at this point that you began working with layers of materials and impressions in your painting, and introducing stamps, leaves, stenciling, tracing, and the figure drawn over the paint. The Greek-styled *Origin of the Species* in *Trace Elements* is one example of the presence of patterns and lines making up the layers of the painting and intersecting with the human form.

SS: I spent a whole summer looking at Greek vases and finding a way of painting surfaces that would feel like the surface of pottery. I found a cold-wax medium that can give the paintings the sheen of a Greek vase. I wanted to take my non-Classical nudes and place them in this Classical context. I looked for ways to contrast methods, styles, and images that bring order to nature against those that evoke or portray the primal urges, which threaten the order we establish. The layering you mentioned allows me to integrate disparate elements within the painting—order/disorder, self/other, nature/culture, the body/the land. I am not specifically after the properties of flesh. I am specifically interested in paint because of its close relationship to flesh, to skin, to pigment.

SDB: How much of this history of painting, this collection of images and myths and truths, are you able to convey to your students?

SS: What our studio program aims to do is teach our students to think visually. I'm not sure that this has had a profound effect on everybody, but that is exactly what I want to do, and that fits my personality. I have a restless mind, and I don't separate thinking from the work I make or from the process of making art. And I love everything about making art—art history, technique and method, the materials and various media, the subjects and the genre. It's not limited to the practice of painting for me. What I have found and come to value about teaching at Oberlin is contextualizing what I do, embedding the practice of art in the context of ideas. With the help of my colleagues, I teach my students to think rigorously about art-making, where these forms came from, and where these artists fit in historically. For instance, I like to teach about the idea of the sublime and its origins. I can't get to the bottom of it, but I can talk about how it has evolved, and how it developed with Abstract Expressionism, and what happens to it with Postmodernism. If I can train my students to be educated viewers, whether they become artists or not, I feel that I've accomplished something.

Fig. 63 (Cat. No. 26) [facing top]. **SARAH SCHUSTER**, *Undergrowth*, 2005. Xeroxed collage on wood panel; oil on canvas (diptych), 96 × 120 in. Courtesy of the artist.

Fig. 64 [facing bottom]. **SARAH SCHUSTER**, *Excavations: Three Ferns*, 2005. Oil with cold wax medium on birch panel, 3 panels, each 6³/₄ × 5 × 1¹/₄ in. Courtesy of the artist.

NANETTE

YANNUZZI-MACIAS

(B. 1957, EL PASO, TEXAS)

Concerned with identifying and illustrating the fluidity and contiguity of identity and experience, Nanette Yannuzzi-Macias's work hinges on the problems and possibilities of framing elapsed time and its content. Her art investigates the specific and unique machinations of a particular female body as it changes through time—as she puts it, the "personal and political archaeology of identity and feminism." Born in El Paso, Texas, in 1957 to an Italian-and-Mexican-American family of seven and raised in a mid-Atlantic suburb, locating cultural identity became a predominant force in Yannuzzi-Macias's formation as an artist. She today finds her work in the specific attention and focus on the moment as a means of navigating the difficult terrain between privacy and professionalism, words and actions, the personal and the public.

Yannuzzi-Macias's work has evolved over time. Her early work of the 1990s consisted of analytical installations in which the art was easily identifiable as the finished product. *Clomid and Pergonal* (1990) was the result of the artist's fascination with the intersection of human life and scientific inquiry, with the proto–sci-fi of the nineteenth century like Mary Shelley's *Frankenstein*, and with the artist's own then-nascent inquiry into female productivity and creativity. A 9-by-10-foot metal-and-Plexiglas-paneled cross was used as a physical matrix for information, and each panel could be lifted to reveal diagrams of the female body, statistics on organ donation, or even a taped conversation between a doctor and his nurses about golf held across an operating table. As a young artist then living in New York and working through the Whitney Museum's Independent Study Program, Yannuzzi-Macias channeled her artistic energy to the studio and her art product, focused on professional output.

Fig. 65 [detail, facing]. NANETTE YANNUZZI-MACIAS, Oberlin, Ohio, May 2005. Photograph by John Seyfried.

This interest in energy and creative production has become the precise site of the artist's investigations over the past decade. In 1993, Yannuzzi-Macias moved to Oberlin, Ohio, and became Associate Professor of Art at Oberlin College. Life as artist, teacher, and, by then, mother accentuated her ongoing projects, well evidenced in her 1997 installation *Scales*, a collaboration with artist Melissa Smedley, in which the gallery was suspended with objects stabilized only by their counterweights located somewhere else within the space (see fig. 69). Having experienced the ultimate productivity of the female body, Yannuzzi-Macias's artistic attention shifted largely away from analysis and representation to become more fully invested in process, surveillance, and the collection of information in an expanded artistic field.

Since 1997, Yannuzzi-Macias has been working on gathering the intimate details of daily life as artist and mother. Though related in focus to artists like Mary Kelly, she refuses to confine her artistic framing of life to a specific fetishization of ritual. Repeated performance is clearly important to Yannuzzi-Macias; however, she acknowledges the falsity of prescribed boundary and of artificial organization, like Kelly's near-scientific chronological *Post-Partum Document* (1973–79). Yannuzzi-Macias seeks not to critique domesticity, but to understand it through the accretion of its artifact. Time is a key element in the artist's work, both in its gestation and its expression. Her series *Action: Collections* from 1994 to the present is the artist's attempt to document her life through alternative, unedited means: collecting her own dryer lint, her son's nail clippings, audio feed from a recorder worn at her waist as she went about her work over the course of a month (*Audio Days*, 1998), video feed collected over three months from two stationary cameras positioned within her home (*Video Days*, 2000; see fig. 14). The latter is incorporated in her new works for *Trace Elements*, *The Hours* and *Piano with Scenes from Life* (2005). Time and experience in Yannuzzi-Macias's art are understandable only in each and every choate artifact, the personal, evocative, and intimate evidence of life.

The installation and manifestation of such inquiries also serve to foster precisely the sort of calm, reflective environment necessary for the viewer to be able to focus on themes in her work. Yannuzzi-Macias points to the writing of Thich Nhat Hanh, whose work she discovered in graduate school, as a particular complement and source of information for her work. His teachings of the unity of private and public domain, and of the location of truth in the process of discovery speak precisely to Yannuzzi-Macias's personal artistic projects with their far-reaching implications. [s n]

Fig. 66. NANETTE YANNUZZI-MACIAS,
Oberlin, Ohio, May 2005. Photograph by John Seyfried.

My work has been involved in issues of the female body, identity, reproduction, and agency for a very long time. These interests came out of my experience of being a woman in this particular culture and the way I understood and was impacted, both physically and emotionally, by those experiences. From a very young age I was conscious of being identified as female by the outside world. The issue of gender and the conversations around this subject are multifaceted and complex. For the past twenty years I've been paying a lot of attention to them and they have evolved considerably, but there was a point in time at which the rhetoric around those ideas prevented us from going deeper into important questions of identity politics. We were relying too heavily on the acceptable way in which we talked about certain things, instead of questioning those assumptions and allowing that questioning to sit there for a while and be looked at and thought about and not just assumed. I feel the very same way about issues of race. One's identity is complex, and there are so many points at which it changes and becomes influenced by other aspects of who we are. I listen very hard for the places in between what someone is saying because it's so easy to rely on language to describe something that is much more complex than we're giving it credit for. Angela Davis was in Oberlin not long ago, and she gave a very inspiring lecture. Afterwards I thought, this is a woman who has lived a life steeped in the complexity of these issues. There is so much wisdom and so much depth in what she's saying and how she is saying it. She understands the connections between things, and the places in which things fall apart and are not so clear. —Nanette Yannuzzi-Macias

Stephen D. Borys: Your work is closely fused with the female identity—can you talk a little about the roots of this preoccupation in your art?

Nanette Yannuzzi-Macias: I have to talk about the work and the life at the same time, because they're part of the same process. I'll start with life, because that's where I usually start. I grew up in a family of three brothers until my sister was born when I was almost ten. I was the only girl in the family for all of that time, and being "the only girl" was very much a part of my identity within the family. Because of this, I became very conscious of the way I experienced the world and how that was different from my brothers' experience of it. I observed them experiencing the world as boys. This difference was something I was conscious of from a very young age. That consciousness seeped into my life and was reinforced through my involvement with the church. I was raised in a very religious family—we went to church every Sunday and every religious holiday, and catechism after mass on Sundays. Since we didn't go to a Catholic school, my parents wanted to make sure we were well versed in the doctrine of Catholicism, so catechism was a necessity. At that time in my life I was immersed in the culture of the church, and although the message they were sending young women was clear, I was confused about how all of that connected with the spirit of Christ and his teachings, and of course I was very resistant to being shaped by it.

These experiences fueled who I was becoming; they became both something challenging to me and something I didn't quite understand, but I was also very taken by the ritual and icons of the church. I was trying to figure out where all these messages were coming from—the role of the Madonna, virginity, and one's relationship to one's husband.

During the late 1960s and 1970s there was a lot happening in the women's movement, and some of it managed to trickle into suburbia. I don't have many specific memories about the women's movement, and most of what I experienced was through my mother. Being very close to her and tied into her identity, I became aware of her struggles as she moved through the world. She wasn't going to demonstrations or things like that; she was involved as a woman who was

working very hard in all of her relationships to identify who she was. My mother is very beautiful and as a young woman she was incredibly beautiful, and I remember walking with her in public and men coming up to her and saying things to her. I was a rather shy child, and most children who are shy are usually sensitive to their environment, and this really impressed me. I guess it was the first time I saw my mother as a woman and not just as my mother.

Abortion was also a very big issue at the time and I was definitely aware of it. I remember the first Neilsson photographs of a fetus in-utero, which I believe were featured in *Time* magazine. Being Catholic and the mother of five children, my mother could not reconcile this issue of choice, and she was very vocal about her opposition to it, and yet I did not see it that way.

SDB: Was your father present throughout?

NYM: He was present, but he worked a lot. He traveled a lot, too. My father was trained as an engineer. Like my mother, he came from a poor family, though his was an inner-city kind of poor. From him I learned that anything was possible and that one person could make a difference. I also learned a lot by watching him constantly tinker. He insisted on fixing everything in our house himself—and still does. He maintained and repaired all of our cars, built an addition onto our house, finished our basement, and kept a garden. At his day job he worked as a civilian for the Navy at an outpost in suburban Philadelphia. He was a brilliant project engineer and took a lot of pride in his work and the success of many of the research projects he headed. He is also, and always has been, a conservative Republican. My father came from a very patriarchal Italian American culture and I found myself more often than not in disagreement with his conservative perspectives. Although we have a wonderful relationship now, in those days we were at odds with each other's ideas, and of course this was inflamed by the process of asserting my own identity as a woman.

SDB: How do you think your cultural identity changed growing up in the suburbs of Pennsylvania?

NYM: I was born in El Paso and we moved when I was young. So from a very young age, identity was many things to me. It had to be. There I was in this German, Irish, and Polish neighborhood in Bucks County, Pennsylvania, and yet intimately connected to two vastly different cultures—Mexican American and southern Italian. It was clear to me that I was different from the people I was growing up around, and although it wasn't so much a physical difference, I knew that my

experiences of life included many things that theirs did not. I have this vivid memory of a summer afternoon after my mother made some tortillas—which she didn't do often so it was a real treat—some of our neighbors stopped by and she gave them a tortilla. They had never seen or heard of them so they joked about them for a while then decided the best way to eat them was with peanut butter and jelly. I was highly insulted, and it confirmed everything I felt about living there: they simply had no clue how to respect difference. At the same time I was confused because there were very conflicting messages about culture and identity coming from within my own home. My mother's first language was Spanish. And as many people did at that period of time, she and my father had decided the best thing to do for their children was to help us be as American as possible, to embrace everything American. There was confusion about who we were. Although as a child I couldn't really articulate it, *I felt* all of the conflict and confusion about the adults not being clear about what it meant to them.

SDB: In embracing an American culture, you ended up losing things. Did you sense this loss when you were growing up?

NYM: Yes, without question, but I didn't know how to articulate it. I felt the loss of language the most profoundly as I matured. Actually, it was a decision both my parents made, but she was the one who carried language. My mother's father once said to her, and she later relayed this to me, that we (meaning his grandchildren) were losing our history. My grandfather understood the consequences of this, and that their decision not to pass on the language of her culture to all of us would cause us to be disconnected from our history. That's what I mean when I say we lost many things. We are connected through our personal lives to our own history and to the world around us. That's the violence of the American dream: we have successfully cut those identities and left people in situations in which those identities are not there—and they're incredibly necessary.

SDB: Your art is very personal, physical, inflective, and at the same time you're dealing with major issues as well: universal concerns including female agency, gender, and race. Is there any need to reconcile or move between those two forces, or do they manage to coexist in your work?

NYM: I don't feel like I've gone from one to the other, but, rather, that one leads me to the other and back again. In a certain sense you can't separate them. If you're a conscious being, you're attentive to the world around you. The combination of the personal and political

Fig. 67 [facing]. MELISSA SMEDLEY (American, b. 1960) and NANETTE YANNUZZI-MACIAS, *Animal, Vegetable, Mineral: Comida para su Sombrero*, 1994. Mixed media installation, 30 × 30 × 10 ft. (approx.). Courtesy of the artists.

led me to the work I do, and at any particular moment in time that combination will lead me to the next work, and the next work. There is no reconciliation needed because I don't see them as opposing.

SDB: There was a shift to a more personalized, introspective art-making when you moved to Oberlin in 1993, and with this came your pregnancy. You talk about it changing everything in your experience.

NYM: It was a major shift in my life and in my work. And, yes, definitely, my work responded to the intensity of the place I'd found myself in. I didn't expect the transition to living in the Midwest to be so difficult, and I didn't expect to be so personally impacted by giving birth to our son. At times I tend to go through life in this very analytical way. I clearly understood that having a child would change my life in significant ways, but the experience of this was another thing altogether. I was not a very young person when our son was born, and I'd already had a very full life. Giving birth was a turning point in the work and in my life, and I sort of immersed myself in it because I saw that it was an unexpected yet rich gift, and it was right in front of me! This reality was so profoundly different from what I had been doing. I felt very fortunate and I very much wanted to find out what this was all about.

SDB: In terms of family, children, domesticity, it seems that this was the first time in your artistic career that it really took hold.

NYM: All of those things became part of my creative field. I have a lot of energy and I'm not someone who was used to spending long periods of time at home. Just that one element, staying at home, changed radically. It was not my studio, but in a sense it became one.

SDB: *Scales* is actually based on the layout of the computer's motherboard. Was this collaboration coming out of your new experience of motherhood?

NYM: Yes. The collaboration was a continuation of the dialogue (of artists as mothers) with Melissa Smedley, a sculptor and videographer in California. We worked together in grad school and became involved in the inSITE '94, a bi-national installation exhibition. Our first major collaboration began with *Animal, Vegetable, Mineral: Comida para su Sombrero*, which took place simultaneously in Tijuana and San Diego in 1994. We had kept in touch after I moved to Ohio and were very connected as artists. The conversations we were having were about family life and were new to both of us. These conversations quickly translated into how the notion of *scale* and *perspective* had changed radically. As new mothers with very young children, we found ourselves in this continual, extremely challenging balancing act. Soon our discussions focused on how our lives were now about balancing, connecting, holding, weight and counterweight. The installation *Scales* came from an opportunity to show our work. We began communicating via fax, letters, and e-mail. It was through those media that we began to formulate the shape of the installation, but it wasn't until we were actually at the site that things began to solidify.

I don't remember how the motherboard came into play, aside

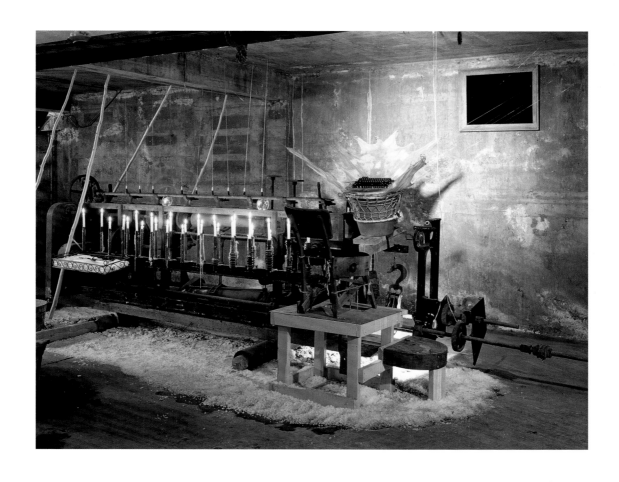

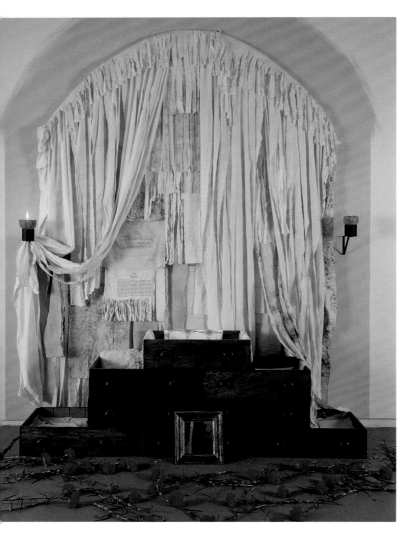

Fig. 68 [above]. **NANETTE YANNUZZI-MACIAS**, *Umbilicus: Las Madres*, 1996. Needlepoint, crochet, drawers, candles, and carnations, 10 × 6 × 2 ft. (approx.). Courtesy of the artist.

Fig. 69 [facing]. **MELISSA SMEDLEY** (American, b. 1960) and **NANETTE YANNUZZI-MACIAS**, *Scales* (detail), 1997. Mixed media installation, 12 × 30 × 30 ft. (overall installation, approx.). Courtesy of the artists.

from the obvious reason that it is both the mainframe of the computer and that it has that amazing name. Formally, the installation was laid out like a motherboard. We purchased a few of them and looked carefully at the circuitry, and decided that these little circuits were actually something we could work with. They were parts, but they were all interrelated and interdependent, and worked as a metaphor for what we were experiencing as mothers and artists. Each of the "stations" in the installation was taken from the motherboard, but instead of little pieces of circuitry and wire we used the "circuitry and wire" from our obsession with our new life, our space, our chores, and challenges.

SDB: The *Action* series started shortly after—the collections, the audio collecting, the video collecting. You went from examining the body, its parts and circuitry, to a survey of your daily life, and the physical trappings and elements connected with this experience.

NYM: The collection of residue and molting actually began in 1994. It continued after our son was born as I obsessively collected his fingernails. I saw them very much as moltings from the body. So I was collecting my son's fingernails and my own hair, which fell out profusely after the birth, which I had not expected—somehow I missed that note—and the residue of laundry, the unbelievable amount of laundry that we were doing. When I lived alone or when it was Johnny and me before the children, I went to the coin Laundromat or to the basement of an apartment building to do wash. Suddenly, here I was with a washing machine in the home! From that washing process—the washing machine had a screen to collect lint from the clothes—came the residue. I looked at it and I thought, what an amazing amount of material! I mean, I'm doing all this wash and you pull out the screen and then there's this goo on it that's all the evidence there is from all of this labor. And it's not even done! You have to do it over and over and over again. So I started piling it on the side of the washing machine and it kept growing and then I realized that I knew what it was—I knew that I needed to collect it as a residue or marking of that labor.

SDB: You went from being inside the body (in an earlier piece), where you wanted the viewers to feel themselves centered within, to the place where you've stepped outside of this organism and initiated a form of self-surveillance. And you were able to do this by wearing

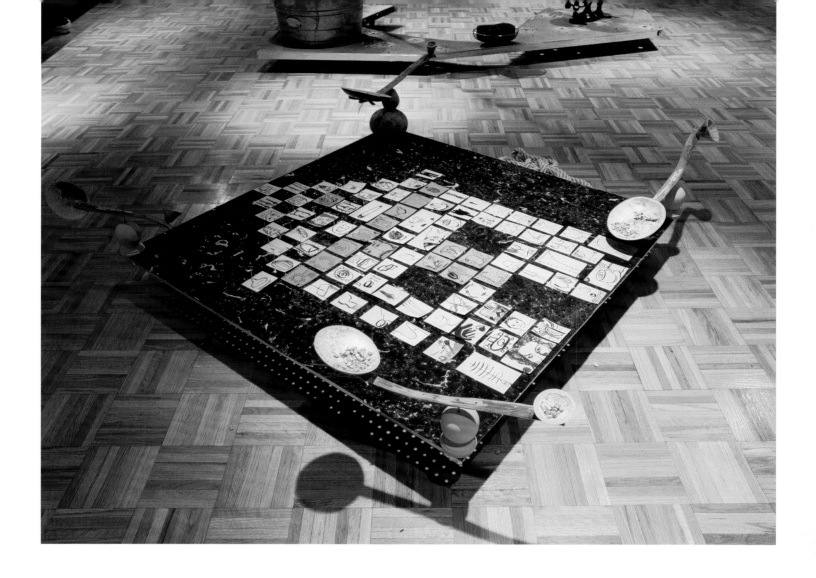

the self-activating tape recorder, and then, two years later, installing video cameras in your home.

NYM: *Video Days* took place in the summer of 2000, just after my daughter was born. I set up two stationary cameras in our home and used the same strategy I had used earlier with the voice-activated tape recorder in *Audio Days*, so that the cameras were ready and loaded and plugged in and turned on at spontaneous moments by whomever. They ran until we remembered to turn them off. I had not really figured out a strategy for turning them off and on, so it just happened the way it happened, and many times we would forget that it was on. The images recorded by the camera ranged from people walking through, people not walking through, children doing something, children not doing something, voices being heard in the distance while the refrigerator is humming, meals being prepared, things falling on

the floor, etc. The piece was begun in early July and ended in late August. The video is completely uncut. I had never intended to edit it, to me it's just not a document to be edited—it's a document that involves time. It's about taking a look at and experiencing that duration of time.

SDB: What were you doing with these images—gathering, documenting, or framing?

NYM: Documenting—that's very much what it was about, about a response to the idea that I was not producing enough work. This is something that I heard continually shortly after our son was born. "When are you going to get back into your studio?" and "Don't forget about your work." So I say to myself, what is this idea of production about? How are we measuring production? And again, my response to this was coming from a gendered perspective. I had just had a child! Talk about production!

HUMAN

HUMANE

HUMANIST

HUMBLE

HUMOR

Clearly this idea of production needs to be interrogated because it's not understood. And I needed to articulate it because I needed to understand how production was working for me now that I was associated with an institution and also a mother, an artist, and a teacher. So that's where the surveillance comes in. The surveillance at the same time is about attentiveness—an attentiveness that I'm becoming more aware of in my everyday life. I began reading the work of Thich Nhat Hanh because there was something in what he was saying about how meditation can be attentiveness to everyday life. Meditation didn't work for me; attentiveness did. I was questioning what it meant to peel carrots or bundle loads of laundry as you're attentive. It occurred to me that if you frame those activities in a particular way, and you're attentive to them in a particular way, then yes, of course they could be meditation.

SDB: Does that kind of meditation work as a way to justify a process for you, or is it a way to amplify it?

NYM: It's a way to understand it, not a way to justify it, because the word "justification" is an implication that someone or something is holding me responsible. And, yes, as much as the institution was holding me responsible, I have no allegiance to the institution. No, it's not about justification, but it is about framing—taking a moment or an idea away from its surroundings and looking at it. Hopefully in that framing I can move those that are open to a fuller understanding of what it means to support women and families both from within the culture and the institution.

SDB: Was the application of Thich Nhat Hanh's writing to your own life situation a revelation for you?

NYM: It made sense to me. Actually, long before his writings I was reading J. Krishnamurti. I started reading his work in my early twenties. Krishnamurti was a profoundly connected being who understood that, as humans, we are far less than perfect, and if we have any chance of surviving with hope of living a life devoid of fear, or hope of creating a life that is whole and not fraught with war, jealousy, power, and discontent, we have to change the way we think, change our perceptions. I am not a Buddhist; I was just interested in those ideas. I had so many questions I wanted to find answers to, especially after being raised in the Catholic Church. But what I have found is that there are very few answers, just more questions. More recently this questioning has led me to quantum physics. Many physicists

speak about the idea of reality as one, which we create with our minds and bodies—that there are parallel universes and simultaneity in our thoughts, both present and future. This had led me back to the words of Krishnamurti and more recently the work of physicists like Fritjof Capra, Stephen Hawking, David Bohm, and others.

SDB: Thich Nhat Hanh, Krishnamurti, and the Jesuit priest Michel de Certeau you mentioned previously—all these philosophies come together in this domestic setting where you, referring to Certeau's *The Practice of Everyday Life*, continue to frame these practices in your life and work toward the possibility of having them coalesce in objects.

NYM: The coalescing of objects—what does that mean? I find myself less and less interested in the coalescing of objects at this moment in time, because I feel like there's a lot of work to be done that is as important to me and as creative, and they don't necessarily coalesce. I'm very much in agreement with Allan Kaprow, whom I studied with in grad school, in that the person who creates and calls herself an artist is also the person who constructs the frame. In the example I am thinking of, Kaprow was working for a particular school district because he felt there was so much work to be done there yet so little creative problem-solving was happening. So that's what he was committed to at that point in his life—it wasn't that he was not an artist, it was just that he was framing it differently. And as I go through life I find that there are similar situations for me. My creative impulse and my desire to be here in this studio that you see will always be there, but I'm not devoted to it in the same way as another artist who sees it as the site of their production. How do I work on several different and opposing artistic fronts simultaneously? It's something I've struggled with for a very long time, and which I'm completely committed to. I've tried to separate my social and political ideas as something that exists outside of my artistic life, but it never worked that way.

SDB: You have talked about the object becoming less important and about your moving away from the analytical toward a more tactile involvement. You've mentioned Kaprow, Duchamp, and even Monet in this regard. How has the found object evolved in your work? How is it manipulated in this process of selection and framing?

NYM: That I can talk about, because it's process! The object is not only the residue, the documentation of everyday life, but also

Fig. 70 [facing]. NANETTE YANNUZZI-MACIAS,
Tonalpohualli for Ayo, 1996–ongoing through 2013. Artist's book, unbound
(eight leaves shown); fabric dye, ink, stamps, breast milk on handmade
paper, 10 × 7 in. (overall book dimensions). Courtesy of the artist.

process. I'm working with the materials you see here. I've had that piano for maybe eight years—I saw it for sale for $40 and I said to myself, you've got to have a piano if it's only $40. I didn't know what I was going to do with it, but I know now. For *Trace Elements*, I'm going to use the footage from *Video Days* in this piano, as well as a number of metronomes. There are going to be metronomes, there are going to be clocks, there's going to be a sense of a domestic space, objects from domestic life that are skewed, accentuated, changed, embellished. There's going to be a bed, there could be a giant clock. There could even be a little fingernail sculpture.

SDB: You have also been working with molds taken from everyday objects.

NYM: Yes, some of these molds are created from objects from everyday life and some are taken from clay renderings. Whether it's an ironing board or a teacup, a shoe, a foot, a heart, I see them all very much as objects from everyday life, and those objects are having a dialogue with the ritual of milagros. Milagros are religious medallions of certain body parts. If you have an ailment in your arm, you use the milagros of an arm to pray to a saint to be healed. Afterwards it's attached to a sculpture of a saint, or even nailed to a wooden cross. I've always been completely fascinated by that ritual. Yet it's not only the object itself, but also the process that leads to the object that I find so interesting. This has been an obsession of mine for twenty years or more, and that's what we're—Iz Oztat worked with me in the studio before she graduated—experimenting with here. I'm trying to find a way to take the objects from everyday life and use those in the same way.

SDB: Are you keeping the religious iconography intact with the milagros?

NYM: It's all there, it's definitely all there, but the context is very different. I've been making altars for a very long time. If you look at the images of my installations, you'll see they are very much structured in that way: they're part of that dialogue, a continuation and a revisitation of that experience. And I've often thought about the obvious connection between my installations and altars. I was usually so bored sitting in those pews for hour upon hour, and so my mind, my eyes, everything, wandered to objects: the paintings on the walls, the crown of thorns, the paintings of the stations of the cross, the light as it passed through the stained-glass window, the images of sacrifice. As a child I saw those images over and over for many years and also

in many different churches. I particularly loved the bays of wax candles in the vestibule. Section after section of hundreds of candles, each dripping warm wax—they just glowed. Now they're all electric, which is really sad. My attraction to embellishment, the beauty of the object and its place in our everyday lives, and our personal rituals comes from those experiences and memories.

SDB: What about the sounds and fragrances from these places? Do they play a role in your work?

NYM: Not really. I'm working with the element of time and using clocks to express that. That ticking has been with me throughout all my thinking about the pieces for this show—for obvious reasons, but also for the not-so-obvious reasons. I guess I'm not thinking of an installation per se because installations for me are very connected to the space they are in. In this exhibition at the museum, I feel very much that I am part of a group exhibition, and our raison d'être is that we are a group of people who work together. And I am finding it very difficult to see myself outside the group I'm dialoguing with.

SDB: This might be a good place to just talk about your role as a teacher. One thing you've said about your teaching is that students quickly become aware of your insistence on process.

NYM: I'm using something that I believe in—process—as a way of helping students illuminate, formulate, and recognize their own path. I think that by paying attention to that process they will find what it is they do best, even if in the end they reject the emphasis on process. I have a student right now who's engaged in that whole dialogue with me. He isn't interested in process, he wants to *make objects*. Eventually I allowed him to make the object because, as he said, "I have a clear idea of what I want to do, I want to make a bench, just a simple bench." Great! I was very happy for him, not only because he got to make his bench, but also because he let go of this bench-and-chair-making for a while to venture down a different road.

SDB: Do you have strong associations with your art teachers in New York and San Diego?

NYM: At Cooper Union I had some phenomenal teachers, including Irving Petlin, who is a painter, and Robert Slutsky, who was a painter as well as an architect. I just found out that he passed away. They weren't invested in process, but they were able to point me in the right direction as a young artist. They required that I be conscious of what it was I was doing. I didn't work with many sculptors there

Fig. 71 (Cat. No. 28) [detail, facing].
NANETTE YANNUZZI-MACIAS,
Collections: Our Family's Shoes, 2001. Shoes and
paint, varied dimensions. Courtesy of the artist.

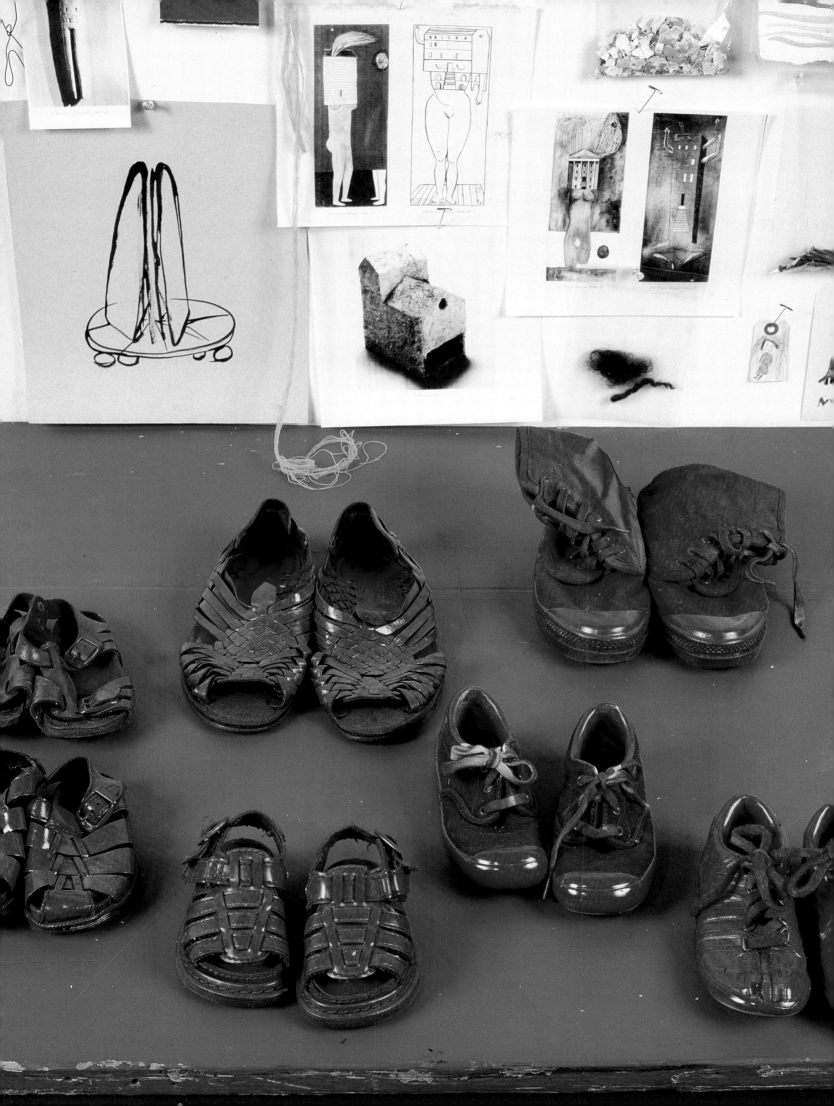

because most of their methodologies were rooted in a kind of formalism that I wasn't interested in. Hans Haacke was teaching there at the time. He was often on leave, and his classes were difficult to get into, but I was very aware of his work and ideas. I also took a class with Mary Miss but, again, I wasn't interested in that kind of approach to sculpture. There were also some incredible teachers at UCSD—Steve Fagin, Patricia Patterson, Newton and Helen Harrison, and Allan Kaprow.

SDB: Is there more of a dialogue or a mentoring with your students in the studio spaces at Oberlin?

NYM: I feel like it's my obligation in my relationship with my students as teacher to create the best learning environment in which to realize their potential in the arts. Sometimes that takes the form of a dialogue and sometimes it is more of a mentoring relationship—it depends on the student. Many students will take more than one course with me, or a course and a private reading. Over the years I develop a closer working relationship with some of them; we all do that in the Art Department. It's very different teaching art as opposed to other subjects. Teaching art requires one to know and respond to the whole person.

SDB: Do you feel the need to expose your own art-making and processes to them?

NYM: They want to know, and they're very interested, but usually I forget to involve them in what I'm doing in my work. If I do show them my work, I do it at the end of the term because I don't want them to start making certain decisions about their work based on what I'm doing. I don't want them to think I expect something. I don't think it's the role of a teacher to create acolytes. The students I work most closely with are not my acolytes; they are students I've formed strong bonds and relationships with. They understand my method of teaching and are getting something out of it. Ultimately, I want them to find their own way of making and that is a very difficult process involving a lot of time just living.

SDB: Do you sometimes see a young artist emerging who shares the same lineage or a similar vision with you?

NYM: Yes, absolutely. And it's very interesting. I like to hold back a little bit, with all I have to say about it, and discover through them how they move along that path. Teaching is an incredible honor—to be able to teach and support a young person in this important transition in their life is a rich experience. When I look at them sitting in a class or during a discussion I think, they're so young. Yet they have adult actions, adult ways, adult bodies along with that memory of childhood still fresh in their minds. My memory of childhood is sporadic; theirs is fresh and they still can feel it. They're at that precipice, moving into adulthood and real independence. When they're with us, many of them are faced with that experience of adult independence for the first time and it's a huge issue for them. I feel very responsible to them. What am I giving them? What have I led them to? I'm showing them the door, but when you walk through that doorway it's a little like a Surrealist painting—there's a sky, and there's land somewhere but they can't see it, and they don't know how they're going to find it. Helping them to find their voices as young artists is only part of our job; the other part is preparing them for the journey to come.

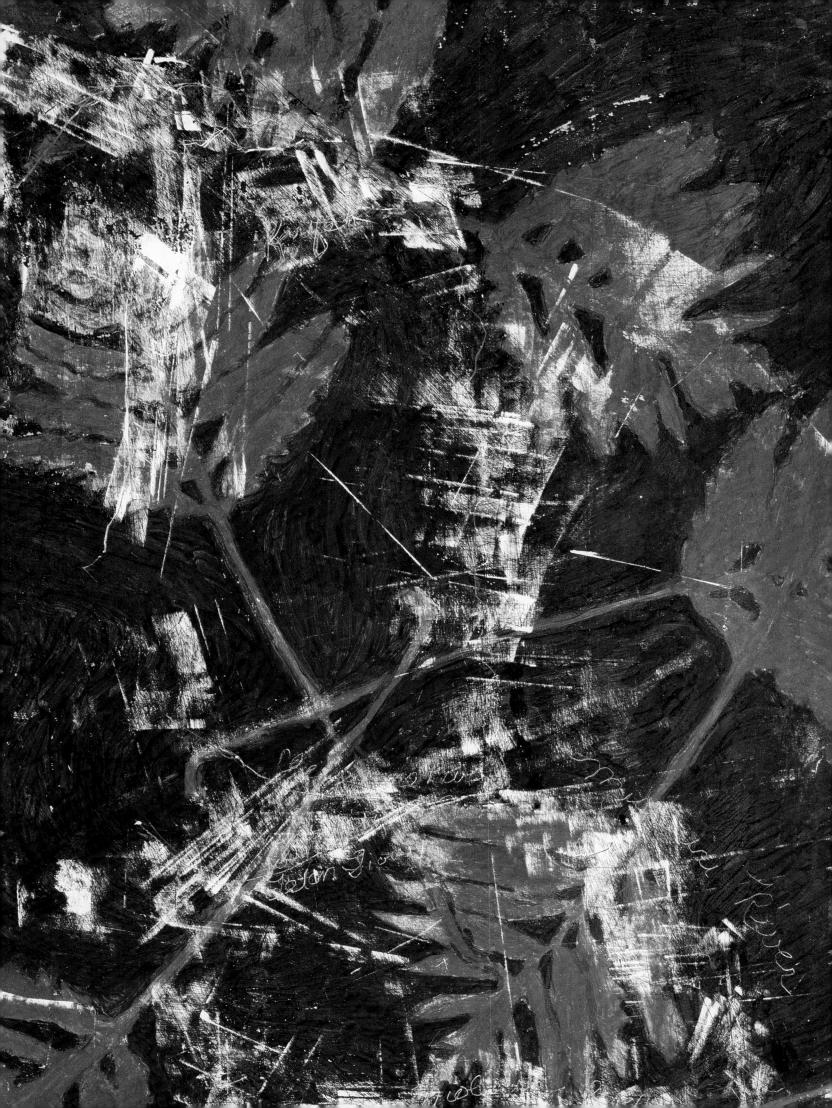

Rian Brown

EDUCATION

University of California at San Diego
 Master of Fine Arts, 2000
Massachusetts College of Art, Boston, Massachusetts
 Bachelor of Fine Arts, 1994

SELECTED SCREENINGS AND EXHIBITIONS

2004

Death of the Moth, Victoria Film and Video Festival, Victoria, British
 Columbia
The Settler, Duke University, Durham, North Carolina
Presence of Water, Kent State University, Kent, Ohio

2003

Death of the Moth, Finney Chapel, Oberlin College, Oberlin, Ohio; Massa-
 chusetts College of Art, Boston, Massachusetts; Suffolk University,
 Boston, Massachusetts
Mediated Nature, Here Here Gallery, Cleveland, Ohio*

2002

The Settler, California State University at Northridge, Northridge, California;
 Film Festival de Cannes, Cannes, France; New York International Film
 and Video Festival, New York, New York; UCLA Hammer Museum of
 Art, Los Angeles, California
Presence of Water, Joiner Center, University of Massachusetts, Boston,
 Massachusetts
Traces and Lines: Western Avenue, Spaces Gallery, Cleveland, Ohio

2001

The Settler, Cinema and Television International Multimedia Market
 (MIFED), Milan, Italy; Cleveland Institute of Art, Cleveland, Ohio;
 Shorts International Film Festival, New York, New York
Presence of Water, Shorts International Film Festival, New York, New York
Western Avenue, Here Here Gallery, Cleveland, Ohio

2000

Presence of Water, Nashville International Film Festival, Nashville,
 Tennessee; Oberlin College, Oberlin, Ohio; Women in the Director's
 Chair, Chicago, Illinois; Zygote Press, Cleveland, Ohio

1999

Presence of Water, Ann Arbor Film Festival, Ann Arbor, Michigan; Bar
 Harbor Film Festival, Bar Harbor, Maine; Independent Film Channel
 2001 Finalist, Angelika Film Center, New York, New York; Los Angeles
 Municipal Gallery, Los Angeles, California; Massachusetts College of
 ArtMedia One Roadrunner Digital Film Festival; University of California
 at San Diego, San Diego, California; New York Expo of Short Film and
 Video, New York, New York
Saca Una Foto/Hierophant, Los Angeles Municipal Gallery, Los Angeles,
 California

1998

Saca una Foto/Hierophant, University of California at Santa Barbara, Santa
 Barbara, California

1995

Saca una Foto/Hierophant, Zeitgeist Gallery, Cambridge, Massachusetts

1994

Saca una Foto/Hierophant, Harvard Film Archive, Boston, Massachusetts
Piano Store, New York, New York; Massachusetts College of Art, Boston,
 Massachusetts

*DENOTES GROUP EXHIBITION

SELECTED READINGS

Brown, Rian. "Southern California as a Futuristic Landscape." *Allen
 Memorial Art Museum Bulletin* 52, no. 2 (2001): 62–73.
Szczerba, Lisa. *The Aesthetics of Self-Representations: Portrayals of Preg-
 nancy and Childbirth in Autobiographical Film, Self-Portraiture, and
 Literary Autobiography*. Ph.D. diss., New York University, 2005.
Washington, Julie. "Experimental Filmmaker Focuses on Settings."
 The Plain Dealer (Cleveland), December 30, 2000.

Johnny Coleman

EDUCATION

University of California at San Diego
 Master of Fine Arts, 1992
Otis Art Institute of the Parson's School of Design, Los Angeles, California
 Bachelor of Fine Arts, 1989

Facing: Detail of SARAH SCHUSTER,
Excavations: Three Ferns, 2005 (see fig. 64).

117

SELECTED EXHIBITIONS

2005

Remembrance of Blue, Pomerene Center for the Arts, Coshocton, Ohio

This Is the Place, This Is the Thing, This Is the Person, The Brewery Project, Los Angeles, California*

2004

Material Witness, Museum of Contemporary Art, Cleveland, Ohio*

2002

Song of a Landscape, William Cannon Art Center, Carlsbad, California

Ghosts of Ohio, David Zapf Gallery, San Diego, California

2001

Rememory, Here Here Gallery, Cleveland, Ohio

A Landscape Convinced: For Nyima, Akron Art Museum, Akron, Ohio

Sculpt(pure): Terry Adkins and Johnny Coleman, G. R. N'Namdi Gallery, Chicago, Illinois*

2000

The Healing Spirit of Home, Collaborative Performance with Adenike Sharpley, Hall Auditorium, Oberlin College, Oberlin, Ohio*

48 Hours of Art, B. K. Smith Gallery, Erie College, Painesville, Ohio*

For Oshon: A Gathering of Brothers, College of Wooster Art Museum, Wooster, Ohio

1999

Stories Not Yet Spoken: New Works, David Zapf Gallery, San Diego, California

Another Prayer for My Son, William King Art Center, Abingdon, Virginia

Another Conversation, University of Northern Iowa, Cedar Falls, Iowa

California: A Second Look, California Center for the Arts, Escondido, California*

1998

Three Conversations with My Son, Hall Walls Gallery, Buffalo, New York

A Prayer for My Son and Myself, Radio Performance, WCPN, Cleveland, Ohio

1997

A Prayer for My Son and Myself, Randolph Street: Project Room, Chicago, Illinois

Stories from Here, FAVA Gallery, Oberlin, Ohio

1996

Stations, Installation Project, David Zapf Gallery, San Diego, California

Waterfront Line, Ninth Avenue Station, Greater Cleveland Regional Transit Authority, Cleveland, Ohio

Northern Ohio Crossroads: Urban Evidence Project, Spaces Gallery, Center for Contemporary Art, Cleveland Museum of Art, Cleveland, Ohio

Crossroads, Collaborative Performance, Warner Main Space, Oberlin College, Oberlin, Ohio*

Fathers and Sons, BAM Next Wave Festival: Artists in Action, Majestic Theater, Brooklyn, New York*

1994

Crossroads/Baggage, inSITE '94, Santa Fe Depot, San Diego, California*

Constructed Sketches: Crossroads, David Zapf Gallery, San Diego, California

5th Havana Bienal, Museo Nacional, Havana, Cuba*

Self/Others: New Portraits, David Zapf Gallery, San Diego, California

1993

Dia de los muertos, University of Nevada at Reno, Reno, Nevada*

Engaging Materials, Municipal Art Gallery: Barnsdall, Los Angeles, California*

1992

Counterweight, Santa Barbara Contemporary Arts Forum, Santa Barbara, California

Ruminations, David Zapf Gallery, San Diego, California

1991

Installations: Objects, Works, Angels Gate Cultural Center, Long Beach, California

White Wash(ed), Centro Cultural, San Diego, California

Blood Is Thicker, Southwestern College, Chula Vista, California

Freedom Views, Euphrat Museum, De Anza College, Cupertino, California

* DENOTES GROUP EXHIBITION

SELECTED READINGS

Coleman, John. "Landscape(s) of the Mind: Psychic Space and Narrative Specificity (Notes from a Work in Progress)." In *Space, Site, Intervention: Situating Installation Art*, ed. Erika Suderburg, 158–70. Minneapolis: University of Minnesota Press, 2000.

Crutchfeld, Margo. *Material Witness*. Exh. cat. Cleveland: Museum of Contemporary Art, 2003.

Heartney, Eleanor. *Urban Evidence*. Exh. cat. Cleveland: Center for Contemporary Art, 1996.

Pincus, Robert. *Of Gifts, Landscapes and Homes: The Art of Johnny Coleman*. Exh. cat. Carlsbad, CA: William Cannon Art Center, 2002.

Pinder, Kymberly. "Marked by the Body You Are In: An Interview with Johnny Coleman." *Pform Magazine* 44, no. 2 (Fall/Winter 1997): 24–27.

Pipo Nguyen-duy

EDUCATION
University of New Mexico at Albuquerque
 Master of Fine Arts, 1995
Carleton College, Northfield, Minnesota
 Bachelor of Arts, 1983

SELECTED EXHIBITIONS
2005
East of Eden, Light Work, Syracuse, New York

2004
AnOther Western, Olin Gallery, Kenyon College, Gambier, Ohio

2003
Mediated Nature, Here Here Gallery, Cleveland, Ohio*

2002
Myth and Memory, Association for Vietarts, San Jose, California*

1999
AnOther Western, Schneider Museum of Art, Southern Oregon University,
 Ashland, Oregon
Image Ohio 1, Roy G. Biv Gallery, Columbus, Ohio*
New Works, Wisconsin Union Gallery, Madison, Wisconsin*

1998
AnOther Western, Elizabeth Leach Gallery, Portland, Oregon
New Works, El Taller Boricua Gallery, New York, New York*

1997
Uncommon Traits: Re/Locating Asia, Center for Exploratory and Perceptual
 Art, Buffalo, New York*
Assimulation, Bucheon Gallery, San Francisco, California
Issues of Identities, Bucheon Gallery, San Francisco, California*
Faculty Show, Schneider Museum of Art, Southern Oregon University, Ash-
 land, Oregon*
Naturales Muerte, Bucheon Gallery, San Francisco, California*
Young and Restless, Bucheon Gallery, San Francisco, California*

1996
New Stories, Stevenson Union Gallery, Southern Oregon University, Ashland,
 Oregon*
Southwest '96, Museum of Fine Arts, Santa Fe, New Mexico*

1995
Assimulation, ARC, Albuquerque, New Mexico
M.F.A. Show, Fitzgerald Gallery, Albuquerque, New Mexico

American Photography Institute Fellows, Tisch School of the Arts, New York,
 New York*
The Nickel Matinee, ASA Gallery, Albuquerque, New Mexico*
SPE, Albuquerque, New Mexico*
Peace Art Show, touring New Mexico and Japan*

*DENOTES GROUP EXHIBITION

SELECTED READINGS
Roy G. Biv Gallery. *Image Ohio 1*. Exh. cat. Columbus, OH: Roy G. Biv
 Gallery, 1999.
Borys, Stephen D. "Pipo Nguyen-duy." *Contact Sheet, The Light Work
 Annual* no. 128 (2004): 4–9.
Light Work. *East of Eden*. Exh. cat. Syracuse, NY: Light Work, 2005.
Odita, Donald. "Pipo Nguyen-Duy." In *Fresh Talk, Daring Gazes: Asian Amer-
 ican Issues in the Contemporary Visual Arts*, Elaine H. Kim, Margo
 Machida, and Sharon Mizota, 139–42. Berkeley, CA: University of Cal-
 ifornia Press, 1998.
Schuster, Sarah. *Mediated Nature*. Exh. cat. Oberlin, OH: Oberlin College
 Press, 2003.

John Pearson

EDUCATION
Northern Illinois University, DeKalb, Illinois
 Master of Fine Arts, 1968
Royal Academy School, London, England
 Certificate, R.A.S., 1963

SELECTED EXHIBITIONS
2004
PMC Gallery, Tokyo, Japan

2002
Meli Solomon Fine Arts, Seattle, Washington
Here Here Gallery, Cleveland, Ohio

2001
John Pearson: Yorkshire Series: Regeneration-Continuum, City Museum of
 Fine Art, Ljubljana, Slovenia

2000
Japan Passage, Center for Contemporary Art, Cleveland, Ohio

1999
The International Print Biennial, Tokyo Museum of Graphic Arts, Tokyo,
 Japan*

1998

Cleveland Collects Contemporary Art, Cleveland Museum of Art, Cleveland, Ohio*

1996

Paintings/Constructions, Museum of Modern Art, Rijeka, Croatia; Taiheikan Art Gallery, Tokyo, Japan

1995

Shinto Series—Paintings/Constructions, Ukraine National Museum of Fine Arts, Kiev, Ukraine

1994

Prints/Drawings, Dewa Shonai International Center, Tsuruoka, Japan

1991

The Invitational, Cleveland Museum of Art, Cleveland, Ohio*

1988

John Pearson: Large Constructions/Paintings/Drawings, Center for Contemporary Art, Cleveland, Ohio

Art Ware: Kunst und Elektronik, Kunstmuseum, Munich, Germany

1987

Digital Visions: Computers and Art, IBM Science and Art Gallery, New York, New York*

Second Emerging Expression Biennial: The Artist and the Computer, Bronx Museum of Art, Bronx, New York*

Third International Print Expo, Lenin Museum, Kiev, Ukraine*

1986

International Drawing, Ivan Dougherty Gallery, Sydney, Australia*

Siggraph '86, Dallas, Texas*

Trends in Geometric Abstract Art, Tel Aviv Museum of Art, Tel Aviv, Israel*

John Pearson: Drawings/Paintings/Constructions 1986–87, Center for Contemporary Art, Cleveland, Ohio

1985

Siggraph '85, Tokyo, Japan, and San Francisco, California*

1984

Bertha Urdang Gallery, New York, New York

1983

Drawings/Paintings/Prints, Akron Art Museum, Akron, Ohio

1979

Visual Logic 1 & 2, Parsons School of Art and Design, New York, New York; Joslyn Art Museum, Omaha, Nebraska*

1978

Galerie Swart, Amsterdam, The Netherlands

1977

John Pearson: Paintings/Drawings/Prints, The Arts Club of Chicago, Chicago, Illinois

1976

John Pearson: Works from 1968–76, Wright State University, Dayton, Ohio; Arts/Humanities Gallery, Ashland, Ohio; Canton Art Institute, Canton, Ohio; Fine Arts Gallery, Athens, Ohio; Contemporary Arts Center, Cincinnati, Ohio; University Art Gallery, Columbus, Ohio

1975

Usis Sanat Gallerisi, Ankara, Turkey

Drawing Since 1940, Cleveland Museum of Art, Cleveland, Ohio*

1974

Fischbach Gallery, New York, New York (1975–76)

1973

First International Festival of Computer Art, The Kitchen, New York, New York*

Evanston Art Center, Evanston, Illinois

American Drawing 1963–73, The Whitney Museum of American Art, New York, New York*

1972

John Pearson: Paintings/Drawings, The New Gallery of Contemporary Art, Cleveland, Ohio (1974, 1975, 1976, 1977)

1971

Paley & Lowe, New York, New York

Reese Paley Gallery, New York, New York

Pollock Gallery, Toronto, Ontario

1967

Richard Gray Gallery, Chicago (1972, 1981, 1984)

1965

Galerie Schiessel, Freiburg, Germany

1964

Galerie Müller, Stuttgart, Germany

1963

Young Talent, Institute of Contemporary Art, London*

* DENOTES GROUP EXHIBITION

SELECTED READINGS

Henning, Edward. "The Art of John Pearson: An Analogy of Works of Art and General Systems." *Art International* 21, no. 2 (March–April 1977): 18–19, 39–45.

———. *Visual Logic*. Exh. cat. Cleveland: Cleveland Institute of Art, 1979.

Kuspit, Donald. *John Pearson: Drawings/Paintings/Constructions 1986–87*. Exh. cat. Cleveland: Center for Contemporary Art, 1988.

Mestna Galerija. *John Pearson: Yorkshire Series: Regeneration-Continuum*. Exh. cat. Ljubljana, Slovenia: Mestna galerija, 2001.

Ostromenskaya, Irina. *John Pearson*. Exh. cat. Kiev, Ukraine: Ukraine Museum of Fine Arts, 1995.

Toman, Boris. *John Pearson*. Exh. cat. Rijeka, Croatia: Moderna Galerija, 1996.

Bertha Urdang Gallery. *John Pearson: Drawings 1983–84*. Exh. cat. New York: Urdang Gallery, 1985.

———. *John Pearson: Paintings/Constructions 1985–86*. Exh. cat. New York: Urdang Gallery, 1986.

Weintraub, Linda. *John Pearson: Japan Passage*. Exh. cat. Cleveland: Center for Contemporary Art, 2000.

Sarah Schuster

EDUCATION

Yale School of Art, New Haven, Connecticut
 Master of Fine Arts, 1982
Boston University, Boston, Massachusetts
 Bachelor of Fine Arts, 1979

SELECTED EXHIBITIONS

2004

Your Ticket to Hell, Cleveland Public Theater, Cleveland, Ohio*

2003

Mediated Nature, Here Here Gallery, Cleveland, Ohio*
Ceres at 20: Birthday Duet, Ceres Gallery, New York, New York*

2002

Fragments of Nature/Fragments of Memory: Rebecca Cross and Sarah Schuster*, Adam Joseph Lewis Center for Environmental Studies, Oberlin College, Oberlin, Ohio*

2001

Liminal Dreams, Ceres Gallery, New York, New York
Personal Space: Twelve Contemporary Painters, Bowling Green State University Fine Arts Center Gallery, Bowling Green, Ohio*
Aeons and Aeons, Studio 70, New Haven, Connecticut*
Oberlin at the Here Here Gallery, Here Here Gallery, Cleveland, Ohio*

1999

The Technology of Desire: If I Had Wings, Fisher Gallery, Oberlin College, Oberlin, Ohio

1998

If I Had Wings, Ceres Gallery, New York, New York

1997

In Stitches, Abrons Art Center at the Henry Street Settlement, New York, New York*

1995

Ms. Conceptions, Ceres Gallery, New York, New York
Conceptual Textiles/Material Meanings, John Michael Kohler Arts Center, Sheboygan, Wisconsin*
Prime Source, FAVA Gallery, Oberlin, Ohio*

1994

Fashioning Life and Death: Athena Tacha and Sarah Schuster, College of Wooster Art Museum, Wooster, Ohio*
Views from Different Directions, Ceres Gallery, New York, New York*

1992

Sense of Self, Spaces Gallery, Cleveland, Ohio*
Salon of the Mating Spiders, Herron Test Site, Brooklyn, New York*
Group Exhibition, The Artist's Warehouse, Stamford, Connecticut*
Women's Body of Work, Miami University School of Fine Arts, Miami, Ohio*

1991

Open Studio, 368 Broadway, New York, New York
Women in the Visual Arts, Erector Square Gallery, New Haven, Connecticut*

1990

Sarah Schuster, Denison University Art Gallery, Granville, Ohio
Common Ground/New Directions, I. M. Pei City Hall Building, Dallas, Texas

1989

Exhibition, Yale University Art and Architecture Gallery, New Haven, Connecticut
Works in Progress: Kat O'Brien and Sarah Schuster, ICA Gallery, Oberlin, Ohio*
Daughters in Hell, Acme Gallery, Columbus, Ohio*

1988

Recent Graduates, Yale School of Art, London Institute, London, England*
Group Exhibition, Gloucestershire College of Art and Technology, Gloucester, England*
72 Degrees of Longitude, Sheffield City Polytechnic, Sheffield, England*

*DENOTES GROUP EXHIBITION

SELECTED READINGS

College of Wooster Art Gallery. *Fashioning Life and Death: Athena Tacha and Sarah Schuster*. Exh. cat. Wooster, OH: College of Wooster Art Museum, 1994.

John Michael Kohler Arts Center. *Conceptual Textiles/Material Meanings*.
Exh. cat. Sheboygan, WI: John Michael Kohler Arts Center, 1998.
Schuster, Sarah. *Mediated Nature*. Exh. cat. Oberlin, OH: Oberlin College
Press, 2003.

Nanette Yannuzzi-Macias

EDUCATION
University of California at San Diego
Master of Fine Arts, 1991
The Whitney Museum of American Art, New York
Independent Study Program, 1990
Cooper Union School of Art and Science, New York
Bachelor of Fine Arts, 1984

SELECTED EXHIBITIONS

2004
Your Ticket to Hell, Cleveland Public Theater, Cleveland, Ohio*

2003
Mediated Nature, Here Here Gallery, Cleveland, Ohio*
Ceres at 20: Birthday Duet, Ceres Gallery, New York, New York*

2001
Red, Here Here Gallery, Cleveland, Ohio

2000
Snapshot, Contemporary Museum, Baltimore, Maryland
North/South/East/West/Center, College of Wooster Museum of Art,
Wooster, Ohio*
Action: *Video Days*, Oberlin, Ohio

1999
*Transitional Spaces for the Millennium: The Mathematical Equation of
Randomness*, Crane Pool, Oberlin College, Oberlin, Ohio*
*Live Performance/One Hour Duration: Birth of Nyima Lucia Funmilayo
Coleman*, Lakewood, Ohio

1997
Scales, Hyde Gallery, San Diego, California*
Live Performance/Twenty-five Hour Duration: Birth of Emanuel Ayo Coleman,
Oberlin, Ohio

1996
Umbilicus: Remnants and Huaraches, Gallery 3770, San Diego, California

1995
Cultural Connections: Explorations of Transcultural Identities, Spaces
Gallery, Cleveland, Ohio

1994
Animal, Vegetable, Mineral: Comida para su Sombrero, inSITE '94, San
Diego, California, and Tijuana, Mexico*
Veinte dedos, El Sótano, Tijuana, Mexico*

1993
Dia de los muertos, University of Nevada at Reno, Reno, Nevada*
Ethnic Frequencies, Café Cinema, San Diego, California*

1992
Repo History/The Lower Manhattan Sign Project, New York, New York*
Al Fin del Siglo: Meditations for the Twentieth Century, El Centro Cultural de
la Raza, San Diego, California*

1991
Arte joven en Nueva York, Sala Romulo, Caracas, Venezuela*
Nature Morte: Modern Day Monsters, Art in General, New York, New York

1990
Dream Machinations in America, Minor Injury, Brooklyn, New York*
Clomid and Pergonal, ISP Installation, The Whitney Museum of American
Art, New York, New York

1989
Dia de los muertos, The Alternative Museum, New York, New York
Images and Words: Artists Respond to AIDS, Abrons Art Center, New York,
New York; The Painted Bride, Philadelphia, Pennsylvania

DENOTES GROUP EXHIBITION

SELECTED READINGS

Ghirardi, Gary. "El Sótano Project: Tijuana, Mexico." *Whitewalls* 37 (Winter
1996): 9–18.
Schuster, Sarah. *Mediated Nature*. Exh. cat. Oberlin, OH: Oberlin College
Press, 2003.
Yannuzzi-Macias, Nanette. "The Many Faces of Chief Wahoo and Other Lawn
Jockey Poems," *Whitewalls* 41 (Winter 1999): 103–8.
Yard, Sally. *inSITE 94: A Binational Exhibition of Installation and Site-
Specific Art*. Exh. cat. San Diego, CA: Installation Gallery, 1994.

Rian Brown

1. *Breadcrumbs*
2005
Triple video projection with sound
16 min.
Courtesy of the artist
Figures 6, 7, 28, 29

Johnny Coleman

2. *A Promise of Blue in
Green: For My Mother*
2005
Recovered oak beams,
timber-framed treehouse,
tin roof, dried flowers,
and a layered sonic narrative
of the artist's children
15 × 15 × 15 ft. (approx.)
Courtesy of the artist
Not illustrated; see Figure 41

Pipo Nguyen-duy

3. *East of Eden: Nomad*
2003
C-print
30 × 40 in.
Courtesy of the artist
Figure 1

4. *East of Eden: Rapture*
2003
C-print
30 × 40 in.
Courtesy of the artist
Figure 2

5. *East of Eden: In the Garden*
2003
C-print
30 × 40 in.
Private collection
Figure 47

6. *East of Eden: Mountain Fire*
2003
C-print
30 × 40 in.
Courtesy of the artist
Not illustrated

7. *East of Eden: Fighting Twins*
2003
C-print
30 × 40 in.
Courtesy of the artist
Figure 45

8. *East of Eden: Swordmen*
2003
C-print
30 × 40 in.
Courtesy of the artist
Figure 46

9. *The Garden: 01-15-A-03*
2004
C-print
30 × 40 in.
Private collection
Figure 49b

10. *The Garden: 01-20-A-04*
2004
C-print
30 × 40 in.
Private collection
Figure 48a

11. *The Garden: 02-04-A-01*
2004
C-print
30 × 40 in.
Courtesy of the artist
Figure 4

12. *The Garden: 02-11-A-01*
2004
C-print
30 × 40 in.
Courtesy of the artist
Not illustrated

13. *The Garden: 02-11-A-03*
2004
C-print
30 × 40 in.
Courtesy of the artist
Not illustrated

14. *The Garden: 02-22-C-01*
2004
C-print
30 × 40 in.
Courtesy of the artist
Figure 48b

15. *The Garden: 04-27-A-03*
2004
C-print
30 × 40 in.
Courtesy of the artist
Not illustrated

16. *The Garden: 05-06-A-03*
2004
C-print
30 × 40 in.
Private collection
Figure 49a

17. *The Garden: 05-06-B-01*
2004
C-print
30 × 40 in.
Courtesy of the artist
Not illustrated

18. *The Garden: 05-06-B-02*
2004
C-print
30 × 40 in.
Courtesy of the artist
Not illustrated

John Pearson

19. *Japan Passage: Fuji #2: Silence*
2000
Polyurethane, acrylic, and glitter
on birch
84 × 22 × 6 in.
Courtesy of the artist and Meli
Solomon Fine Arts
Figure 54

20. *Yorkshire Series:*
HH 1/3; 2/3; 3/3
2003
Acrylic on birch
3 panels, each 96 × 15 × 5¹/₈ in.
Courtesy of the artist and Meli
Solomon Fine Arts
Figure 56

21. *Yorkshire Series:*
Regeneration-Continuum:
Fall: AMAM; Genesis:
AMAM; Spring: AMAM
2005
Acrylic and pencil on wood
3 panels, each 96 × 16³/₄ × 1¹/₈ in.
Courtesy of the artist
Figure 21

22. *Yorkshire Series:*
Regeneration-Continuum:
AMAM Series: 150, Panels A–K
2005
Silkscreen inks and pencil on paper
150 prints, each 7³/₄ × 5¹/₄ in.
Courtesy of the artist
Figures 24, 55

Sarah Schuster

23. *Origin of the Species*
2001–2002
Acrylic and charcoal on canvas
60 × 72 in.
Courtesy of the artist
Figure 9

24. *Replicants*
2005
Oil and carbon transfer on
birch panel
125 panels (approx.), 2 × 2 × 1¹/₂
in. to 4 × 5¹/₂ × 1¹/₂ in. (varied)
Courtesy of the artist
Figures 10, 59, 61

24a. Cartoon for *Replicants*
2005
White transfer paper
6 × 7¹/₂ in. to 4 × 8 in. (varied)
Courtesy of the artist
Figure 10

25. *Cultivations*
2005
Oil and carbon transfer
on birch panel
24 panels, each 7 × 5 × 1¹/₂ in.
Courtesy of the artist
Figures 11, 60, 62

25a. Cartoons for *Cultivations*
2005
Red transfer paper
7¹/₂ × 6 in. to 10 × 6 in. (varied)
Courtesy of the artist
Figures 60, 62

25b. Cartoons for *Cultivations*
2005
Xerox copy
7¹/₂ × 6 in. to 10 × 6 in. (varied)
Courtesy of the artist
Figure 60

25c. Cartoons for *Cultivations*
2005
Museum postcards
6 × 4 in.
Courtesy of the artist
Figure 60

26. *Undergrowth*
2005
Xeroxed collage on wood
panel; oil on canvas (diptych)
96 × 120 in.
Courtesy of the artist
Figure 63

Nanette
Yannuzzi-Macias

27. *Collections: Teeth, Fingernails*
1997–present
Teeth, fingernails
Varied dimensions
Courtesy of the artist
Figure 13

28. *Collections: Our Family's Shoes*
2001
Shoes and paint
Varied dimensions
Courtesy of the artist
Figure 71

29. *Collections: Ayo*
and Nyima's Hair
2001
Hair
Varied dimensions
Courtesy of the artist
Not illustrated

30. *Unos Milagritos de la Vida*
2005
Metal, wood, plastic
Varied dimensions
Courtesy of the artist
Figure 72

31. *Piano with Scenes from Life*
2005
Video, piano, metronomes
Varied dimensions
Courtesy of the artist
Not illustrated

32. *The Hours*
2005
Nineteenth-century wooden
pegged bed rails, clocks, metal
Varied dimensions
Courtesy of the artist
Not illustrated